S0-ARW-635

BERTHE MORISOT

BERTHE MORISOT

ANNE HIGONNET

UNIVERSITY OF CALIFORNIA PRESS
Berkeley • Los Angeles • London

University of California Press
Berkeley and Los Angeles, California

University of California Press, Ltd.
London, England

The lines from "Natural Resources" from *The Dream of a Common Language, Poems, 1974–1977*, by Adrienne Rich, are reprinted with the permission of the author and W. W. Norton & Company, Inc. Copyright © 1978 by W. W. Norton & Company, Inc.

First California Paperback Printing 1995

BERTHE MORISOT. Copyright © 1990 by Anne Higonnet. English translation of Berthe Morisot's letters and notebooks © 1990 by Rouart Frères. All rights reserved. Printed in the United States of America. No part of this book may be used or reproduced in any manner whatsoever without written permission except in the case of brief quotations embodied in critical articles and reviews.

Library of Congress Cataloging-in-Publication Data

Higonnet, Anne, 1959–
 Berthe Morisot / Anne Higonnet. — 1st California pbk. print.
 p. cm.
 Originally published: New York : Harper & Row, 1990.
 Includes bibliographical references and index.
 ISBN 0-520-20156-6 (pbk. : alk. paper)
 1. Morisot, Berthe, 1841–1895. 2. Artists—France—Biography.
I. Morisot, Berthe, 1841–1895. II. Title.
[ND553.M88H5 1995]
759.4—dc20
[B] 94-31157
 CIP

10 9 8 7 6 5 4 3 2 1

The paper used in this publication meets the minimum requirements of American National Standard for Information Sciences—Permanence of Paper for Printed Library Materials, ANSI Z39.48–1984. ∞

For my grandmother
Thérèse David Higonnet
and to the memory of my grandfather
René Alphonse Higonnet

The women who first knew themselves
miners, are dead. The rainbow flies

like a flying buttress from the walls
of cloud, the silver-and-green vein

awaits the battering of the pick
the dark lode weeps for light.

My heart is moved by all I cannot save:
so much has been destroyed

I have to cast my lot with those
who age after age, perversely,

with no extraordinary power,
reconstitute the world.

> —ADRIENNE RICH
> *Natural Resources,* 1977

CONTENTS

Illustrations follow page 114.

Preface

Berthe Morisot seems so very simple. An art so radiant and calm, a life led soberly. And yet . . . how much accomplishment that art, that life contained. One of the few women to win a place in the history of art, Morisot was also an exemplary private person: daughter, sister, wife, mother, hostess. Two contradictory attainments in nineteenth-century Europe. Though not in Morisot's case. Perhaps simplicity is not as easy as it seems.

I learned about her life through her painting. I was just out of college, working as a research assistant. A long list of assignments came my way, and on it was a name only vaguely familiar: Berthe Morisot. There was little then in print on this founder and mainstay of Impressionism; enough, though, to galvanize me.

Why did these images command my attention? It took five years of graduate school and a doctoral dissertation to answer

that question. I learned slowly how Morisot made pictures of other women from a profoundly feminine point of view. And in a time when important painters were not supposed to see that way, she persisted, against all odds. Throughout her adult life she painted professionally. She worked, not for money, but with lucid detachment, intellectual rigor, and aesthetic integrity.

Meanwhile she managed to lead a full personal life, unlike virtually any other woman artist or writer of comparable caliber in the nineteenth century. All too many aspiring women have had to compromise their art or sacrifice their social position in order to appease convention. Morisot did neither. At every moment in her career she negotiated a narrow but almost uncannily astute path between the demands of society and those of art.

Who was this woman, I came to ask myself, who had the wisdom to make such choices? Who was this woman strong enough to make many choices very much less obvious, and very much more difficult, than they appear in retrospect? Because Morisot's reputation has, paradoxically, been diminished by her success. Had she faltered, or even fallen, we might recognize more clearly how daunting were her prospects. Instead, she left us a flawless record, deflecting any inquiry.

Morisot's letters revealed more. A selection, published long after her death, began to suggest a Morisot behind the facade: a woman who doubted and struggled. A woman who coped with loss, separation, professional anxiety, and conflicts between career and family. A woman who loved deeply and steadily. Her unpublished letters and private notebooks confirmed this other Morisot.

By the time I had finished my dissertation, I knew there was a second story to tell about Morisot. The life, I had learned, was as admirable as the art. Or rather I had learned from Morisot that life and art could consolidate each other. It was a lesson about risks and self-discipline, about caring and creation. It was a story about ordinary life and extraordinary success. It was the story of a woman who achieved that rarest, most elegant, most durable attribute—simplicity.

* * *

This book could never have been written without Berthe Morisot's descendants, the Rouart family. Their generosity, their acuity, and their tact have been unfailing. I am deeply grateful to them for the many ways in which they have helped me. I would like to thank in particular Mme Denis Rouart and M. Jean-Dominique Rey. My special thanks go also to M. Julien Rouart, M. Clément Rouart, Mme Agathe Rouart-Valéry, and M. Yves Rouart. I cannot praise too highly the scholarship of the late M. Denis Rouart; on his work all study of Berthe Morisot must be based.

Mme Janine Bailly-Herzberg and M. Philip Nord shared their erudition with me. The staffs of the Bibliothèque Nationale and the Musée Marmottan facilitated research. The Galerie Bernheim-Jeune, the Fondation Durand-Ruel, and the Fondation Wildenstein graciously provided photographs.

To my family, as always, my loving gratitude.

I

FORMATION

1841-1868

I

Family Background

1 8 4 1 – 1 8 5 7

"This is the lineage," wrote Morisot in a notebook near the end of her life, asking herself what her daughter Julie would become. Thinking into the future through her daughter, Morisot reflected on her past, on her mother and her mother's mother.

> Marie Caroline Mayniel, my grandmother, whom I am like . . . a boyish frankness, a very lucid, very keen intelligence . . . didn't ever hesitate to speak boldly . . . gullible, superstitious . . . flew into terrible rages during which she swore like a man— It could be so vivid, so gay! Nothing can convey her imagination. . . .

> My mother, Marie Cornélie, married quite young to Tiburce Morisot, very much enamored of him, wildly fond of

3

social life, intoxicated by her successes, saved from the intrigue around her by her great love for her husband. She had wit, innocence, grace, and kindness . . . she had the gift of charm and an admirable nature.

As Morisot describes her mother and grandmother, she concentrates on their moral character and their intelligence. More particularly, she recalls the expression of their intelligence—the way they spoke. And because she values self-expression and its formulation, she dwells on their education. Of her grandmother:

Her education at Saint-Denis,[1] which was then considered very superior, had instilled in her, besides the French language, which she spoke with extreme precision, a smattering of ancient history and a rather elementary knowledge of science. Her intellect went no farther, however; she firmly believed that this was the last word in female development, often taking me aside and nonplussing me with a test on Arabia Pétréa or some such equally interesting topic. . . . She would have been delightfully charming had she had the genuinely intellectual training that would have kept her from suddenly giving way to childish nonsense.

Of her mother:

She wrote with great facility and charm. I've saved her letters. . . . Though she had little education (her mother, having kept her at home because of her sweet character, taught her only spelling, boxing her ears to drive the lesson home), her reading and her social graces had made her a very pleasant companion.

It is education—however little they receive—that gives shape and charm to women's intellectual gifts, and it was Morisot's own education, which she graciously ascribes to circumstance, that made the difference between her fate and her grandmother's.

I said I was like my grandmother; I meant only in terms of appearance. I'm not her equal in many respects, but circumstances have improved me more.

And finally, more grimly, Morisot finds in her mother a legacy of spiritual strength that makes suffering endurable.

She was indifferent to the material world, knowing it was beneath her. She died in atrocious pain, conscious until the last moment, perfectly lucid in spirit.

If her maternal lineage gave Morisot a sense of moral and intellectual identity, her paternal lineage provided her with social and artistic security. Of her father and grandfathers, Morisot never wrote. The facts were public knowledge.[2]

The men in her mother's Thomas family were high-level civil servants, *trésoriers-payeurs-généraux* (chief treasurers and paymasters of the province), and her father, Edme Tiburce Morisot, was a civil servant also. He was born in March or April of 1806 into a family of skilled artisans. Family tradition claims indirect descent from the painter Fragonard. Tiburce's brother became a "master carpenter," but he himself had higher aspirations. Somewhere along the line he picked up an engineering degree.

Around the age of twenty-six, in Paris, Tiburce Morisot founded with some others an architecture periodical: his bid for artistic status. Unfortunately, his partners were crooks and absconded with the funds, leaving Tiburce to face the creditors. Honest but unable to cover the magazine's debts, he left what little furniture he owned to his landlord in lieu of rent and fled to Greece in about 1834.

He returned to France a prudent time afterward, penniless. A "very handsome man," "with a distinguished education," he managed to make a "very good marriage," and suddenly he had an independent income of eight thousand francs a year. (The average French worker then earned three francs a day.) His powerful father-in-law Thomas, at that point "personnel director of the Finance Ministry," pulled strings, and Tiburce was offered the job of subprefect at Yssingeaux on February 20, 1836. Yssingeaux was and is the second most important city in the department of the Haute-Loire in southeast central France.

The job, though honorable, was not so important that the government was taking a big chance in awarding it to this unqualified young man. Tiburce outdid expectations. Only a year later he was promoted to a more important subprefecture at Valenciennes, a large town very near the Belgian border. His former

boss congratulated him with regret and predicted further advancement in the civil service, lauding his administrative acumen and his good taste in people as well as in things.

Soon after his arrival in Valenciennes, Tiburce suppressed worker unrest in the Anzin mines, to the central government's satisfaction. This and subsequent handling of provincial matters earned him praise, and a July 1839 report characterized him as upright and prudent in every way, "kindly and reserved at the same time, straightforward without being harsh."

On January 29, 1840, came another promotion, this time to the full prefecture of the Cher, a province almost in the center of France. Once again, a ministry official used the same sheet to draft both an announcement to Tiburce and a note to his father-in-law, assuring M. Thomas that he was "glad to have this occasion to prove my desire to be agreeable." Now Tiburce was the monarchy's chief administrator for an entire province. He had also, between 1837 and 1840, obtained a sinecure as "rapporteur" of the Council of State. In 1841 he and the prefect of the Haute-Vienne, a province slightly to the southwest, switched posts, and the Morisot family moved to Limoges, the Haute-Vienne's capital, in August. On April 29, 1846, he was named an Officer of the Legion of Honor, a major award.

From then on, Tiburce Morisot's career, and hence Berthe Morisot's childhood, followed in the turbulent wake of French politics. Tiburce was a model bureaucrat, who accepted whatever government came to power, but the radical shifts from monarchy to republic to presidency to autocracy during the next twenty years put even his malleability to the test.

The revolution of 1848 included mob action in Limoges, which Tiburce defused "by asking the population to return to order, assuring it of the vigilance of the public authorities." The new republican government ousted him nonetheless. His father-in-law—now *Caissier-Payeur Central du Trésor* (Paymaster General of the Treasury) at the Finance Ministry—pleaded his case repeatedly, as did his wife's maternal uncle, arguing the Mayniels' proven patriotism and four young children involved. Finally, Tiburce Morisot was named prefect of the Calvados, a northern, Norman province, on January 10, 1849. (His independent income had risen by this time to ten thousand francs a year.) The

shadow of his service to previous regimes still hung over him, however, and when Louis-Napoleon Bonaparte seized absolute power in 1851 with his December 2 coup d'état, his ministry of the interior fired Tiburce Morisot within the week. A hue and cry ensued among the Calvados population. From its capital, Caen, came letters from every quarter, warning that "news of the dismissal has produced a very unfortunate impression there among all classes of society" and even admonishing the ministry.

It had been an insufficient proof of loyalty, apparently, to have posted a sign on December 6 announcing to the Calvados "the happy outcome of the supreme struggle begun in Paris. . . . Everywhere the Authorities have done their duty." Still, it would have been unwise to ignore the evidence of his popular support, so on December 9 the new Napoleonic ministry appointed Tiburce to the prefecture of the Ille-et-Vilaine, a lesser post in a Breton province to the west.

The Morisot family moved to the populous city of Rennes, but not for long. Whether he bore a grudge against the Second Empire, or whether for once he could not reconcile his principles with administrative policy, Tiburce Morisot proceeded to commit a serious political error. He protested vigorously and in writing against Napoleonic confiscation of Orleanist possessions. Napoleon had nationalized properties belonging to the previous reigning family on January 23. Tiburce was not alone in his alarm at this act of appropriation. Nonetheless, though on April 23 he signed an oath of obedience to the new regime, on July 5 he was removed from active government responsibility. The family returned to Paris: in what was then a Parisian suburb, Passy, they dwelt on the steep rue des Moulins, now the rue Scheffer.

Once more Cornélie's Thomas family rallied. The usual letters were dispatched, but to no avail. Finally, Cornélie's mother, the outspoken Caroline Mayniel, penned a tart note to the ministry, rebuking the government's ingratitude for Tiburce Morisot's years of service and her family's contribution to the first Napoleon's military successes, and castigating their implacable condemnation of her grandchildren to a reduced standard of living. No result. Over the years new appeals would be filed, interviews solicited. Tiburce was consigned to the respectable but much less

powerful administrative position of *Conseiller-référendaire à la Cour des Comptes* (Judicial Adviser to the Auditor's Office).

Still, Tiburce Morisot held an eminently respectable position in society and a distinguished civil record, and he enjoyed a sizable private income. The family were decidedly and permanently members of the upper middle class, what in France is called *la grande bourgeoisie.* In the years to come, when Berthe Morisot's choices made her a social eccentric, class privilege would protect her from overt criticism. And she would never need to earn her living. A career might happily supplement an income; but she would never depend on a career for her daily needs.

Berthe's family by this time consisted of father, mother, two sisters, and one brother. Her mother, Marie Cornélie, was married in 1835, when she was only sixteen, and gave birth to her first child, christened Marie Elisabeth Yves but called Yves, three years later. One year after, in 1839, came Marie Edma Caroline Morisot, called Edma. And on January 14, 1841, in Bourges, capital of the Cher, Berthe Marie Pauline Morisot was born. Tiburce, always to be a rather vague character, followed sometime between 1845 and 1848.

We know little about Berthe Morisot's childhood, but two recollections give us an idea of how she herself perceived her formation.

In the same notebook in which she described her mother and grandmother, Berthe wrote about her English governess, Louisa. Louisa was her governess for only a year or two, around 1848–49, but she left a lasting impression on her small charge, giving her, among other traits, a deep appreciation of Shakespeare.

> I loved her as only children can love, I thought she was *perfect,* you understand, *just perfect;* I saw her as pretty and apparently she was quite ugly— She instilled in me, first, an absolute faith—even in miracles—a faith I've lost, or almost— Then a certain moral strength, the courage to suffer in silence. When I was very small, I would cry in my bed when I was feeling sorry for myself, and she pretended not to hear me and did not console me. She taught me the meaning of equality, of fraternity— I've never despised a disabled person. I've never loved one either; that was the

flaw in her education, she didn't appeal to my sensitivity, and a woman has to be sensitive, or certainly seem to be.

A child crying alone in her bed. A child without self-pity—and yet a woman remembering a passionate attachment and characterizing her feelings for others with two of the three concepts from the stirring motto of the French Revolution: "Liberty. Equality. Fraternity."

What of liberty, the liberty to be or develop oneself? Berthe would preserve her mother's letters, and the two she kept from her childhood touch on her early efforts to express herself in writing and in music. Both are letters of maternal encouragement, praise, and pride, though in the first letter, her mother chides her "dear little fawn," her "jewel," for her sloppy handwriting, before saying:

> Continue to be sweet so that I can be proud and especially happy because of my little Berthe. Since you have an aptitude for the piano, study with care and perseverance; you'll see later how glad you'll be to be able to give pleasure to others and some good moments to yourself. I've on more than one occasion said that I would have been willing to suffer some handicap in exchange for musical talent— So if you're like me, work.

Cornélie wished, then, that she had been a musician, and hoped Berthe would be one in her place. Not because it might become a career but because music would be a satisfying way to please others and, occasionally, oneself.

Although Berthe was encouraged and brought up by her grandmother, her governess, and her mother, her closest childhood companion and influence was her sister Edma. Two years apart in age, they would share a commitment to painting instead of music, make plans and vows together, travel together. Their partnership seems to have been based on a long-standing complicity and a closeness that excluded even other members of the immediate family. Their sister Yves, only a year older, wrote Edma wistfully in the summer of 1862:

> Father was saying yesterday evening that we would never be privy to all the incidents of your trip, but that, for the

next six months, you would discuss them with each other in the solitude and secret of your room; we would have to listen at the door if we were curious to know of your impressions.

Behind every great woman there is another woman. Perhaps the only common denominator among nineteenth-century women of outstanding public achievements is their private bond to a female relative, almost always a sister, very often a sister with considerable talents of her own. It remains a subject of fascination that one family produced three exceptional writers: Charlotte, Anne, and Emily Brontë. But it would be more accurate to consider the marvel of the phenomenon as its explanation. Each sister was the other's most constructive critic, challenging audience, and loyal supporter. In the case of many women, like the Brontës, there was for many years no other. Morisot grew up in an atmosphere infinitely freer and more stimulating than the Brontës': privileged, teeming with new ideas, opportunities, and companions. But in her crucial, formative years, she too depended most of all on her sister. Behind Berthe Morisot was Edma Morisot.

2

First Lessons

1 8 5 7 – 1 8 6 7

Together Berthe and Edma resolved to become painters. We shall never know exactly when or how. Berthe let no one moment be noticeable. Her talent emerged almost imperceptibly. Only in retrospect can we see how subtle maneuvers added up to a brilliant strategy.

Cornélie decided that her daughters should offer drawings to their father on his name day in 1857. Tiburce had often expressed the hope that his children would learn to draw, and Cornélie decided to surprise him with the fulfillment of his wish. So she trooped Yves, Edma, and Berthe off to the apartment of an obscure drawing master called Geoffrey-Alphonse Chocarne. There, in his rather dark salon on the rue de Lille, the three sisters took their first art lessons.

Their younger brother, Tiburce, described the very conven-

tional idea of art that Chocarne maintained and the dreary exer-
cises he set for his pupils, all according to strict rules.

> The result was reminiscent of the landscapes made out of
> hair which are displayed in the windows of some funeral
> shops.
> Oh! those wretched journeys back from the rue de Lille
> to Passy for the three little girls in short capes, long skirts,
> and hats with ruffles and ribbons tied under the chin, es-
> corted by their father, who fetched home, in sullen silence,
> his bevy stupefied by Chocarne's instruction. . . .
> After a few months Yves, the eldest, patient and docile,
> was still bearing up, but Edma and Berthe announced to
> their mother that they would prefer to abandon the whole
> idea of painting rather than spend four hours three times
> a week at Chocarne's.

This is a tale that contains several points of interest: the consid-
erable investment of time put into drawing lessons—twelve
hours a week plus commuting time, perhaps another three hours
a week; Tiburce's participation in his daughters' education;
Edma and Berthe's willfulness. The only problem is that young
Tiburce is not a very reliable witness, since he was remembering
as an adult what had occurred when he was at most twelve years
old; he calls his sisters "little girls," when in fact at the beginning
of their lessons they were nineteen, eighteen, and sixteen years
old.

Certainly Tiburce's testimony has to be put into perspective.
The Morisot sisters were taking art lessons from a drawing-
master; there was nothing unusual in this at the time. Most mid-
dle-class girls or young women took art lessons. Drawing and
painting were more important parts of a standard bourgeois
education for girls than arithmetic, the sciences, or history.
There were some relatively rigorous schools in Paris for girls,
especially convent schools or the Écoles de la Légion d'Honneur,
but even these placed great emphasis on art, music, deportment,
and especially sewing. Many girls, like the Morisots, received
their education—consisting usually of a language or two, the
classics of literature—at home from their mother or from a gov-
erness like the Morisots' Louisa.

As to the art lessons, it was customary to take one's girls to a drawing master or have him come to one's home. The master could be quite eminent—painters as famous as David and Ingres had taken women pupils—and the lessons could be quite extensive—witness the Morisots' twelve hours a week—but these lessons were in no way professional. If an artist taught aspiring young male painters, he did so in hours carefully distinguished from the hours devoted to his female pupils. Despite the appearance of relatively serious studios like Chaplin's, in the 1840s or 1850s there was no place like the later Académie Julian, which at least purported to offer young women the kind of training that prepared official careers. Only one completely professional possibility presented itself to Cornélie Morisot: the free art school funded by the city of Paris, then directed by Rosa and Juliette Bonheur. There girls were trained to earn their living, usually in subsidiary art occupations like embroidery-pattern design or miniature painting. But Cornélie obviously had no intention of encouraging her daughters to enter any kind of artistic career. She was merely allowing the development of a banal amateur hobby.

Acquired privately, however, skill at painting took its graceful place alongside music, familiarity with light literature, and conversation as accomplishments expected in polite society. Social convention allowed only amateur skills as adornments for unmarried girls; all others fell under the condemnation of immodesty. Through the arts, girls could display themselves to their best advantage at social functions. Innumerable young women worked quite seriously at developing artistic skills, most often the piano, singing, painting, or at least sketching. They tended to devote the most time to these endeavors at the end of their adolescence, in the years between their schooling (however unofficial) and their marriage—exactly the years the Morisot girls were sent to Chocarne for their drawing lessons.

It would be a mistake to underestimate the proficiency or the satisfaction that young women gained from their artistic pursuits. Many produced lovely and skillful pictures, or played the piano well enough to entertain discriminating audiences, throughout their adult lives. But it would also be a mistake to minimize the difference between women's and men's approach

to art. This difference would permanently shape Berthe Morisot's subject matter and her ways of making pictures.

Women tended to make small pictures in pencil, gouache, or watercolor. This enabled them to work casually, at home or on holiday. Nineteenth-century pictures of all sorts show women working at little easels in their parlor and sketching by the sea in tiny bound notebooks. Before the nineteenth century, painting had required meticulous preparations, sophisticated knowledge of pigments, and a permanent installation, for artists then had to grind their own colors and store the paints they mixed in bladders. Painting anywhere but in a studio was a complicated proposition. Paints dried rapidly, and equipment was heavy. In the late eighteenth century, technological innovations made possible a more spontaneous kind of painting. Tin watercolor boxes holding tablets of color, as well as prepared papers available in the new art supply shops, spared artists mess and fuss. Women could now paint wherever their family obligations might take them, pick up or put down their work whenever their attention was called for.

Money was a factor as well. Edmond Duranty, friend and advocate of the Impressionists, estimated that while the yearly expenses of a professional studio ran between two thousand and three thousand francs, an amateur painter who worked at home might spend as little as fifty francs a year. A landscape painter's equipment, consisting of spike, field stool, knapsack, umbrella, and travel box, cost ninety francs. A woman painter, even one who worked very seriously, Duranty calculated, would not spend more than a thousand francs a year on her material, including the price of frames.[1]

If women could work so unobtrusively, it was also because they depicted domestic subject matter. Amateur women painters, especially during the period in which Morisot grew up, shunned the sort of massive and erudite religious, mythological, or historical subjects that required hired models, sets, and props. They tended instead to paint portraits of family and friends, or landscapes encountered near the country homes they stayed in on trips with their families.

So when they encouraged Yves, Edma, and Berthe's art lessons, M. and Mme Morisot were behaving like average middle-

class parents. They had no reason to believe their daughters would focus their lives on painting. In two out of three cases they were right. Even Berthe was acquiring other conventional accomplishments at the same time, masking the centrality of painting to her life. Family lore records her youthful grace and worldly distinction, her deft conversation, and her vivacious letters. She played the piano so well, apparently, that the composer Rossini, a frequent guest of the household, chose an instrument for her and signed it. Along with Yves, Berthe took lessons from the piano teacher and musician Stamaty, a professor far more eminent than her painting professor, Chocarne. Recalling those lessons, what Yves remembered was Berthe's attention not to music but to an image on the wall of Stamaty's music room, one of J.A.D. Ingres's finest drawings, a refined and yet intimate picture of the Stamaty family: parents, daughters, and Stamaty himself as a little boy leaning closely against his mother.

Nothing distinguished Berthe from her environment in her childhood and adolescence. She seemed then to fit into Passy and its way of life. Passy was almost the countryside, a village still of seventeenth- or eighteenth-century garden pavilions and low white houses. Tile roofs and old shady parks made the dense, noisy heart of Paris seem far away. Passy was almost a society unto itself, in which the women, especially, knew one another and constantly exchanged visits. After 1852 Morisot would never leave this neighborhood for longer than a few months. Child and woman, she would move from apartment to apartment within the same tiny area. There she was married. There she was buried. It was the world of Passy that she would translate into her paintings.

Convention, schedules, and fashion tightly circumscribed the life of Passy women. Women of the leisured classes felt the call of obligation all day long. They had servants, and they had leisure, but correct direction of their domestic sphere required an unflagging executive and cosmetic vigilance. Mornings were devoted to affairs of the household: supervising chores, planning provisions and menus, paying bills, balancing accounts, writing letters, tending and teaching sons not yet old enough for school, training their daughters. Women conducted these morning activities from their feminine sanctuary, the boudoir, or if they

lived in a big apartment, the small salon, with its furniture sacred to the feminine heart: the *écritoire,* or small writing desk, and the *chaise longue.* Lunch was usually a casual meal taken at home among family. In the afternoon came errands—the fabled *courses* that in Paris were elevated to a consumer art. Only the very wealthy had their clothes designed by couturiers; only the very poor made their own clothes. Bourgeois women designed their outfits from head to toe, going from specialized boutique to specialized boutique, picking out ribbons here, gloves there, ordering linen from the *lingère,* hats from the *modiste.* Everything had to be fitted, and usually not just once but several times.

Frivolity, perhaps. Luxury, certainly. But while women lavished what seems an inordinate amount of energy and money on their clothing, it has to be understood how great a role dress played in women's social function and, more profoundly, in a woman's sense of self. Each of a nineteenth-century woman's multiple daily occupations required a special outfit, functionally appropriate, of course, but, more important, signifying that duties were being fulfilled and rank maintained. With errands completed, the social obligations of the day began: the endless round of afternoon visits to friends, relatives, neighbors, or the wives and daughters of one's husband's or father's colleagues; the dinners, receptions, balls, concerts, theatrical performances, card games, and suppers. At these events women were on display, for their men's greater glory and for their own tactical purposes. Correct appearances were considered an intrinsic part of their social obligations. And of course of their femininity, since it was supposed to be the innate desire and aspiration of all women to be beautiful and elegant.

Such was the world, busy and virtuous according to its own values, of Passy women. Morisot in her youth gave no sign of resenting Passy or its way of life. She was still at the age when at least part of the morning could be, without argument, given over to music, reading, or painting, and some of the afternoon to lessons. But as her brother said, she soon found Chocarne's lessons insufferably dull. Yves decided she preferred sewing. Berthe and Edma demanded something better. What they got was Joseph Guichard, a competent if minor painter whose biggest assets were his connections and his ability to recognize his

own limitations. He came from Lyons but was then living on the Morisots' own street, where his wife ran a school for girls. Guichard had taken a bit of this and a bit of that from the warring artistic schools of his day: the Classicists, champions of Line and the Antique, on the one side, and the Romantics, advocates of Color and Drama, on the other. Guichard made pompous historical paintings, stiff religious paintings, and even some pictures, smaller and, oddly, murkier, of contemporary subjects. Whatever the quality of his own painting, he had the sense as a teacher to introduce Edma and Berthe to two livelier pictorial sources: Gavarni and the Louvre.

The Louvre contained the grandeur of the Old Masters, while Gavarni (Sulpice Guillaume Chevalier) caricatured the everyday. For quite some time, artists not primarily involved in official painting, but working instead for illustrated newspapers or for the print market, had been making and popularizing scenes of contemporary life. Gavarni was among them, along with others such as Achille Devéria, Henry Monnier, Grandville, and above all the brilliant and compassionate Honoré Daumier. When Charles Baudelaire wrote in praise of the "Painter of Modern Life," his acclaim went to an artist not unlike Gavarni: Constantin Guys, master of the boulevard scene, of the Dandy and the Cocotte, the Flâneur and the Lionne. These were Parisian "physiognomies," codifications of social, moral, and professional traits into stock figures, synthetic symbols of their time and condition. Working with these types, Gavarni and his colleagues recorded, sometimes with affectionate sympathy and sometimes with savage wit, the *moeurs*, or customs, of their time, whether domestic, political, sexual, or financial. Their turf was Paris: its streets, theaters, homes, and parks. Their technique was a nervous line, the trace of a rapidly analyzed moment or expression. They were masterful draftsmen, and this, no doubt, is why Guichard set Edma and Berthe to learn their methods— Gavarni's especially because their father owned a collection of Gavarni prints.

The Louvre taught different lessons. There Guichard brought Edma and Berthe in 1857 to learn by looking, and then from 1858 onward to learn by copying. In the Louvre hung the acknowledged masterpieces of European painting, the touchstones

of artistic genius. During Morisot's formative years, it was inconceivable that a painter could do better than emulate these masters, especially Raphael and Rubens. Moreover, photography was then in its infancy, and periodicals like the *Gazette des Beaux-Arts* were just beginning to use engravings to spread knowledge of art's history. But photographs and engravings could not convey color or the subtle techniques of brushwork and glazes. To acquire the tricks of the trade, an aspiring painter had to go to the Louvre and copy the Old Masters.

Which Edma and Berthe dutifully did. Berthe worked from Titian, Veronese, and Rubens, indicating a decided preference for those models then considered primarily colorists. On the days set aside for copying, the halls of the Louvre were thronged with painters young and old, both men and women. For if virtually all "original" professional painters were then men, many women made their living copying masterpieces, not as lessons but as products for sale. The Louvre was the most open art school of all, a place where students of many persuasions could watch and meet each other. All the copyists' work was out on their easels, proclaiming their interests and their talent. For Edma and Berthe, trained in seclusion, the Louvre meant exposure not only to painting's history but suddenly to the other art students of Paris.

By 1860 Berthe Morisot had become dissatisfied with Guichard and his methods. Perhaps someone's work had caught her eye. Perhaps she had drawn her own conclusions about the direction painting was taking. In any case, she declared that she wanted to begin working out-of-doors. She was rejecting the hallowed traditions of art and joining the most advanced trends in painting. And she was doing so in 1860, as early as any of the future Impressionists.

Her motives can be explained in part by her feminine amateur status, which also explains why her request did not seem extraordinary at the time. While serious male painters worked in studios, even very accomplished amateur women often worked out-of-doors. But by 1860 Berthe must have resolved to become more than an accomplished amateur, so her challenge to Guichard is one of the many critical moments in her career that remain somewhat mysterious. We can only surmise that at nineteen she

was a person gifted not only with exceptional intellectual acuity but with an even more exceptional will.

Guichard gave up on his obstinate pupils and passed them on to his friend Camille Corot, but not before sending Cornélie Morisot a letter that included the following prophetic passage:

> With characters like your daughters', my teaching will make them painters, not minor amateur talents. Do you really understand what that means? In the world of the *grande bourgeoisie* in which you move, it would be a revolution, I would even say a catastrophe.

It was a first warning, but a warning the family ignored.

Corot seemed a genial, fatherly figure, despite his avant-garde reputation and chronic near-poverty. He was famous for his gentle character, intellectual integrity, and sage advice to younger painters, many of whom, like the future Impressionist Pissarro, he taught on an individual basis without ever claiming or wanting the authority of a master.

He never pushed Edma or Berthe, never exposed them to the ribald life of the male art student, never urged them to paint anything outside the limits of what young ladies ought to know. He liked Edma's work better than Berthe's, because it was more docile. His own pictures were exceedingly chaste. Marginalized by established art institutions because they ignored the academic subjects of history, myth, and the nude, his canvases evoked with exquisite delicacy a quivering sylvan realm, a home for nymphlike peasants.

Corot did what he did impeccably well. As he brought Edma and Berthe to the banks of the Oise River between Pontoise and Auvers, the kind of site he liked to paint, he taught them his sense of color, a peculiar sense by contemporary standards because, rather than shaping images of volumes and space with sharp color contrasts or dramatic light and dark effects, he coaxed an impression of solidity from a narrow range of hues and tones. His official pictures might look gray, but from that gray emerged broad ponds, stately trees, and, above them, around them, a vast misty sky. For himself, he made pictures that seemed more exciting to the younger generation but that he considered merely studies, reductions of volume to light-saturated planes, exercises

in the translation of three dimensions to two.

The most advanced painters of the Parisian avant-garde revered Corot. Without overtly challenging the official painting standards of the government Académie des Beaux Arts, he flouted its conventions and its standards even in his official work by his refusal to paint what were evocatively called *grandes machines.* Large and belabored, the *grande machine* was brushed in a technique called "licked" because it was so slick, and referred verbosely to the past or to allegorical ideals, preferably to both, often with an added erotic spice. Corot painted rather small pictures of timeless scenes without morals, sometimes even pictures of cityscapes or contemporary women in his studio. Although he was famous within the French art world, he made little money and gave away much of what he did make. He never married, preferring to devote himself to art and live with great simplicity, and indeed, Corot never abandoned the simple and direct manners of his artisan background.

Not that he cherished solitude or became misanthropic; on the contrary, Corot enjoyed company and was on good terms with everybody he came in contact with. He had a knack for making people from all walks of life feel comfortable, including Tiburce and Cornélie Morisot. The Morisot parents were no snobs, and besides, it was fashionable for members of the middle class to include artists, writers, and musicians among their guests. Mme Morisot was in the habit of entertaining on Tuesday evenings, and Corot felt relaxed enough during these soirees to take the liberty of smoking his favorite "pipette."

Berthe had taken the first step in a career pattern, and she would under cover of family sociability continue cultivating professionals whose work she admired. Did Corot realize, did the Morisot parents realize, that their soirees served their daughter's tactics? Perhaps Berthe herself acted unconsciously, but all her life she would draw even the most intellectually strident into her private life, where they would play a double role: guests and colleagues, social companions and artistic allies, or, in Corot's case, family friend and teacher.

3

Contacts

1 8 5 9 – 1 8 6 7

Through her family as well as through Guichard and Corot, Morisot began in the early 1860s to establish a network of professional contacts. Though these were not to be the vital intellectual companions of her mature years, they placed Morisot in an artistic context larger than her home and gave her the models and the incentive to define herself more openly as a painter.

Morisot met Félix Bracquemond, a fellow student of Guichard's, while studying at the Louvre in 1859. Both painter and engraver, Bracquemond was involved in current literary trends and artistic societies; he was also the husband of a talented painter exactly Morisot's age, Marie. The same year, Félix Bracquemond, in turn, introduced Morisot to Henri Fantin-Latour. (Proper young ladies had to be introduced; they never introduced themselves.)

21

Fantin-Latour, an introverted and gloomily mystical young man, was still at that point open to fresh ideas and acquaintances. He painted in a rather traditional style, tightly constructed and evenly gradated, that reflected his passion for the Old Masters: "the most remarkable of all the copyists," commented Duranty, and Fantin-Latour himself exclaimed to Renoir, "There is only the Louvre! You can never copy the masters enough!" Not at heart a radical—except in his ardent admiration of Wagner's revolutionary music—he nonetheless knew and esteemed his most adventurous peers. He sensed that someone who painted quite differently from himself was to be the leader of his generation—Édouard Manet. Manet in 1860 was still a young unknown, for the scandals that were to make him notorious had yet to occur. But he too studied in the Louvre between 1850 and 1862, and it became increasingly clear, even from his copies, that he was ready to break the rules. His brushwork refused to melt into smoothly rounded volumes but instead held its own on the canvas, creating shape and light with swaths of flat color.

Edma and Berthe were aware of Manet's painting, and he of theirs, long before they met one another. Their reputations preceded them. In the summer of 1867 Cornélie wrote to Edma:

> La Loubens came back on Sunday. . . . She told us she had spent the evening at Manet's, that there had been much talk about you two, that Fantin had expressed his admiration for your beauty, saying that he had never seen such a ravishing creature as you a few years ago. It's emotion, then, that keeps his hat on his head [i.e., keeps him from greeting you]! His friend Manet then told him that he could easily have introduced himself to you, but he replied that he had always heard you didn't want to marry. Less was said about your painting, it seemed to me, than about your appearances. Manet, however, spoke of the approach he had made to an art dealer on seeing a delightful thing of yours. . . . Mme Loubens was asked which artists you saw. . . .

Mme Morisot thought Mme Loubens "should introduce you to the Manet brothers, who have money." In the meantime, Edma and Berthe were seeing a number of artists. There was of course

Corot, and the other members of the Barbizon landscape school to whom he introduced them. By 1868 Fantin-Latour's work had won their undivided admiration—with reason, for his paintings, if ultimately timid, had the merit of decidedly modern subject matter. He often painted pictures of women—his mother, his sisters, or his future wife—in their domestic surroundings, dressed in simple middle-class clothing, occupied by their daily routines. In contrast to acclaimed academics like William Bouguereau or Jean Léon Gérôme, his colors were richly glowing and his forms luminous. Two other painters Edma and Berthe met in the early 1860s also devoted themselves to what were then called modern genre scenes: Carolus Duran and Alfred Stevens. Carolus Duran, a swaggering entrepreneur, retooled academic subjects with bright colors and loose brushwork, but he also made portraits of currently fashionable women. Stevens became so famous for his Parisiennes that he was credited by critics with the very invention of the genre. Stevens's pictures, thought at first titillatingly shocking because so resolutely contemporary, almost immediately began to fetch soaring prices. Famous, wealthy, handsome, and charming, Stevens, with his wife, won friends at every turn, among them the Morisots. Carolus Duran the Morisots liked less.

But many people were welcome at the Morisot home. Cornélie entertained with grace and frequency in her new house on the rue Franklin, a stone's throw from the rue Moulins. Tiburce had been promoted to *Conseiller-maître à la Cour des Comptes* (Chief Judicial Adviser to the Auditor's Office) in 1864, whereupon the family moved to a building in a "hamlet" off the rue Franklin. It was (or is, for it still exists) a very large square white house, with wrought-iron balconies outside, and inside spacious rooms with delicate and gilded moldings, fine parquets, and a sturdy wood staircase. On the ground floor, a large living room gave onto a small verdant garden with a view out over Paris across the Left Bank. Morisot painted in this living room and made two versions of a picture showing the garden view from behind the garden railing. Directly above the main living room was a ladies' living room, in which she also painted.

Besides the afternoons during which they were "at home" chiefly to other women, gregarious or socially ambitious women

of the upper-middle or upper class could choose to institute a series of evening receptions, often referred to by the day of the week on which they regularly occurred. Sometimes these were organized around dinners for at least eight, sometimes they were less formal and focused around after-dinner entertainments, and sometimes they were a mixture of both. One was usually invited to these evenings, especially the dinners, but the process of inviting and being invited was governed by friendships and alliances that were as much made by soirees as the reverse. Hostesses developed styles of guests, who would in turn attract new guests of the same sort, while guests could use such evenings as meeting places and forums for their concerns. Some guests were regular features, while others came and went. The difference between a soiree and a "salon" was only one of degree. Some soirees were noted for their political figures, others for their literary luminaries, while almost all provided a setting in which people with different professions but common interests could mingle.

Mme Morisot gave friendly and unpretentious Tuesday dinners, to which she invited painters because her daughters knew painters, but by no means only painters. The most remarkable thing about her guests was that while some were already eminent in their respective fields, many more would become so. Rossini, Berthe's musical admirer and a Passy neighbor, was a familiar face and would be so for more than a decade. The Ferry brothers, Charles and Jules, "irreproachably correct," paid court, respectively, to Edma and Berthe. According to young Tiburce, it was from their father that Jules—later one of France's most distinguished statesmen—obtained the sources for his notorious *Haussmann's Fantastic Accounts,* a searing indictment that helped bring down Haussmann, redesigner of Paris, from his powerful place as the capital's prefect.

All soirees placed a high premium on lively and intelligent conversation, devoted sometimes to current events but sometimes also to the arts. Not only were literature, music, and the visual arts discussed in terms of ideas or trends, but they were also performed. One of the reasons girls acquired artistic skills was to be able to entertain their parents' guests. After dinner, music was almost always played, theatrical parlor games could

be organized, albums might be drawn in or inscribed with verse. For a young woman like Berthe, these evenings were invaluable, for they furnished the only occasions on which she could develop her acquaintance with professional artists, learn about their work, and even exchange ideas with them, while at the same time playing a conventionally bourgeois feminine role.

As yet undecided about her career, Morisot, introduced to people of such varied talents, wavered from her commitment to painting in the winter of 1863–64. For about six months she studied sculpture with Aimé Millet. In an irony that was to repeat itself, the product of Morisot's passage through someone else's studio was not her own work. No sculpture by Morisot survives from this period, but on one side of the carriage entrance to 14 quai de la Mégisserie in Paris, a large bas-relief medallion by Millet still adorns the wall today—the face is Morisot's, somewhat exaggeratedly statuesque and full but characteristically hers, strong-jawed and deep-eyed.

Millet, a friend of the Morisot family, was also a friend of Achille François Oudinot, the Barbizon painter, to whom Corot passed Edma and Berthe Morisot in 1863 when he felt too busy to give them the training they wanted. One of Millet's and Oudinot's meetings turned into the earliest record we have of Edma's and Berthe's professional standing.

> I'm writing you these few lines from your teacher Oudinot's because I can't resist the pleasure of having you hear what is being said in this room. Oudinot shows your sketches, your paintings, to M. Busson, a colleague, and my pen becomes too slow and clumsy to repeat this man's exclamations. He's simply bowled over. Three times he asked your age, he just can't believe that young ladies of nineteen and twenty could possess this power of conviction.
>
> If only you could be here in some little corner! Then you would be convinced of the sincerity of those who tell you: "Go on! go on!" Oudinot talked of the reproach that has apparently been leveled at you, that you imitate Corot! First of all, it's not true, entirely, and secondly, what takes the form of reproach would to my mind be praise.

Obviously Millet meant well. His praise, like Busson's and presumably Oudinot's, was sincere; Oudinot on another occa-

sion predicted to Mme Morisot an "exceptional future" for her daughters. The Morisot sisters must have been, and with reason, much encouraged by Millet's testimonial. Still, over Edma and Berthe's early work hung two imputations difficult to shake because so persistently attached to women's work. One is the tendency to make women into children, hence the subtraction of several years from both sisters' ages. The other is the allegation that their work merely reflected their male teacher's. Early critics of paintings by Edma and Berthe often claimed their work was strongly influenced by Corot's, diminishing thereby their individual achievements.

Those few of Morisot's early canvases that survive do resemble Corot's, but most young students' work bears the imprint of their teachers' style. In the early 1860s all the future Impressionists' work looked quite a bit like Barbizon painting, or like Eugène Boudin's work, or even Johan-Barthold Jongkind's. All of them, including Morisot, were still maturing as artists. A young painter could do worse, though, than to produce work that was thought to resemble painting as highly esteemed as Corot's.

Both Edma and Berthe Morisot later repudiated Oudinot, but in so doing they reveal that at the time of their studies with him, their relationship was serious enough. Berthe wrote to Edma on May 11, 1869:

> I've just been sorting out some papers, and reread a packet of Mr. Oudinot's letters; some are hilarious; how could I have ever thought he was so likable? I wish I had my replies; the complete collection must be killingly funny. These are distractions which, alas, can't be repeated every day and which cost me quite a few tears (at the time). Now I think I was quite stupid, quite silly, to have cried so much over something so trivial: There are some expressions of despair which are simply grotesque but which I took in a spirit of high seriousness. God, how foolish women are! But I do think that in this I surpassed the average.

Edma replied:

> I can well understand that you can only laugh now about the Oudinot correspondence; to anyone else but ourselves it would have seemed grotesque much sooner. I too have

kept a packet of letters, which I'll reread someday to amuse
myself. I'm still too full of hatred for the man to look back
to the time when we lived so intimately together.

It remains unclear what had cost so many tears. Guichard in
a later letter refers to a "disappointment." Had either Oudinot or
Berthe Morisot overstepped the boundaries of a teacher-student
relationship? Possibly, but the drama at any rate seems to have
caused an emotional flurry on Morisot's part and effectively
ended contact between Oudinot and the two sisters. Edma and
Berthe soon judged the episode "grotesque" and henceforward
cited Corot as their teacher.

Although professionals like Oudinot could be the butt of their
humor, Edma and Berthe Morisot always took each other seri-
ously. Probably the earliest picture we have of Berthe is her
portrait by Edma, dated 1863. The portrait is of a painter. A
warm light grazes through the image from the right, past the side
of Morisot's square face with straight nose and bow-shaped
mouth; her eyes are in shadow, intently focused on the light's
destination, her canvas; its edge runs along the edge of the pic-
ture, a pale golden stripe. As luminous as the canvas border are
Berthe's tools, her brushes and her palette's rim. Her hands hold
her tools, at the center of her portrait, as the focus of Edma's
image. Berthe's eyes are absorbed in the work of her hands, in
the vision that her hands are translating into painting. She seems
barely conscious of the spectator, barely conscious of herself;
her hair, long, dark, hanging in loose curls, her simple jewelry,
and her plain comfortable black velvet skirt and jacket merge
into the background, accented only by the embroidered details
of her gold-buttoned red blouse and matching hair ribbon.

Edma and Berthe decided in 1864 to submit paintings to the
Salon. Their decision was another of several markers along the
discreet way to Berthe's professional goals. The Salon dominated
the business of painting in nineteenth-century Europe. Held
every year or every other year, both social event and market-
place, the Salon was a huge exhibition that opened in the spring.
In the 1860s it was still by far the most important place for
professional painters to make their reputations, seek commis-
sions, and be judged in comparison with their peers by senior

members of the field and public alike. To hang in the Salon, an artist's pictures had to be approved by a jury composed of professional luminaries, most of them members of the Academy or other official art institutions. The jury was conservative. Corot's pictures had been rejected in his youth. Gustave Courbet's pictures had been refused. All four pictures Berthe and Edma submitted were accepted in 1864. Berthe showed two small landscapes. The sisters' work was greeted by critics with tepid benevolence.

Berthe went on showing in subsequent Salons. She showed two pictures in 1865, two in 1866, one in 1868, two in 1870, one in 1872, and one in 1873. One of her submissions was rejected in 1872, and several in 1874. Perhaps she showed only one picture in 1868 and 1873 because of other rejections. Nonetheless, in comparison with Manet and the painters who were to become known as Impressionists, she was doing quite well. One factor in her favor may have been the unobtrusiveness of her small canvases; another may have been the subtlety of her subject matter, palette, and technique. To an obtuse jury, Morisot's work may have seemed merely an outstandingly competent version of the kinds of pictures they expected from women. Her work was not nearly as overtly threatening as Paul Cézanne's, for instance—Cézanne, who never had any of his paintings accepted by the Salon jury.

Berthe and Edma Morisot were also pursuing other sales or exhibition possibilities, by the usual and meager avenues then available. In 1867 both sisters followed the common practice of sending pictures to one of the provincial exhibitions organized by Friends of Art societies; in Bordeaux, Berthe showed one picture and Edma three. That same year, while the two sisters were off on a painting expedition, Oudinot came by their Paris home to choose canvases for an exhibition in Versailles. Some innovative merchants were beginning to imagine sales tactics other than the Salon or commissions. Though they were not yet dealers as we have come to define that occupation, men such as Louis Martinet and Alfred Cadart were working through their membership in societies like the Société Nationale des Beaux-Arts or the Société des Aquafortistes to organize exhibitions of paintings or prints on a regular basis, in order to bring together

artists and private buyers. Cadart, both a merchant and an editor, had a shop with a street-front window, in which he regularly sold paintings. Berthe and Edma placed a revolving series of works with Cadart, hoping—largely in vain, it seems—that they would draw clients; they were asking three hundred francs a picture. Sales seem to have been slim, but some of Berthe's pictures at least attracted attention. Her mother wrote to her on July 23, 1867:

> Let me say to you now that Mr. J[ules] Ferry asked me to tell you that your paintings were much noticed at Cadart's. He was passing by the shopwindow with a friend who was a connoisseur or an artist, I don't know which, who stopped in front of the pictures saying: "Now that's curious (in other words, that's something), who's that by?" There followed the spelling out of some impossible name, it's by an Englishman—Morz, Monse—anyway, on the way back, drawn once again to this painting, they look more closely and Jules reads your name just as people in the shop were asking to have the painting turned around so they could see it better. That seemed like a good sign to him; nonetheless I have no news for you about sales and I still wonder how artists survive who rely on sales for their living. It can't be those who, like you, want to devote themselves entirely to art that succeed.

It would be hard to overestimate the importance of Morisot's exhibitions in her transition from amateur to professional painter. To exhibit was to seek public exposure, to court professional comparison or judgment, and to suggest that she could be paid for her work. No matter how much time she had devoted to painting, no matter how great her native talent or her commitment, if Morisot's work had never faced public scrutiny it would always have remained amateur. It wasn't so much a question of profit or critical consensus as of detachment. Professional means in part impersonal—that is, what goes beyond the subjectively satisfying. In terms of nineteenth-century painting, it meant producing work that fit somewhere, even on the fringes, within standards shared by many people. At the Salon hung pictures whose adherence to visual conventions—a "realistic" style based on optical illusions and subject matter corresponding

to bourgeois ideals—was recognized and therefore matched with rewards.

It would also be hard to overestimate the courage of Morisot's exhibitions. We have some evidence from art manuals and guidebooks that by the 1890s it was considered unusual but not extraordinary for a woman to make a career of painting. But in the 1860s an artistic career for a woman was exceptional. It was men's prerogative to exchange goods and services, even aesthetic ones, for money; women belonged to a private realm, which might also produce art but in which all exchange was personal. Exhibition at the Salon by a woman was perceived as perilous exhibitionism.

During Morisot's youth, it was unthinkable for an unmarried middle-class woman to go anywhere or do anything in public without a chaperone. In an age when sheltered innocence con-stituted a girl's greatest asset, conventional families zealously guarded their daughters. A chaperone both protected her charge and acted as a guarantee to the world of that protection. Often girls remained under the supervision of a relative or governess even within their home. A young Russian painter, Marie Bash-kirtseff, who aspired to a professional career, left a record of her reactions to her sheltered situation in a diary, published in 1887 after her early death:

> What I long for is the freedom of going about alone, of coming and going, of sitting on the seats in the Tuileries, and especially in the Luxembourg, of stopping and looking at the artistic shops, of entering the churches and museums, of walking about the old streets at night; that's what I long for; and that's the freedom without which one can't become a real artist. Do you imagine I can get much good from what I see, chaperoned as I am, and when, in order to go to the Louvre, I must wait for my carriage, my lady companion, or my family?[1]

Morisot had the good fortune to be able to circumvent this problem. She never needed to ask anyone to accompany her. She was always with Edma. The two sisters painted side by side. They had identical notions of how much time to spend painting, where to spend it, and on what. If a very public situation re-

quired further companionship, Cornélie Morisot seems to have been willing to go along. She sat and sewed while her daughters worked at the Louvre; she enjoyed Salon openings. For twelve important years Morisot didn't have to choose between painting and etiquette.

Even so, Morisot's training might have seemed to preclude professional attainments. A successful career in painting meant—in the 1860s—commissions, high prices, medals, prizes, seats on state committees, professorships in state schools, and memberships in state academies. For these there was a proper training: study in the prestigious studios of Academy professors, leading to further study in the central school at the École des Beaux-Arts. Only in such studios could a young painter find the full program of anatomy, drawing after classical art, and composition classes, as well as the requisite scholarly instruction in mythological, religious, and historical subjects. More crucially, it was in these studios that young painters found the support and stimulating competition of peers, and the professional contacts that could lead to lucrative state commissions and fellowships. None of these studios then accepted women students.

Corot's instruction counted for little. He operated outside the official atelier circuit, and also, with a kind of circular logic, his instruction could be devalued because Berthe and Edma Morisot were women. In the middle 1860s many young women spent time perfecting their amateur accomplishments and by their marriage had produced quantities of pictures comparable, it could be claimed, to those painted by Berthe and Edma under Corot's tutelage. Furthermore, the kind of painting young women did was thought to be relatively slight even among the pursuits considered suitably feminine. Writing, for example, seemed a more austere art, because more solitary and more demanding intellectually. The dreaded "bluestocking," or learned woman, caricatured even by the otherwise liberal Daumier, was almost always a writer or a politician, not a painter. In an 1864 chapter on "women in professional careers," Ernest Legouvé, considered an authority on the subject, made no mention of painting, though he included a section on women of letters.

Finally, it might have added to an impression of amateurism

that Edma and Berthe did the bulk of their painting during summer trips. Women of the middle classes tried not to spend their summers in the city. The seaside, the mountains, or a provincial château brought relief from urban heat and from social obligations. Though some fashionable resorts generated a whirl of events equivalent to a Paris "season," at many others women were liberated from their fittings, their visits, and their friends. They could even take off their corsets during the day and indulge in wafting white cotton dresses, shading their faces with flower-laden straw hats. Edma and Berthe spent every summer, rounded out with late-spring and early-fall weeks, away from Paris in the usual places middle-class families went. They were occasionally even away from their parents, once their older sister, Yves, had married Théodore Gobillard, a tax administrator, late in 1866, and could thus chaperone them appropriately.

Berthe and Edma, however, far from being on vacation, were getting the year's work under way. In 1861 they summered at Ville d'Avray, conveniently near Corot. The next year they went off to the Pyrenees, trekking by mule and donkey. Oudinot drew them in 1863 to the Chou, a picturesque village on the banks of the Oise River. There he introduced them—along with their mother, of course—to other artists outside official circuits: to the Barbizon school leader Charles-François Daubigny, to Daumier, and to a younger landscape painter, Antoine Guillemet, another friend of Édouard Manet's. Eighteen sixty-four saw them at Beuzeval, a quiet little beach on the Norman coast between Caen and Trouville, where they returned the next year, though part of the summer of 1865 was spent not far away in Fécamp. In 1866 and 1867 they worked in Pont-Aven,[2] Douarnenez, and Quimperlé, fishing villages along the rocky Breton coast.

The summer of 1864 was especially crucial. Tiburce Morisot remembered Berthe working feverishly for days at a time, going off with her knapsack and easel, seeking out motifs and good sunlight; Edma, of course, must have been with her. Perhaps they worked so willingly because they had met a new companion. The Morisots rented their mill in Beuzeval from a painter, Léon Riesener, who lived not far from them in Paris. Riesener had impressive connections in the arts: he came from a line of superb eighteenth-century cabinetmakers and was himself the

accomplished if conservative author of pastels, several of which are now in the Louvre Cabinet de Dessins. He was also a cousin of Delacroix, revered master of the previous generation. Morisot respected his ideas on art enough to spend part of that summer copying 135 pages of them into a notebook titled "Riesener, Notes taken from his Notebooks on Painting."[3] Léon's daughter, Rosalie, was also a painter, about to make her first appearance at the Salon the next year, and back in Paris after the summer, she, Berthe, and Edma worked together at the Louvre. Berthe stayed in close touch with the Rieseners for the rest of her life, continuing to quote Léon's opinions on art along with those of her younger colleagues.

Another important woman entered Morisot's life through the Rieseners. Adèle Colonna had been a tenant of the Rieseners' in Paris since 1859, in a studio next to their home. By 1866 Rosalie Riesener had painted a life-size portrait of her, so perhaps Morisot and Colonna met through Rosalie. Born d'Affry, Adèle Colonna came from an aristocratic Swiss family and married into the highest Roman nobility. Her husband died suddenly only six months later, leaving a desperately lonely young widow, who turned to art to fill her thoughts and her days. Quickly Adèle d'Affry discovered in her consolation a vocation, and a persona. She rechristened herself Marcello and embarked on a meteoric Parisian career as socialite and sculptor. When Morisot met her, in 1864, she already knew everybody worth knowing. Besides the aristocracy of blood, she cultivated an aristocracy of the mind: politicians like Thiers (who also happened to be a friend of the Morisots), intellectuals like Eugène Delacroix, George Sand, Jean-Baptiste Carpeaux, and Charles Garnier. She had brilliantly inaugurated her official career with three successful sculptures at the 1863 Salon. She had been personally invited by the empress Eugénie to the palace of Fontainebleau. She was rich, socially prominent, and beautiful, blond and small-featured, widely read and irreverent in her wit. She was just older enough—five years—to be both an accessible friend and a mentor. Looking back over her life years later, Morisot wrote in a notebook that her best friendship had been with Marcello; she recalled long days whiled away in shopping, *flânerie,* and chat:

"we had everything to say to each other and I could dare to really *confide* in her."

Morisot would never feel as close to any woman outside her family. Yet Marcello did not quite reciprocate. Although she did cultivate Morisot's friendship and genuinely admired her personally and intellectually, she was held back by snobbery. Throughout her life, Marcello had difficulty accepting discrepancies between social rank and actual accomplishment. She could never reconcile herself to inanity, but neither could she resist the seduction of a title.

For Morisot, Marcello's artistic ambitions overrode all other considerations. Morisot, so reserved and so proud, this once in her life sought and treasured the approval and companionship of someone who would not fully respond. Since Morisot never gave any other sign of social climbing, we can be sure it was Marcello's professional determination that made her friendship so exceptionally precious. Just then, as she was beginning to show her works in the Salon and develop her style, Morisot needed a role model.

In retrospect, Marcello's sculptures, and even more her paintings, seem tame and cold. But at the time she met Morisot she was showing extraordinary courage in the pursuit of her career. Although she had the wealth and social standing to command respect should her work alone not prove sufficiently imposing, she dared to work in sculpture, an even more exclusively masculine province than painting, and more intriguingly, she insisted on retaining her femininity and a normal social life despite her claims to a masculine genius. Unlike George Sand or Rosa Bonheur, the two most prominent women artists of the previous generation, who both behaved symbolically like men, Marcello demanded to be treated like a woman in her private life and like a man in her professional life.

The year after Morisot met Marcello, she and Edma had a studio built in the garden of the family home. It entailed considerable expense, but what was being constructed was not just a building; it was a statement of intellectual independence. The studio, a substantial rectangular building with high windows on either side, was set apart from the house. In this place consecrated to work, Berthe and Edma could withdraw from domestic

obligations to find concentration and solitude. The studio was, to adapt the expression Virginia Woolf was later to make so famous, "a room of their own."

By 1866, when Berthe was twenty-six and Edma twenty-eight, their mother began to worry. She could be very supportive: "I'm with you every moment of the day. It's impossible that you shouldn't find the success you deserve." She could even give quite seditious advice about the allocation of her daughters' energies: "If it's true that the essence of womanhood is tenderness and devotion, these ties are certainly paid for at a high price," she wrote them, and urged a little counterbalancing "selfishness."

But her letters had begun in the past year to reflect some irritation at her daughters' priorities, complaining gently that Berthe and Edma were neglecting family obligations and appearances, that they were stubborn, uncompromising, and not appreciative of the marriage prospects she was so diligently seeking for them. She had begun to sense the degree of Berthe's commitment to painting, and her intransigence. She wrote to Edma (not daring to write to Berthe?) in July of 1867:

> Never have I seen you choose what was within your reach. Whimsy is all very well, but not when it creates trouble. The real science of life, in small matters as in large, is always to smooth things out, to make them easier, to adjust to things rather than wanting them to adjust to you. . . . I know you're shrugging your shoulders and I can see Berthe's sarcastic or glacial expression telling me: "Take the brush yourself then."

Relations between Berthe especially and her father also seem to have been strained or at least distant. Cornélie Morisot recorded in the summer of 1865 the possibility of a trip to Italy by father and daughter: "being alone together would appall you more than it would please you."

Cornélie wondered whether the kind of painting Berthe and Edma made was really worth the trouble, and tried to impose her suggestions. She argued for a more immediately pleasing style, accessible to a wider audience, and first of all to the painters' parents. But Berthe disdained anything she deemed vulgar, profoundly and irrevocably. In her maturity she would look

back on the 1860s, trying to remember herself, and would recall, with characteristic self-deprecation, her desire to experience the drama of life.

> I'd like to know now what I was thinking when I was twenty. I think I was very silly and yet I identified very much with Shakespeare's women; in any case, I had a wild desire to taste life, which is always attractive.

A photograph survives of her in her late teens or early twenties. Her pose is quietly self-assured, her gaze forthright, but on the whole she seems ordinary enough. Her exceptional resolution brewed within, still secret from everyone but Edma.

Years later Morisot adapted words by Baudelaire to explain the feelings she had had during those years. Not only did she change Baudelaire's text just enough to fit her situation, but she kept the date of his diary entry, 1862, as if it had been her own.[4]

Beneath Morisot at twenty-one yawned the chasm of despair and aimlessness: "I have always had the sense of the abyss"; "I felt the wing of madness." She could see too far into the grandeur and dangers of life not to feel at the edge of the uncontrollable. She was "dizzy" with the prospect of it. Could she master the "hysteria" of a mind too aware, too conscious of the conditions of its existence? Could she impose meaning on her spiritual chaos? "Any shrinking of the will is a bit of substance lost. How wasteful, then, is hesitation! And only consider how immense the final effort necessary to repair so many losses!"

Morisot invoked traditional values. "It is high time to act, to look upon the present moment as the critical moment, and to make of my daily torment, work, my perpetual pleasure." "Work"—the virtue of the middle classes. Work would bring its own rewards, riches and calm. Like innumerable young women of her time, Morisot wanted to dedicate her work to her mother, despite her mother's ambivalence. It was an offering of creativity, of sustenance, of support, to the woman who had given her life and who had raised her. She was acting out the selflessness and the identification that would provide her with a sense of feminine self, and by consecrating her work to her mother, and to God, she was absolving it of selfishness and commercial motives.

Yet these traditional values of the bourgeoisie and femininity were being subverted to new purposes, for however she justified her plans, Morisot was intent upon a career in painting—this in her early twenties when, wealthy, gifted, and attractive, she could count on any number of prestigious, gratifying, and lucrative marriage proposals. All her adult life, painting was for Morisot a choice and a spiritual commitment. She could not settle for a way of life that would subjugate the "abyss" within her. She was driven to pursue a career that drew upon her energies, and that needed her full capacity for elation, for sorrow and even self-doubt. The path Morisot chose did, as she had hoped, tap her energies and turn them to creative uses, but the price she paid was constant exposure to her inner turmoil. She had traded peace of mind for what she called "the power of obsession, the power of hope."

II

DECISIONS

1868-1871

4

Encounters and Partings

1 8 6 8 – 1 8 6 9

The Louvre in the 1860s both taught the past and ushered in the future. In its galleries young painters of disparate origins discovered common inclinations. Away from traditional pedagogic institutions, new configurations of allegiance and aspiration could crystallize. No encounters better illustrate the Louvre's radical potential than those of Berthe and Edma Morisot. For where else could female and male artists meet at work; where else could two young women learn that their elders' lessons could be absorbed in order to be superseded?

Their teacher Guichard had first enrolled them on March 19, 1858,[1] and ten years later the two sisters were still there—chaperoned by their mother. She divided her attention between her two daughters and her embroidery or her book. She was skeptical

41

but tolerant of the many bearded young men so devoted to Art whom her daughters met.[2] Too enthusiastic, came her sensible maternal verdict—"Those fellows have no brain; they're weathercocks who play games with you"—but harmless enough, and so far these male acquaintances had behaved properly. Then sometime by the end of 1868, Fantin-Latour introduced Edma and Berthe to Édouard Manet.

Manet belonged to a family and a social circle ideally suited to make the Morisot sisters feel his influence thoroughly. He was one of three handsome and sophisticated brothers; Édouard was born in 1832, Eugène in 1833, and Gustave in 1835. Much less is known about Eugène and Gustave, but surviving images and accounts indicate strong fraternal bonds and shared interests.[3] Eugène and Édouard were blond and fine-featured, with remarkably silky beards; Gustave was dark. Eugène was very slender, Gustave and Édouard fashionably well-built.

Édouard cultivated his reputation as a dandy. Impeccably attired, faultlessly shod, gloved, and hatted, he was always to be seen in the right places at the right times: for breakfast at Pavard's in the rue Notre-Dame-de-Lorette, in his studio on the chic rue Saint-Petersbourg, at the Café Tortoni or the Café de Bade in the late afternoon, on "the Boulevard" between the rue Richelieu and the Chaussée d'Antin. He knew clever men and fast women. He was stylish, witty, flippant, and charming. The controversy surrounding his painting made him all the more alluring.

He worked the art circuit while Gustave operated in the political arena, but each brother participated in the other's work. Gustave posed for the central male figure who leans slightly forward, hands tucked under his coattails, in Édouard's 1862 *Music in the Tuileries.* He is surrounded by the critics and artists both brothers knew well, including the poet Charles Baudelaire and the composer Jacques Offenbach, along with two hostesses (seated in the left foreground), Mme Loubens and Mme Lejosne, at whose homes all these men met. Gustave also did the long job of modeling for the recumbent figure in Édouard's *Luncheon on the Grass.*

Conversely, when Édouard chose mind over glamour and slummed it at the Café Guerbois or the Café de la Nouvelle Athènes, he met men like Philippe Burty, Edmond Duranty,

Théodore Duret, Armand Silvestre, and Émile Zola, who, besides their commitment to art, engaged in political journalism of a radical but not extremist republican cast. Édouard even ventured fully into Gustave's turf, the Café Frontin, a "Radicals' rendezvous," where his brother discussed republican tactics with Arthur Ranc and Eugène Spuller. The police kept an eye on the place and on the Manets. Édouard is known to have attended, during these years, a lecture series on the rue de la Paix featuring a number of Radical republican speakers. Moreover, he chose to paint themes like the execution of the emperor Maximilian, hapless tool of Napoleon III, as well as the demystifyingly secular *Christ with Angels* and the unionist *Battle of the Kearsarge and the Alabama*, which demonstrated convictions consonant with a Radical republican stance.

Eugène lived somewhat in his brothers' shadow. Loyal but aimless, he espoused both Édouard's and Gustave's causes, cultivated independent friendships in his brothers' circles, and painted in a casual kind of way, mostly in watercolor or pastel. Years later he would write a novel, *Victims!*, set in this period and dedicated to those who had been persecuted by Napoleon III after he seized power.[4] To ascribe opinions retrospectively is of course dangerous, but given his brothers' known views and the three men's consensus, it seems fair enough to read back from *Victims!* into Eugène's state of mind at the time he met Morisot. On the basis of the novel's evidence, Eugène would have been fiercely anti-Bonapartist, rabidly anticlerical, and possibly, along with his brothers, a Freemason. In comparison with the Morisot parents' politics, more Orleanist than Bonapartist, but staunchly conservative, the Manet brothers' allegiances were daring and progressive.

The older Manet generation was more reassuring. M. Manet had died in 1862; he had occupied a position analogous to that of Morisot's maternal grandfather but in a different ministry; while M. Thomas had been *chef du personnel* at the Finance Ministry, Auguste Manet held the same position at the Ministry of Justice. The Manets' mother, Eugénie Désirée Fournier, daughter of a diplomat and goddaughter of Bernadotte, Napoleonic *maréchal* and subsequently king of Sweden, was still very much on the scene. Her sons were in and out of her house, in

part because she entertained them and their friends each week. Édouard portrayed both his parents in 1860. Dourly they focus their gazes downward, perhaps not quite wanting to confront their son's activity. He looks rather like Gustave; she has the bonier face, the long, fine nose, and the thin lips of Édouard and Eugène. Her son pictures her as Morisot would picture her mother almost a decade later, in a plain and matronly but rich black dress, her still-dark and neatly smooth hair partially covered by a lacy white headdress. His father displays the red lapel bar of his Legion of Honor award.

None of the brothers earned much of a living. Luckily there was money in the Manet family. They owned extensive holdings in the Parisian suburb of Gennevilliers, an area increasingly valuable as the metropolis expanded rapidly outward in the sixties. After their father's death, Édouard, Eugène, and Gustave had independent incomes.

The Manets and the Morisots were alike in many ways. Both fathers had conducted eminently respectable careers and wished all their children would do the same. (In which wish, of course, both were thwarted.) Both mothers were pillars of grand-bourgeois domesticity: model wives, mothers, and hostesses. Their children were about the same age and had cultural interests in common. The 1868 encounter was therefore as much one between two compatible families as between Berthe Morisot and Édouard Manet.

Each family began to entertain the other regularly. Mme Morisot continued her Tuesdays. Mme Manet received on Thursdays. At her receptions, Berthe, Edma, and their parents met a new group of intellectuals, including musicians, art critics, and writers like Baudelaire, author of the saturnine *Les Fleurs du Mal,* and the scandalous Zola, whose naturalist novels were as scathingly attacked as Manet's paintings. Zola had repeatedly defended Manet, denouncing Academy "recipes" and extolling "a bit of nature seen through a temperament." He was a shy but decided admirer of Morisot's work; to get one of her paintings he resorted to Édouard Manet, and he had his wife write the thank-you note. Alfred Stevens and his wife, familiar faces by now, reappeared at the Manets'.

Perhaps they had already introduced the Morisots to their

friend Pierre Puvis de Chavannes, a somber and somewhat older personality, called the "condor" behind his back, whose paintings were both thematically conservative and formally avant-garde; he made mural-sized allegories for institutional spaces, but in order to respect the wall surfaces of his sites, he began to abstract his forms and colors. He liked to associate with younger, more adventurous artists, appreciated their audacities and sympathized with their goals, but he could never really be one of them. His attitude was as unfailingly correct as his appearance. Around this time Puvis became particularly devoted to Berthe Morisot, assiduously visiting her at home, seeking out her company at parties, writing her long and somewhat pompous letters. She could hardly object to him: he was kind, he was respectful, he was professionally successful, he had been decorated the year before with the Legion of Honor. And he was a bore. Meanwhile a Romanian princess, Marie Cantacuzène, hovered in his background.

Many gentlemen had established mistresses. It seemed perfectly normal, unless of course you were like Baudelaire and not only had a mistress who wasn't white but then trumpeted your passionate tastes in print. Or if you were like Pissarro and slept with the family maid (which was fine) and then actually married her when she became pregnant. (That was beyond the pale.) Almost anything else would pass if you handled the situation correctly and especially if your family colluded with you. In the case of the Manets, family unity prevented all criticism of a very unusual arrangement.

Plump, blond, and Dutch, Suzanne Leenhoff had entered the Manet family as one of the younger Manet boys' piano teacher. By about 1850, she and Édouard were living together. In 1852, Leenhoff returned from a trip to Holland with an infant she presented as her younger brother and called Léon Koëlla. The child was raised in the Manet household with unfailing kindness but was never treated as a son by Leenhoff or Manet nor as a grandchild by Auguste or Eugénie Désirée Manet. Koëlla's declared origins are improbable. He was not, however, as some of Manet's historians have assumed, Édouard Manet's son. In Manet's milieu, children born out of wedlock to subsequently married parents were not freaks. Cézanne, Monet, Pissarro, and

Renoir all had such children. Nor did Édouard Manet ever give signs of being embarrassed by Suzanne, whom he finally married in 1863. Yet years after Suzanne and Édouard's marriage, they maintained the same attitude to Koëlla.

Morisot met Leenhoff at the Manets' evenings, whose entertainment Suzanne provided with her piano music. She played Chopin particularly well, softly drawing out the notes with her tiny white hands. The Manets did not merely tolerate Leenhoff, let alone conceal her quietly. Not only did they display her to all their guests, but Mme Manet, after initial hesitations, became extremely attached to her. After all, she did come from a respectable family. Her brother was an artist, close enough to Édouard to have posed along with Gustave for *Luncheon on the Grass* in 1863. Suzanne Leenhoff was a pliant sort of character, accommodating, somewhat stolid, it would seem from portraits of her. Morisot had little fondness for her, perhaps residually because of her dubious past, much more because of her temperament. But as for open criticism of Leenhoff, or speculation on Léon Koëlla's parentage, that was and is impossible. The Manets presented a completely unbreakable front. Their unity and generosity in the face of bourgeois double standards were admirable. Whatever she had done, now she was a member of their family, and that was that.

Most important for her in the long run, Morisot during this same period met Edgar Degas. He was seven years older than she, born in 1834 into a wealthy aristocratic family. No one could retort more sarcastically or more incisively than Degas. He spared no one, least of all himself. Slight, with a flattish oval face, almost as dapper as Manet, he lived alone, dedicated to an increasingly rigorous and innovative art. He was a terrible snob both socially and intellectually—sometimes worse than a snob, almost a bigot. Yet over and over, Degas's friends forgave him. His witticisms were so cleverly on the mark, and at his best he could so devastatingly dismiss banalities, that if you were on his side it was difficult not to feel both maliciously and gleefully complicitous.

Much has been said about Degas's possible misogyny. He certainly painted cruel pictures of women. Degraded prostitutes, grotesque society dames, brutish working girls—all of these are

in Degas's pictorial repertoire. But his pictures of the women in his family display sentiments more tender. In his life as in his art he was loyal to them, as he would be to Berthe Morisot, as well as her family, from the moment he met her. Degas's disparaging treatment of women was influenced by class, and within class boundaries by blood ties and by intellectual considerations. He did not gladly suffer fools of either sex. Edma and Berthe Morisot were no fools, as Degas immediately recognized. Almost as soon as he could have met them through the Manets, Degas began to frequent the Morisots' receptions regularly, as fond of the mother as he was of the daughters. Edma seems to have been his favorite, perhaps because Berthe championed Manet.

Degas and Édouard Manet complemented each other; where Manet charmed, Degas cowed, where Manet's resilience lay in his unquenchably naive optimism, Degas cynically disdained success. One celebrated the fashionable bourgeois world to which he belonged, the other dissected a bourgeois world he held in mesmerized contempt. If Manet brilliantly represented the surfaces of Paris, Degas revealed its darker underside. Each man and his art held a very different kind of appeal. Morisot was ideally suited to understand both, she who acknowledged the importance of surfaces and yet had a somber aspect of her own.

Eighteen sixty-eight unfolded for Morisot in an atmosphere of challenging discoveries. She and Edma were exposed to new ideas, new currents in painting, new books, new people. In 1868 she and her sister, Édouard Manet, Degas, Fantin-Latour, Stevens, and Puvis de Chavannes all got along faultlessly, each looking toward a future that held nothing but opportunities and promise.

On March 8, 1869, the idyll ceased. Edma married Adolphe Pontillon, a naval officer who had known Édouard Manet since 1848. The vow the two sisters had taken together had been broken. The prospect of a life devoted to art may have seemed more daunting to a woman than to an adolescent. Would Edma have felt as she approached thirty that if she waited any longer marriage would not even be an option? At thirty, many women settle for something other than what they dreamed of. Like kind pro-

vincial naval officers without distinguishing traits of any sort.

The new couple moved to Lorient in Brittany. For the first time in their lives, Edma and Berthe were separated. Edma wrote to Berthe as soon as she arrived.

> I have never once in my life written to you, my dear Berthe, so it isn't surprising that I should have been so very sad when we were separated for the first time. I'm beginning to recover a bit and I hope my husband doesn't notice the emptiness I feel without you. He's very sweet, full of solicitude and attentiveness for me, which I neglected to tell you yesterday. When he heard that I hadn't mentioned him, he cried out: "But they're going to think I'm making you very unhappy!"

Letters went back and forth from Passy to Brittany, poor substitutes for presence. Berthe wrote on March 19:

> If we go on like this, my dear Edma, we'll be good for nothing; you cry when you get my letters and as for myself, I did just the same this morning; your notes, which are so affectionate but so melancholy, and your husband's kind words brought tears to my eyes; but I'm telling you again, this behavior is unhealthy; we'll lose what little is left of our youth and beauty; it makes no difference to me, but for you it's different.

Mme Morisot to Edma:

> Berthe was so touched by Adolphe's letter that I just found her with her nose pressed against the wall, crying and trying to hide it.

Yves came to stay at her parents' home that spring, on her way from one of her husband's posts to another. She inherited some portion of Edma's role, attracting Degas in her turn. He asked her to sit for him, producing from these sessions both preparatory drawings and two finished portraits. When he exhibited one of them in the 1870 Salon, Berthe pronounced it a "masterpiece." But Yves was only a sister. Edma had been Berthe's sister, friend, and partner. For twelve years they had worked together, learned a common art, planned a joint career. What now? Berthe held out three months. Then she joined

Edma in Lorient and stayed through June and July. Mme Morisot wrote to her there:

> Your father seemed quite touched, dear Jewel, by the letter you wrote him; he seemed to have discovered in you treasures of the heart he was unaware of . . . an unusually tender feeling for him . . . so he often says he regrets your absence; I ask myself why? You rarely speak to each other, you're hardly ever together. . . .

Better to be with the Pontillons, Mme Morisot wrote, than at home, "lost and unhappy over a fate about which we can do nothing." A sister cannot stay eternally, however, with a young couple. Feeling that one kind of life had already passed her by, Berthe returned to Passy, to a home that was no longer as much a home, to a father with whom she rarely spoke and a mother increasingly impatient with her choices. To Edma she wrote in September: "I'm sad and what's worse, everyone is abandoning me; I feel lonely, disillusioned, and old into the bargain."

5

Alternatives

1 8 6 9 – 1 8 7 1

Did Morisot have to choose?
Was painting utterly incompatible with marriage and maternity?
Edma Pontillon made it seem that way. Her career ended at
her wedding, although she made halfhearted and sporadic attempts to work. In August 1869 she wrote to her sister:

> I wanted to try working during the day. I made a complete
> mess of a still life on a blank canvas, and it tired me so
> much that after dinner, I lay down and I almost slept on the
> sofa. . . . What good is it tiring yourself so much to do
> something that satisfies you so little.

Berthe alternated between answering her sister with encouragement—"From what you tell me, I think the flowers you did
must be quite good"—or with a sympathy couched as self-deprecation:

I wanted to write you, my dear Edma, but then I was seized by an insuperable laziness. I suffer everyone's reproaches and don't have the energy to react. So I understand perfectly the difficulties you have painting; I've come to ask myself how I ever did anything in my life.

Edma to Berthe in September 1869: "I'm annoyed with myself though for having done nothing this season; my infatuation with painting hasn't left me yet."

Berthe understood Edma's choice all too well. She may often have been tempted to relinquish art and follow Edma's example. But however much she contemplated the possibility, she never gave in to it. After her marriage, Edma produced a portrait of her husband and a few copies in pastel of some of her sister's work, but her professional life had effectively ceased. Her choice, moreover, consigned the canvases of her youth to oblivion. Only two survive: her portrait of her sister and a landscape. These pictures indicate that in 1869 Edma and Berthe were at the same stage of artistic development. But Edma's example demonstrates how much more it took than talent and even accomplishment for a woman to make a place for herself in the world of art.

Every woman, like Edma and Berthe, had to risk forfeiting her personal life if she chose to dedicate herself to a career. Nineteenth-century bourgeois convention recognized only one suitable path for women—marriage and motherhood. Anything else was failure. Single women were "excess" human beings who had not fulfilled their womanly destinies. A career was supposed to "unsex" a woman, leech away her femininity, and render her abnormal. In Morisot's field, such threats acquired a daunting edge. For genius was deemed a masculine attribute. No one could imagine a great woman painter. None had existed yet, and this seemed sufficient proof that none ever would.

At every level, in every way, Berthe's world told her that Edma was right—painting was not for women. The Academy excluded women from its classes and its honors. No women's paintings hung in the Louvre. With which role models could Morisot identify? None. And what were the chances that her professional attainments would scatter before them social opprobrium or even ostracism?

The stakes were high, the gamble was uncertain. A poignant

exchange of letters between Edma and Berthe in the year after Edma's marriage shows how discouraging and lonely Berthe's choice could be, and Edma's as well. While Berthe tried to escape personal doubts through her artistic contacts, Edma clung to the vestiges of her intellectual past. She wrote Berthe in March of 1869 that she was reading books recommended by Degas, that she was going to art exhibitions, "and that the sight of some canvases gives me pleasure as if I hadn't seen any painting for a long time."

> I'm often with you, my dear Berthe, in spirit; I'm in your studio and I'd like to escape if only for a quarter of an hour to breathe the atmosphere we lived in for so many years.

Berthe replied:

> M. Degas . . . spoke with me about you the other evening; he finds you very strange; judging from several things he said on your account, I've decided he's rather observant. He laughed at the idea that you were reading *Adolphe*. He came and sat next to me, pretending he was going to flirt, but his flirtation was limited to a long commentary on Solomon's proverb: "Woman is the desolation of the Just."

Edma to Berthe:

> My infatuation with Manet as a person is over; as for M. Degas, that's different; I'm awfully curious to know what he said to you about me and how he thinks I'm strange. . . . You may call me crazy, but as I think about all these artists, I would trade quite a few steady qualities for fifteen minutes of their conversation.

And back again:

> I think you're childish; this painting, this work you regret, is the cause of a lot of worry, of a lot of trouble, you know it as well as I do and yet, child that you are, you're already crying for what depressed you only a short time ago. Don't worry, you didn't make the worst choice, you have genuine affection, a devoted heart that is all yours, don't be ungrateful to fate, remember that solitude is very sad; whatever anyone may say, whatever anyone may do, women have an

immense need for affection; to try to make ourselves self-sufficient is to attempt the impossible.

Berthe wrote again on April 23, 1869, discouraged and anxious about her eyesight, trying to find in Edma's possible pregnancy a resolution of her ambivalence:

> I understand you can't immediately adjust to provincial and domestic life; you need some hope in your heart. Adolphe would certainly be surprised to hear me speak this way; men readily believe they fill our lives; but I do think that however much affection you have for your husband, you can't abandon a life of work without difficulty; sentiment is all very well provided you have something else to fill your days; that something, I think, in your case, would be maternity.

Edma retorted that marriage too had its disadvantages. Life could be boring in Lorient. She hoped for pregnancy, but the signs were still unclear, she confided. Left alone during the day with nothing more stimulating to occupy her mind than mending her husband's shirts, she warned her sister:

> The longer I'm married, the more convinced I am that you wouldn't be satisfied with this arrangement on the same conditions. Do your utmost with your charm and your skill to find something that suits you.

Berthe's moods continued to fluctuate, alternating between a sturdy enjoyment of her work and crippling self-doubt. The only solution to what she herself called her "lamentation mania" was work. She began to plan her time around painting.

> I wonder what I'll do with my summer; I'd willingly stay with you on the condition that I wouldn't be in your way and I would have the opportunity to work.
> My inactivity is beginning to weigh on me; I'm eager to do something more or less well.

Edma continued wistfully to appreciate her sister's satisfactions.

> Your life seems delightful to me at the moment; having Bichette [Yves Gobillard's small daughter] in bed with you

every morning, chatting with M. Degas while watching him draw, laughing with Manet, philosophizing with Puvis—it all seems enviable. You can't imagine how it would seem to you from a distance.

From the secure vantage point of a provincial marriage, Berthe's life did seem glamorous. While she lived on a day-to-day basis with the ambiguities and costs of her situation, Edma could adopt a larger perspective and appreciate the historical importance of her sister's concerns. Berthe, for instance, recommended to her Gustave Flaubert's novel *Madame Bovary,* whose realism conservatives then condemned as scandalously brutal, and which was deemed entirely unsuitable reading for middle-class women. Edma agreed that the novel was a great work of art and that its style was admirable, but she also praised what Morisot had perhaps only mentioned, Madame Bovary's astonishingly fresh modernity. Its innovations might still be contested, Edma wrote, but would eventually triumph.

Morisot understood the magnitude of Flaubert's achievement without knowing him personally. How much more acute, then, was her sense of Édouard Manet's stature, Manet whom she revered as a painter and cultivated as a friend. She had realized his place in the history of art as soon as she met him. Unlike so many of her contemporaries, unlike her parents and many of her friends, she knew immediately that his paintings were the freshest and most challenging of their generation. She would never waver in her estimation of his genius.

How exhilarating to be so familiar with the leading artist of your generation! And how inhibiting, perhaps. For if you are absolutely sure that someone else does your kind of work best, then where does that leave you? Doing less than the best. The more you admire his work, the more contact you have with it, the surer you might become that you are second-rate. Can exposure to excellence bring a joy unmitigated by envy or self-criticism? Is such a situation eased or exacerbated when the dominant artist is a man and the self-professedly subordinate artist is a woman?

Answers to these questions in Morisot's case must remain speculative. We do know that during the first years of her friendship

with Manet she worked less than she seems to have before and certainly less than she did later. She worked, but inconclusively. Her mother wrote to Edma in March 1869: "I spend my days in the studio or just about. Berthe says she's waiting for you to know whether what she's doing is good or bad. When you're not here anymore she won't dare show anything to anybody." The self-deprecation that recurs throughout Berthe's diaries and correspondence in these years had its counterpart in her actual production.

Moreover, during this period Morisot was also Manet's model. It seems that very soon after their introduction, he asked her to sit for his painting *The Balcony*. He would repeat the request ten times in the next six years.[1] These portraits are extremely important documents in themselves, helping us to understand Morisot's personality better as well as to grasp more fully the bond between Morisot and Manet. Some dimension of their meaning remains ineffable; their message eludes words; but other aspects offer less resistance to articulation.

Consider first their number. Manet may have used Victorine Meurent more often as his model. "Used" is the operative word. While his images of her—paintings like *Olympia*—continue to leave us perplexed if not awed, she is only one part of their effect, and an auxiliary one at that. Whereas his images of Morisot are entirely generated by her presence. Manet's pictures of Meurent look like her. His portraits of Morisot are about how she looks, not just in the sense of her appearance but also in the sense of how she gazes at him. She is not merely the object of his vision but a respondent to his art. She elicits from him a recognition fuller and more nuanced than of any other woman he ever painted, more impressive—if only in sheer extent—than of any man. Their relationship as painter and model is less one of control than one of exchange. He made more portraits of her than of anyone else. ("He has made a portrait of his wife, I think it was about time," wrote Cornélie Thomas Morisot in March 1869.) Domination devolves into inertia; exchange persists. With each portrait, Morisot returned something to Manet that led to a next portrait. In his images of her, two intelligences dialogue.

Morisot exerted enough magnetism to command this sort of attention from an artist as brilliant as Manet. His portraits skip

from one alluring permutation to another. Quick, elegant, sensual, beautiful, engaging, passionate, and delicate—Manet represents all these aspects of Morisot. Hers was not a personality easily exhausted.

Both painter and model guarded the products of their collaboration. Manet relinquished five of them (one a watercolor variation), but only to close friends and respected connoisseurs.[2] After Manet's death in 1883, the remaining seven portraits of Morisot were listed in his estate inventory. He had kept them with him for the rest of his life. Or rather he had kept five of them. Two had always been in Morisot's keeping: *Berthe Morisot Reclining* and the oil version of *Berthe Morisot in Three-Quarters View.* The fact that they continued to be nominally Manet's indicates some feeling of shared possession.[3] Long after Manet's death, Morisot tried to buy back *Repose.* She failed, but she did manage, at considerable cost, to repossess *Berthe Morisot with Bouquet of Violets.* Later her daughter would buy back from Morisot's cousin *Berthe Morisot in Profile.* Of the twelve unique portraits, therefore (as opposed to the reproducible prints), all were kept for many years in the hands of people intimately familiar with their intellectual and personal significance; during Morisot's lifetime, only two came onto the open market.

Manet's request that Morisot pose for *The Balcony* was an unconventional one, for while nice young ladies sat for their portraits, *The Balcony* was not intended to be a portrait. It was to be a very large picture of three figures on a balcony, with a serving boy barely visible inside. Models suffered from a social opprobrium surpassed only by that of prostitutes and were supposed to be women with few scruples who infallibly provided services of a sexual sort to their employers in addition to their nominal work. They were paid little and respected less.

Morisot's family understood her case differently. She had entered Manet's studio, after all, first as a colleague and only secondarily as a model. Along with Manet, many of the younger painters were beginning to insist on making pictures of the people they knew in their routine settings and activities, rather than of models posed as characters from historical episodes or as allegories: both older traditions so often required a nudity too horrible for the bourgeois mind to bear though not too dreadful

for its avid consumption once on canvas. Nor was Morisot ever alone with Manet. The other two models for *The Balcony* might or might not be present, but even absent they reassured, since they too were indubitably bourgeois. The Morisots' old acquaintance Antoine Guillemet sat for the male figure, and the violinist Fanny Clauss for the female figure on the right. In any case, Morisot's mother left nothing to chance and chaperoned her daughter as sedulously in the studio as she had in the Louvre. Manet presumed on her time and her daughter's freely. He made his models pose over and over, till they all tried wearily to convince him that the picture was already perfect. On some days Manet exuberantly predicted a Salon success; on others he plunged into gloomy doubt.

The oscillation in Manet's mood, which Mme Morisot described in March of 1869, did not abate with the exhibition of *The Balcony* at the 1869 Salon. All of Manet's and Morisot's friends attended the Salon's opening at the beginning of May. Mme Morisot in a letter to Edma on May 23 reiterated her doubts about Manet and tried to focus on family questions. Manet had laughed in spite of his hostile reception but felt embarrassed to ask anyone else to sit for him. He had had the good grace to say that "Berthe brought him good luck," and pleased Mme Morisot by asking sensitively after her son.

As for the model herself, as soon as she had seen the Salon, on May 2, she wrote to her sister with circumspection about her image but with warm feelings for Manet:

> You can understand that one of my first concerns was to head toward room M. There I found Manet, his hat on his head in the sun, looking dazed; he asked me to go see his painting because he didn't dare put himself forward. I've never seen such expressive features; he was laughing, he looked worried, affirming all at once that his picture was very bad and that it would be very successful. I definitely think he has a charming character that pleases me infinitely. His paintings produce the same effect as ever of a wild or even rather green fruit. They don't displease me at all. . . .
>
> I'm more strange than ugly; it seems the epithet *femme fatale* has made the rounds among the curious.

Morisot had nothing else to say about her own image. The crowd, Guillemet, Clauss, and Mme Morisot agreed on *The Balcony*'s curious discrepancies. Guillemet's figure may have seemed "failed" and Clauss's "atrocious," but their qualities could only be perceived in contrast to the figure of Morisot. She renders them banal if not idiotic by comparison. Her posture spirals so much more alertly, her hands finely and tightly pressed right up against the front of the picture's space. Her gaze smolders too ardently to be faced directly. The bars of the green barrier barely contain her. In comparison, Clauss and Guillemet play the oafs, he pompously stiff and blank, she lethargically laden with a cabbage-like headdress and gardening-sized gloves. *Femme fatale?* Is it merely sexual energy emanating from this image? Or does Morisot's aura find its sources in a vitality more complete, at once sexual, aesthetic, intellectual, and emotional?

In the next major image he devoted to her, Manet's perception relaxed. *Repose* retreats from the intensities of the previous year to present a calmer and less demanding Morisot. Manet pictures her leaning back on an overstuffed sofa, in skirts as full. No barrier is placed now between us and her; she coquettishly extends toward us a tiny foot in a dainty slipper. Morisot wears much the same outfit as in *The Balcony:* the same hair simply pulled back and curling down to her shoulders, the same white gauze dress accented by a neck ribbon, this time as attributes of a delectable femininity. *Repose* has a twin, Manet's *Portrait of Eva Gonzalès.* The two pictures were made at almost the same time and are roughly the same size; their models, both young, have the same coloring and are dressed similarly. Gonzalès, like Morisot, poses for the spectator's admiration, arms extended out for complete visibility, white skirts artfully draped. The difference between them is that Manet imagines Morisot reclining indolently, while Gonzalès sits at an easel, putting some final touches on a still life.

How rankling! Just as Edma's marriage left Berthe bereft of artistic companionship, Édouard Manet decided to adopt a protégée. Eva Gonzalès was a talented and attractive woman eight years younger than Morisot, who belonged to her social milieu and Manet's. To make matters worse, when Gonzalès approached Manet, she did so as a pupil, catering to the painter's vanity. Morisot refused to make concessions; of course, she

picked up ideas from Manet's paintings, just as he did from hers, but she never took lessons from him and not even always advice. On the one hand, she disdained Gonzalès's passivity and gloated over whatever difficulties Manet experienced in portraying her; on the other hand, Gonzalès's behavior called hers into question and threatened her vanity. Mme Morisot did not hesitate to underline Manet's altered allegiance: "You're out of his thoughts for the time being," she wrote to Berthe, in Lorient.

Back in Paris, Morisot complained to her sister on August 13:

> Manet preaches at me and offers me the inevitable Mlle Gonzalès as an example; she has bearing, perseverance, she knows how to carry something through, whereas I'm not capable of anything. In the meantime, he begins her portrait again for the twenty-fifth time; she poses every day, and every evening her head is washed out with black soap. Now that's encouraging when you ask people to model.

Edma responded loyally:

> Miss Gonzalès makes me feel annoyed, I don't know why; I imagine Manet has considerably overestimated her and that we have, or rather you have, as much talent as she.

When after so many sittings the infamous portrait was finally finished, Morisot magnanimously conceded: "Never has Manet done anything so good." She couldn't resist a last jab, though, once the painting hung officially in the 1870 Salon:

> I can't say Manet has spoiled his paintings, since I saw them the day before in the studio and I was enchanted by them; but I don't know to what to attribute the pallid effect of Miss Gonzalès' portrait. . . . The head is still feeble and not pretty at all.

Just as Morisot would criticize Manet in her letters and affect impatience at his "impossible" character, while defending him and his art whenever anyone else attacked it, so he, who in the long run accorded her infinite respect, could describe her reductively, as in his famous letter to Fantin in 1868:

> I agree with you, the Misses Morisot are delightful. What a shame they aren't men; nonetheless they might, as women, serve the cause of painting by each marrying an Academi-

cian. . . . It's asking a lot of devotion. In the meantime, give them my regards.

In this letter Manet speaks of Morisot the way he saw her in *Repose*. Yet he could also see her as he had in *The Balcony*. He may have been experiencing difficulty accepting Morisot's extraordinary (threatening?) union of intellectual accomplishment and physical seduction. In this he would have been like the vast majority of nineteenth-century men and women, no different, probably, than most of Morisot's friends. Morisot herself may have been vacillating between two modes of self-presentation, or even two kinds of self-perception.

One photograph from these years throws its evidence on the side of *The Balcony*. As in Manet's painting, Morisot pushes ever so slightly forward out of the conventional studio pose, twists just a bit tensely, her hands in a similarly compressed gesture, looking hard off to the side. (She also wears the same locket on a ribbon around her neck.) Apparently her pose in *The Balcony* was not just Manet's compositional invention but a stance she took repeatedly on her own.

Yet her letters in these critical years manifest less adamant determination and more doubt. She had enough self-confidence to write a sprightly letter in two parts to Edma about the May 2 opening of the 1869 Salon, in which she mocked her admirers, poked fun at herself, and pitilessly evaluated her colleagues' and former teachers' work.

> The first thing we saw as we climbed the main staircase was Puvis's painting; it looks well. Jacquemard was standing in front of it and seemed to be admiring it quite sincerely; what he seemed to be admiring less was my person; nothing is worse than old beaux! . . .
>
> I looked for our friend Fantin; he made a rather sad showing with a small sketch placed incredibly high; I met him; he disappeared before I could say a word about his exhibition; I don't know whether he was fleeing me in particular or if he was aware of how little his work was worth. I definitely think that abuse of the Louvre and of Miss Dubourg's company are not bringing him luck.
>
> M. Degas seems pleased, but guess who he left me for? For Mme Lille and Mme Loubens! [Mme Lille was, like

Mme Loubens, a society hostess.] I'll admit I was a bit piqued to see a man I deem very clever abandoning me and offering his witticisms to two fools.

I was beginning to find the occasion lacking in charm; Manet had been leading his wife, his mother, and myself at a brisk pace for almost an hour, when I bumped into Puvis de Chavannes. He seemed delighted to see me, said he had come especially because of me, that he was beginning to despair of ever seeing me again at the Stevens's, he asked permission to walk with me for a moment. . . . This conversation might have been appealing if I hadn't kept noticing familiar faces all around me; what's more, I had completely lost sight of the Manets, which added to my embarrassment; it hardly seemed respectable to circulate alone. Later, when I found Manet again, I reproached him for his behavior; he answered that I could expect every devotion from him but that nonetheless he would never venture to play the role of nanny.

You may be asking where my mother was all this time; she feared a headache and was resting on a sofa, where I came to find her from time to time. . . . We went together to see Manet's painting again and we found M. Oudinot there, perorating. He pretended not to see us, but don't you think the encounter was humorous? I've talked about everything except painting; be patient, I'll give you Salon criticism of my own kind. . . .

I met Carolus Duran; it seemed stupid of me not to compliment him on his painting, which is apparently enjoying some success. But he was very surprised at my courtesy and responded to it with endless compliments on Manet's painting. M. Degas has a very pretty little portrait.

Despite the confident tone of her letter, when she wrote about her own painting she swung between hope and insecurity, always quick to denigrate her efforts but excruciatingly sensitive to any hint of criticism.

Only reluctantly would she let anyone see her work. She asked her mother not to hang her pictures "in any visible place" and wrote to Edma during the winter of 1869–70: "I feel a great weight on my stomach and I'm forever disgusted by painters and by friendship."

At the same time, she depended more than ever on painters and their friendship. From her summer stay with the Pontillons at Lorient she had brought back a picture that marks her maturation as a landscape painter, *The Harbor at Lorient,* now in the National Gallery in Washington. During the following winter, Edma returned to Passy for the birth of her first child. As she sat in the family living room with her mother, Morisot painted their double portrait. It was, for her, an ambitiously large canvas (101 × 82 cm, now in the National Gallery as well), and like *The Harbor at Lorient,* it signals a pictorial coming-of-age. Like every other aspect of her life in 1869–70, the completion, display, and finally official exhibition in the 1870 Salon of these two transitional works both encouraged a professional sense of worth and afflicted her with anxiety.

In September she wrote to Edma:

> During the day I received a visit from Puvis de Chavannes; he saw what I had done in Lorient and didn't seem to think it was too bad. . . . The Manets came to see us Tuesday evening, we visited the studio; to my great surprise and satisfaction I received the highest praise; apparently I'm doing decidedly better than Eva Gonzalès. Manet is too frank to be just saying things, I'm sure he liked it very much. Only I remember what Fantin said: "He always thinks painting by people he likes is good"; since I was told that, without being aware of it, I had painted masterpieces in Lorient, I stand dazed in front of them and don't feel able to do anything else.

Manet had perceived both the quality and the novelty of *The Harbor at Lorient.* It demonstrated a mastery of perspective, scale, and color harmony, of painterly effects like the reflections of clouds on water. It could also have confused even a painter as avant-garde as Manet. For the picture includes passages that are casually, almost calligraphically, brushed, and the picture, by contemporary standards, was very bright. It did look unfinished compared with a Corot, for instance, flayed of the mellow glow and translucent glazes that enveloped Salon paintings. *The Harbor at Lorient* conveys a traditional impression of light and three-dimensional space, but by new means: by a dynamic surface pattern and the juxtaposition of saturated colors.

It takes an effort to comprehend something new. Manet got halfway there, and Morisot was grateful enough for his approbation to give him the picture. If even Manet, though, could not quite understand why Morisot wanted to leave her paintings in what seemed to him like an unfinished state, then who could? For the time being, Morisot had to rely on her own barely dawning stylistic convictions, which faltered at the slightest rebuke from someone she considered an authority. Hence the famous story of *Reading*, now known as *Portrait of the Artist's Mother and Sister*, the first part told by Morisot to Edma in the middle of March 1870.

> Puvis was telling me the head was neither done nor doable; thereupon great emotion; I undid, I redid. Friday evening I wrote him a note asking him to come see me; he immediately replied he couldn't and complimented me profusely on the rest of the painting and asked me only to place a few accents on my mother's head. Till then my woes were not too great. Tired, enervated, I went Saturday to Manet's studio; he asked me how I was doing, and seeing that I was undecided, he said to me with enthusiasm: "Tomorrow after I send off my painting I'll come see yours, and trust me: I'll tell you what you should do."
>
> The next day, which was yesterday, he came about one o'clock, said it was fine, except the bottom of the dress; he took the brushes, added a few accents that looked quite good; my mother was in ecstasy. Then began my woes; once he had started, nothing could stop him; he went from the skirt to the bodice, from the bodice to the head, from the head to the background; he made a thousand jokes, laughed like a madman, gave me the palette, took it back again, and finally by five in the evening we had made the prettiest caricature possible. People were waiting to take it away; willy-nilly, he made me put it on the stretcher and I remained dumbfounded; my only hope is to be rejected. My mother thinks the adventure is funny, but I think it's miserable.

Morisot was so dismayed that she could tell her story only to her sister. Her mother said she looked as if she was sick. Morisot said she felt as if she was sick. Mme Morisot only made matters worse by commenting that Manet's additions had not improved

the painting of the head—on the contrary. When Morisot declared "she preferred to be at the bottom of a river than to learn her painting had been accepted," her mother thought she could alleviate the situation by reclaiming the painting. The affair seemed exaggerated to her, "but you know how here the slightest matters acquire the proportions of a disaster."

Morisot's tensions had their physical consequences. She was eating very little. Previous biographers have ascribed Morisot's frail health and her reduced capacity to absorb food to the 1870 siege of Paris and its privations. Mme Morisot's 1868–69 letters, however, as well as the change in her daughter's appearance between the photograph taken in her adolescence and the images made in her late twenties, point to a pattern begun well before the war. It is impossible to know whether Morisot's body punished her for her psychic distress, whether physical sufferings were less difficult to express than psychological ones, or whether a discipline of her body functioned as only the most tangible manifestation of a complete self-control she imposed on herself. For the rest of her life Morisot remained unusually slender, wrote about food as one of several material aspects of life that should be ignored, and repeatedly used the stomach metaphorically to describe events or behavior she found unacceptable.

Morisot's attitude to food was extreme but not pathological. An intellectual woman might well have reacted against the current ideal of fleshily sensuous femininity. Consciously or unconsciously? Did Morisot cultivate a body image as part of a personal aesthetic, or was she so preoccupied with spiritual matters that she simply forgot about food? Was she knowingly compensating for her daunting character with a frail physique? Was she secretly pleading for solicitous attention? In any case, her weight never dropped low enough to signal a loss of self-control or rationality.

In the end, the painting Mme Morisot had fetched back from the Salon jury was returned again. Probably Morisot had, as usual, been of two minds when she said she would rather be at the bottom of the river than have it accepted. It was accepted, and Morisot enjoyed the opening week's bustle, accompanied by friends and receiving compliments from her colleagues. Still the

doubts persisted. She wrote Edma so vaguely and so diffi-
dently—"I don't make as grotesque an impression as I had
feared"—that her sister had to ask her whether in fact two pic-
tures were on display or one. Their mother wrote: "she has the
same ups and downs." Morisot concluded ambivalently:

> This miserable painting still preoccupies me . . . the first
> emotion once overcome, I think there's always a benefit to
> be gained by exhibition, no matter how mediocre it might
> be. Besides, no one has praised me much, as you can imag-
> ine, but everyone is pleasant enough to leave me no regrets.
> Except of course M. Degas, who has a sovereign disdain for
> anything I might do.

The reference to Degas sounds a new note. He was gaining
ascendancy in Morisot's mind. She was not the only artist adjust-
ing to the onset of professional maturity. The entire clan that had
mingled so harmoniously in 1868 began to break up. Morisot
had hard things to say about Fantin-Latour: "he's become
meaner and uglier than ever," while by her own admission he
had been her hero the year before. She was sure he felt the same
way about her: "Apparently Fantin was sick about our visit; yet
another of that crazy Manet's inanities!!!" Manet got on Morisot's
nerves. He fought back against Degas behind his back, scoffing
at his friend's incompetent womanizing. Meanwhile Degas
mocked Fantin, saying he had become "as sour as an old maid."
Manet pitted Morisot against Gonzalès. And everyone dumped
on Puvis.

Alliances shifted, frustrations were swallowed and complaints
murmured. No one could tell whether they were still friends or
whether they were becoming an artistic movement. Manet re-
mained indubitably the master, but was he still the leader? Ste-
vens, Puvis, and Fantin were reverting to academicism, Degas
and Morisot were conducting pictorial experiments. Yet no clear
positions had emerged.

In 1870 Fantin painted a very large group portrait, called *The
Batignolles Studio*. He intended it to pay tribute to Manet, who
sits in the center, touching brush to canvas. Around him sit or
stand the men Fantin at that point thought constituted the rising
artistic school. They include three figures little known today,

plus Zola, Frédéric Bazille, Monet, Renoir, and, by authorial implication, Fantin himself. In the beginning of 1870, this was perhaps the most probable or potentially dominant alignment of artistic talent in Paris. By the end of the year, all predictions had been contradicted, France was thrown into war, and in the upheavals of the months to come, many artists' futures took unexpected turns.

6

Political Crisis

1 8 7 0 – 1 8 7 1

On July 19, 1870, France declared war on Prussia. Louis Napoleon's authoritarian regime, recently sanctioned by plebiscite but still insecure, grasped at an opportunity to shore up its prestige with some glamorous military swashbuckling. Unfortunately for France, the ensuing events completely outran the imperial court's deluded notions of battle. Pretty uniforms and waxed mustaches proved insufficient to defeat the disciplined and powerfully equipped Prussian troops, who were spurred, moreover, by all the ardor of their emerging nationalism. Against the Prussian military machine, more than half a million men strong, the French marshaled about 235,000 disorganized and poorly led troops. Defeat rapidly followed defeat. Before the French public realized what had happened, Louis Napoleon had been captured at Sedan and the

bulk of the French army was thoroughly trounced. The Prussian army marched toward Paris.

Reaction to news from the front toppled the government. A mob invaded the hastily gathered National Assembly on September 4, then, led by Gambetta and Favre, proclaimed a republic in front of the Hôtel de Ville. The new government hoped to either raise new French troops or win diplomatic support abroad. Meanwhile the capital was encircled, besieged, bombarded; by the winter of that year, Berthe would write to Edma: "Would you believe I'm getting used to the cannon's noise; it seems to me now that I'm absolutely hardened and in a state to bear anything."

Tiburce, Cornélie, and Berthe Morisot had decided to stay in Passy rather than seek shelter in the provinces, although their friends the Manet brothers predicted terrible times to come. M. and Mme Morisot's motives seem to have been a mixture of patriotism and paralysis. On August 18, Berthe—unwilling to believe the worst, impatient with her parents' indecision, and unsure of her ability to comfort—wrote to her sister: "I wouldn't exactly say that my presence gives them much pleasure; I feel quite sad and completely mute." Nonetheless, she concluded that her place was at their side.

Soldiers now occupied her studio; her work ground to a near halt. Watercolors she still managed to produce, encouraged by Degas, who offered her one of his subtle painted fans. Though the Morisots felt isolated, their letters reveal frequent visits from the Manet brothers, Degas, Puvis, and Stevens, but talk centered on politics, not art, and previously veiled aspects of each man's character rose to the fore. The same forces that divided the country now created tensions among friends—with Puvis and her parents at one extreme, and the Manet brothers and Degas at the other.

As the months dragged on and the siege continued, Morisot grew increasingly depressed, despite her brave words about the cannon fire and her allegations of calm. "I'm stupefied by the silence"; "The complete ignorance in which we live is very trying." Food shortages became acute: by winter not only was some of the population eating rats but the rodents had attained the status of luxury commodities. Mme Morisot confided to Edma

and Yves on December 15: "We're very nervous, very sad. Berthe worries me a lot, she seems to have been seized by consumption, the other week she fainted."

And on January 8, 1871: "Berthe's health is noticeably altered, I've called the doctor." By February 4, the family had been eating crackers for twelve days, bread having become so bad it made them sick. Berthe was losing more weight. Stomach cramps debilitated her. Her face became gaunt. She wrote Edma on February 9: "You can't imagine how sad poor Paris is! and how sad everything is."

Passy itself witnessed no battles, though once on an overly venturesome walk Morisot and her mother saw a corpse being carried away on a litter, "and our hearts sank." But most of her closest male friends, as well as her brother, took part in the struggle.

At this point they were still fighting on the same side, though with varying political motivations. Young Tiburce Morisot, Édouard Manet, Degas, and Puvis rivaled each other with assertions of fierce patriotism. Degas and Manet, however, hoped for a liberal republican France. Together with Eugène Manet, the two attended a rally at the Folies Bergère in September 1870, after which Édouard predicted to his wife that "real republicans" would replace the present provisional government. Tiburce and Puvis argued for a conservative if not constitutionally monarchist republic, and M. and Mme Morisot agreed. Édouard Manet joined the Guarde Nationale, a civilian militia, as did Degas; Manet served first as an artilleryman and then as a staff officer. Degas was also enrolled in the artillery, under the command of Meissonnier, a popular painter of miniature military and historical scenes. Neither saw real action; Berthe later accused Manet of having spent the siege changing uniforms. Tiburce fought on the front, was captured, escaped, fought again, earned the rank of lieutenant. His family heard his news intermittently, often not sure whether he was dead or alive.

"Our existence has been a leaden nightmare for the last six months and I'm surprised I've been strong enough to bear it," Berthe wrote to her sister in early March 1871. The worst was yet to come. The next months widened the political rifts among her friends and family.

Everyone agreed on the ignominy of France's capitulation. Paris had surrendered on January 28, 1871. Elections were hastily called, for Prussia demanded the signature of a legal government on any peace treaty. Much to M. and Mme Morisot's relief, the country's new representatives inclined as far to the right as was possible in a republic. Among them was Puvis de Chavannes. The new president was Adolphe Thiers, a family friend who had officially witnessed both Yves's and Edma's marriages. Thiers, moreover, had for years maintained an extremely close—albeit respectably platonic—relationship with Morisot's great friend Marcello. The new government, which had been formed to sign the armistice, suffered from its humiliating loss of two entire provinces, Alsace and Lorraine.

Determined to show it could enforce order at home if not abroad, the Thiers government moved to quell Parisian unrest. On March 18 government forces clumsily and vainly tried to recapture cannon from the Guarde Nationale militia in Montmartre. Each side reacted dramatically. The government withdrew to Versailles, west of the city. Parisian activists held municipal elections on March 26. Many upper- or middle-class voters had fled the siege; many more members of the working class and lower middle class revolted against the excesses of the Second Empire and unrelenting privations; the elections produced a radical left-wing government. Two days later Paris declared itself a commune and seceded from the nation.

The armistice had at least united Frenchmen in a common resentment of Prussia. The Commune elicited as much ire but in Morisot's circle not nearly as much unanimity. The political differences between her family and Puvis on the one hand, and the Manet brothers and Degas on the other, became increasingly apparent.

Thiers colluded with the once-despised Prussians to annihilate the Parisian revolution. The fighting began on March 21, when Admiral Saisset and his Versailles troops fired on insurrectionists in the Place Vendôme. Twelve to fourteen people were killed. Tiburce Morisot was on Saisset's staff. His mother wrote Yves and Edma that he had done his duty courageously.

Once again Paris was under siege. The Morisots had moved to the western suburb of Saint-Germain, together with the Thomas

grandparents. The Versailles general staff camped out on the Morisots' street, rue Franklin. Gustave Manet joined the Ligue d'Union Républicaine des Droits de Paris, an organization of republicans who sided neither with Versailles nor with the Commune but instead attempted to reconcile the two parties and arrive at some sort of peaceful settlement. In early May, Berthe left for Cherbourg. Mme Morisot sent word of her imminent arrival, relieved to think she would be in the company of her beloved sisters and able to find some happiness in work. But she warned Edma: "Don't worry too much about her occasional melancholy, it's become second nature to her."

On May 21 the Versailles troops entered the city. The Communards burned buildings as they retreated, setting fire to the Tuileries palace, the Hôtel de Ville, and the Cour des Comptes. They also executed hostages, including Monseigneur Darboy, the archbishop of Paris. Versailles troops shot anyone suspicious on sight. Without trial, without interrogation, men, women, and children were summarily executed. Perhaps fifteen thousand to forty thousand perished in one week. During the *"semaine sanglante"* (bloody week) Tiburce Morisot invited the Versailles chiefs of staff, led by General MacMahon, to dinner at the Morisot home and was invited in return to lunch on May 24. He offered MacMahon's staff the use of the family linen and china. Meanwhile Manet wandered through the burning city with his friend Duret, sketching the firing squads and the dead.

Mme Morisot, speaking for herself and her husband, supported Thiers's Versailles government wholeheartedly. For her, even a liberal republic would be "one of sharers and disorder."

> I think Eugène Manet is three-quarters crazy and the violence of all those characters doesn't augur well for a lifetime of happiness.
>
> Tiburce met two Communards just when they were all being shot down: Manet and Degas! Even now they're criticizing energetic means of repression. I think they're crazy, don't you?

Did Morisot agree with her mother? Probably not, which may explain, in part, Mme Morisot's insistence on her point of view in correspondence about and to her daughters, as well as Mori-

sot's increasing reserve vis-à-vis her parents. In her 1870–71 let-
ters to her sister, Berthe repeatedly referred to disagreements
with her parents, especially her father, though without elaborat-
ing on the nature of their differences. She told Edma she pre-
ferred to avoid conversation altogether rather than court con-
frontation. The political nature of the disagreement seems
confirmed by Edma's replies: she offered moderate opinions,
like Manet's and Degas's, acknowledging legitimate arguments
and excesses on both sides.

Manet and Degas deplored the slaughter of the *"semaine san-
glante."* With the poses of the figures and general composition of
his lithographs, Manet deliberately connected the Versaillais's
summary execution of presumed Communards with the 1867
execution of Maximilian in Mexico, an incident decried by his
republican friends. He even had the gall to taunt the younger
Tiburce with an inscribed print of *The Barricade.* As to a sympa-
thetic friend, he wrote to Berthe from Paris on June 10:

> What terrible events and how shall we come out of them?
> Everyone blames his neighbor, but, in the end, we've all
> been implicated in what has happened.

No specific reaction from Morisot to Manet's politics survives.
She did come out of the war and the Commune with this to say
about Degas, whose politics were similar: "M. Degas is still the
same, a bit crazy, but delightfully clever." Of Puvis's Versaillais
politics she openly disapproved:

> I've been told Puvis de Chavannes is in the National Assem-
> bly. . . . I know he's so reactionary that, despite all my
> interest in him, I would prefer to see another in his place.

Though we have only scattered clues about her immediate
reactions to the Franco-Prussian War and the Commune, these
events had clear consequences in Berthe's life. For it was during
this time that she became close to Édouard's brothers, Eugène
and Gustave, whose political interests brought them out of the
shadow of their brother's artistic genius. And it was as of the war
and the Commune that she began to question her parents, to
distance herself from Puvis de Chavannes, to renounce Fantin
altogether, and to cultivate Degas. Her shifting allegiances were

of course also aesthetic; Degas and Manet were far more radical pictorially than Fantin and Puvis. But the war and the Commune had galvanized and polarized opinion in a way that included both the politics of government and the politics of art. Out of the crisis of 1870–71 came a republican attitude to the making and marketing of painting that Morisot would be among the first and staunchest to support.

30 years old

III

ALLIANCES

1872-1874

7

Personal Crisis

1 8 7 0 – 1 8 7 2

After the suppression of the Commune, Morisot's parents moved back to their rue Franklin home. The only significant damage had been to Berthe's studio. Puvis went there in her absence:

> The Passy studio was open but gloomy, the curtains three-quarters drawn and sepulchral. I sought your ghost in a white peignoir, but conjured you up in vain. I didn't, more-over, cross the threshold, waiting to do so for the return of she who animates this solitude.

When Morisot left Saint-Germain for Cherbourg in May, she hoped to institute new work habits. Before leaving she had writ-ten to Edma:

I'd like to know from you if there's really a way to work in Cherbourg. This question may not seem tenderhearted, but I hope you will put yourself in my position to understand that it's my only goal in life and that indefinitely prolonged inactivity would become deadly for me in every way. . . . I don't want to work anymore for the sake of working.

I don't know if I'm fooling myself, but it seems to me that a painting like the one I gave Manet could sell and that's my only ambition. . . . You understand perfectly what I mean.

For art to fill a life, Morisot realized, it would have to expand to professional dimensions. She announced her resolve to Edma right around the time of her thirtieth birthday, that same momentous birthday on which Edma had given up art in favor of marriage. Morisot's different choice was both brave and defensive.

A contemporary manual on feminine behavior written by the Baronne Staffe intoned:

as young wives, young mothers, women will have to renounce, for periods of time at least, the sanctioned joys art gives. Sanctioned, that is, when such art is not too absorbing, when it does not take precedence over the sacred obligations of woman.[1]

Edma's decision had been the example. General opinion on the subject was clear enough; what was changing was Morisot's position. As she reached the age of thirty she became convinced she would remain single all her life.

Who could lightly accept the label "old maid"? In the cruel words of another contemporary pundit, Ernest Legouvé: "An old maid is always, as it were, ashamed; she feels herself constantly the object of mocking looks and speculations."[2] It was a dreadful stigma. No accomplishment, however professional, could camouflage the failure to achieve the "sacred obligations" of marriage. No occupation could compete. On the contrary, as an expert on women proclaimed: "Learning can only serve to detract from her happiness and the happiness of those around her."[3]

Marie Bashkirtseff, herself an aspiring painter, decried the talented woman's dilemma:

Ah! how women are to be pitied; men are at least free. Absolute independence in everyday life, liberty to come and go, to go out, to dine at an inn or at home, to walk to the Bois or the café; this liberty is half the battle in acquiring talent, and three parts of everyday happiness.

But you will say, "Why don't you, superior woman as you are, seize this liberty?"

It is impossible, for the woman who emancipates herself thus, if young and pretty, is almost tabooed; she becomes singular, conspicuous, and cranky; she is censured, and is, consequently, less free than when respecting those absurd customs.[4]

The voices of social convention were insistent even within artistic circles. Alphonse Daudet published a book in 1878 about a woman artist. The heroine, Félicia Ruys, so resembles Morisot's friend Marcello that she may have been modeled on her; in any case, she represents Daudet's idea of a woman artist's marital destiny. For one reason and another, Ruys grows up less than immaculately feminine. Studio life has ungendered her, and though she has acquired a "virile" sculptural skill, it has come at the cost of her "natural" inclinations. Faced with the one man who might save her from her artistic fate, she warns:

I'm sure he wouldn't want this monster called a woman artist. . . . Art is a tyrant. You have to give yourself to it entirely. You put into your work all of your idealism, energy, honesty, conscience, so much so that there's nothing left over for your life.

Lest the reader presume any woman could be content with her art, Daudet then forces Ruys to admit: "The fact is that there are days during which my life rings terribly hollow."

Her conclusion, or rather Daudet's:

I'll never be anything but an artist, a woman set apart from others, a poor Amazon with a heart imprisoned in its iron armor, launched into combat like a man and condemned to live and die like a man.[5]

Ruys ends up a debauched and exiled arsenic addict. Not an encouraging scenario. Nor was Daudet by any means alone in

his point of view. Edmond Duranty, who issued one of Impressionism's manifestos in 1876, published a short novel in 1881 whose heroine was a woman artist. Once again, the model may have been Marcello, but Lucie Hambert also resembles Morisot in some details, and the attitudes she faced in the 1860s and '70s. Duranty has one male artist explain to another:

> And then artists shouldn't marry women artists. Creating rivalry within the home? What absurdity! You have to be able to relax at home. Mlle Hambert is no longer a woman in our eyes, she's a comrade with whom we talk business.
>
> . . . an artistic life always disconnects you from an ordered and normal life. Mlle Hambert now goes alone to studios like a boy; of course she is thirty years old! But she now has only one foot in society. Her old family friends are beginning to be shocked by the increasingly independent ways Mlle Lucie adopts as she plunges into the full flood of artistic life.
>
> . . . She suffers from everything! . . . from her uncertain position, from her still slight success, and from the fear of remaining an old maid![6]

Nor were the voices only men's, or only couched as fiction. Geneviève Bréton, a young woman of Morisot's social class, saw Marcello at the 1871 Salon and commented in her diary on June 18:

> . . . she has, because of her name as a society lady and an artist, that court of admirers a free woman can allow herself, that seductiveness, whatever one may say, accorded by liberty and independence. Very much in the public eye, she has the accomplishment given by contact with the wits and artists she surrounds herself with. . . . For now, she holds her head against the storm, making appearances everywhere, defying and seducing society; she has a lot of stones thrown at her, but as soon as she arrives those same hands that had been pointing at her with contempt reach out to her.[7]

Who was Marcello, Bréton asked herself, "a willful eccentric or an unfortunate lunatic"?

These were the estimations of the life Morisot was choosing;

these were the judgments passed on her close friend, the only woman Morisot knew who had tried to pursue a public career in art.

But the worst betrayal came from her mother. Cornélie never withdrew her affection and could even at times understand her daughter's values, but she too heard the voices of social convention and heeded their lessons. As early as 1868 she joined the chorus, always believing she acted in her child's best interests.

Never one to mince words, Cornélie Morisot told her daughter that her looks were fading. It seemed to her that painting brought Berthe few compensations and considerable trouble, and she told Edma of "the anxious, almost fierce look" Berthe "always" had while working. She began to view her daughter's work more as an intellectual distraction or a consolation than as a vocation.

> Berthe isn't happy with what she's doing and I push her only as far as it takes to see her occupied, for to replace indolence with feverishness doesn't seem to me any better for her health. Nonetheless, you know that it takes very little to amuse her and distract her; she always has something funny to say about everything she sees.

She pestered her daughter with a ceaseless stream of matrimonial candidates, each less appealing than the last. Berthe tried to take the business humorously, writing on May 11, 1869:

> My deals have fallen through, my dear Edma, and you should congratulate me on having emerged so quickly from all my agitations. I think I would have been sick if I'd had to decide right then and there in favor of M. D. Luckily that gentleman found me completely grotesque; I wasn't expecting it and I was very surprised, but not entirely displeased!!!

On another such occasion, Morisot dawdled upstairs, staving off the dreaded interview, and her mother came storming up the stairs to ask how long *she* would be left with such an "imbecile."

Meanwhile Cornélie Morisot was losing faith even in her daughter's artistic abilities; she considered Berthe's work adequate for amateur young ladies but hardly of professional, and salable, quality.

> She always wants to work marvels someplace else, where she isn't, and hardly ever seeks out the resources at hand ... she may have the necessary talent, one couldn't ask for more, but she doesn't have a flair for commercial and public tastes; she'll never sell any of the things she does if she goes on like this, and she's incapable of doing anything else.

In her extremity, Cornélie cited Manet (whose painting she also thought was worthless):

> Even Manet, while praising her highly, said: "Mlle Berthe hasn't wanted to do anything up till now, she hasn't pushed at anything; when she wants to she'll make it."

The only efforts Berthe made, her mother retorted, were to impose her will on everyone around her, but the sole result was that Berthe was "making herself ill." She doubted the sincerity of the artists who had praised her daughter's work, accusing them of swelling Morisot's pride and deluding her. To her credit, she said all this to Morisot's face:

> My mother politely told me yesterday she had no confidence in my talent and she believed me incapable of ever doing anything serious.

Why wouldn't Berthe settle for the average lot, she demanded, and complained to Edma in June of 1871:

> I would urge Berthe not to be disdainful. Everybody's opinion is that it's better to get married and make sacrifices than to remain independent, in an untenable position. She ought to bear in mind that in a few years' time, she will be more lonely, have fewer ties, and as her charms fade, she'll have very few of the friends she thinks she still has at the moment.

Her situation grew more complicated, and perhaps more frustrating for her mother, after 1870–71, when two men played significant, if ambiguous, roles in her life. Both of these affairs remain somewhat mysterious, for the evidence that survives in letters tells us almost nothing of Morisot's feelings, which can only be surmised in the uncertain reflections of her correspondents' letters.

She was such an exceptional woman that it cannot have been clear to anyone what kind of husband she could or should want. Conventional wisdom had it that a woman with professional ambitions and a willful personality should have no husband at all. Mme Morisot, at the other extreme, persisted in seeing her daughter as an ordinary woman and thought she should settle for any self-supporting, reasonably well connected and sensible man who could put up with her. Presumably she believed Berthe would, like her sister Edma, cease painting after her marriage, to satisfy the expectations of her husband. Berthe was apparently considering much less conventional possibilities. What kind of man would remain unthreatened by her painting, would even support it?

Clearly no ordinary man would do. She hoped for someone who could understand what she felt was at stake artistically in Impressionism. That narrowed the field to those either in or around the Impressionist circle. It had to be someone who was not too preoccupied with his own career, either because his own was already successfully settled or because he didn't care to have one at all. It had to be someone generous and accommodating. And yet it had to be someone Morisot could respect. That left two candidates: Pierre Puvis de Chavannes and Eugène Manet.

Puvis de Chavannes had been courting Morisot's favor since 1868. He devoted himself to her in letter and in person, praised her painting, and sought to win her family's approval. This last apparently he failed at. He referred repeatedly in his letters to M. and Mme Morisot's antipathy and to the difficulties this created for their friendship. It is hard to understand why Puvis encountered this problem. By the early 1870s he was extremely successful. He had received prestigious commissions for buildings like the Amiens Museum and the Poitiers city hall and, even, in 1874, for murals in the Panthéon, one of France's most venerated monuments. He had the Legion of Honor and came from a perfectly respectable middle-class family. Perhaps the Morisot parents objected to his mistress. Perhaps they thought his intentions were not serious enough.

Did Puvis really intend his relationship with Morisot to become something other than friendship? Did she? He gave hints in his letters, but nothing definite. As for Morisot, the only clue

she left was a juxtaposition in one of her later private notebooks. After explaining that true friendship between a man and a woman was impossible, especially where love had ever been an issue, she changed subjects, but the very next paragraph was about Puvis de Chavannes. We do know with certainty that she found his politics too conservative and his personality too pompous. His being seventeen years older than she was may also have been a factor.

Mentions of Eugène Manet begin to appear in Morisot family letters about 1871, though his friendship with Berthe dated back to 1868. Letters that summer from Cornélie to Berthe allude to a trip to Bordeaux Eugène and Berthe had contemplated taking alone together. Édouard Manet encouraged the scheme, hoping scandal would force his brother and his friend to marry. He told this to Morisot's mother when she came to visit his studio, while he was

> at home making a portrait of his wife and laboring to make of that monster something slender and interesting! . . . then recalling your projected departure with Eugène he claimed that he had wanted to arrange it so as to compromise the two of you in order that you become his sister-in-law. . . . [Suzanne Leenhoff Manet] cried out: "I would so much have liked to have Mlle Berthe as a sister-in-law!" . . . What a case! He's crazy, he has no common sense.

The match may have seemed an obvious possibility to members of both families, but to the Morisot parents it was at first out of the question. Though Cornélie Morisot urged "sacrifices" for marriage, some sacrifices were too great for her and her husband to make. Moreover, the Manets' politics were too radical, and Mme Morisot had heard rumors of illness and even violence in the family. Besides that, Eugène didn't look her in the eye satisfactorily. "I would prefer someone else, even if he were less intelligent and from a less congenial background."

Eugène himself seemed in no hurry to marry. Both he and Berthe were too sensitive and perceptive, as well as anxious, not to see how complicated marriage between them might be. He was high-strung and restless, she was exceptionally strong-willed and committed to painting. Neither was conventional enough to

believe in marriage for the usual reasons. Both felt all too clearly the advantages of being single, and the flaws as well as the strengths of each other's characters. Morisot, moreover, insisted she was too old, at thirty, to be married to anyone. Her mother tried to respond sympathetically, allaying Berthe's anxieties about her age by urging her not to waste the good years still left. She began to wonder whether both of them would ever make up their minds one way or the other, lamenting that Berthe and Eugène were not younger and less realistic.

> If only you knew how I understand and share your reluctance! As bad luck would have it, the two of you didn't begin a common life early enough, and having wanted to think things over or chase after the realization of a dream, you were left with neither enough strength of character nor enough independence of heart to feel committed to each other.

Cornélie Morisot, however, had not given up hope. Apparently her earlier reservations faded as time went on and as she noticed that even if her daughter claimed a marriage with Eugène Manet was impossible, at least marriage remained an issue. She began to watch eagerly for any signs of a more serious interest on Eugène's part and even, finally, requested that he come to pay the Morisots a call.

Berthe held out. Though she could not yet see solutions to her conflicts, she knew her mind well enough to act on her priorities. For the time being, she would paint.

8

Resolutions

1 8 7 2 – 1 8 7 4

> I've come out of this siege absolutely disgusted with my
> fellow human beings, even my best friends. Egoism, indif-
> ference, narrow-mindedness, that's what there is in every-
> one.

So Morisot had written to Edma on February 9, 1871. The
national debacle of 1870–71 forced her to reevaluate many as-
pects of her life and many people. Her commitment to painting,
her refusal to marry, her artistic and personal loyalties, and her
politics, all had been called into question.

She relinquished past bonds with difficulty. Later she would
confess to a private notebook:

> I've always had great difficulty separating myself from
> places, from people, even from animals: and the beauty of
> it is that I'm considered to be the soul of indifference.

If she seemed impassive to others, it was not because her inner sentiments subsided with age but rather because they were well hidden and firmly dealt with. Pain, conflict, or obstacles did not thwart Morisot or confuse her for long. Nor did she deny or repress the problems that beset her. Her decisions were rooted in supremely lucid reckonings of her situation and its implications. Between 1872 and 1874 Morisot picked up the shards of previous years and fashioned from them a personal and professional life whose brilliant reconciliation few women in her time would equal.

Morisot's mature career begins about 1872. Though the prospects for professional success remained dim, she not only persevered with her work but began to find a novel and receptive audience for it.

> I sent my seascape of Cherbourg to M.———. He was supposed to show it to Durand-Ruel; I haven't heard a thing since; I'm thirsting to make a little money and I'm beginning to lose all hope.

Durand-Ruel represented a new kind of venue for painting— the private dealer. While in decades past the Salon had dominated the art market, by 1872 enterprising dealers had begun to take matters into their own hands. They instituted practices that are still in effect today: buying directly from artists; building up stocks by "name"; enhancing individual reputations by displaying each author's work in blocks and commissioning monographic biographies. Moreover, they competed directly with the Salon by holding public art exhibitions in their galleries, as did some of the burgeoning artists' "societies." Of all the young dealer breed, Durand-Ruel took the most risks. Not only did he engage in all the latest marketing tactics but he caught on at a very early stage to the stylistic phenomenon of the avant-garde. He bought Barbizon school paintings while they were still being mocked by the establishment, for he was confident that in time their reputation, and their price, would rise. He was right. In the early 1870s he saw the cycle beginning again; this time it was Manet who filled the role of the revolutionary, while the Barbizon school was the sure investment. Durand-Ruel gambled his

capital and in 1872 bought twenty-two of Manet's paintings. No sooner had he committed himself to Manet than he ventured into the next generation, giving his support, which would be crucial, to those who were about to become the Impressionists.

Morisot belonged to that group. He bought four of her works—one oil seascape and three watercolors—in July of 1872. As far as we know, this was the first public signal of Morisot's professional stature as well as her avant-garde reputation. Nor did Durand-Ruel intend to give away Morisot's pictures; he asked substantial prices for them: two hundred fifty francs for the watercolors, six hundred francs for the oil.

The financial value Durand-Ruel gave Morisot's work vindicated her efforts to push her art beyond conventionally feminine domestic limits. While Morisot did not need to earn money, she needed to know her pictures were worth money. Yet much as she coveted the respect high prices indicated, she could barely bring herself to conduct an actual commercial transaction. She wrote to Edma:

> [Édouard Manet] had written me that morning to announce his departure and to tell me he had given my address to a very rich gentleman who wanted to have his children's portraits done in pastel, that I had to make him pay very well if I wanted to be treated with respect and that it would be an extraordinarily good opportunity for me that I shouldn't let escape. If I really believed it would happen, I would be a bit worried; I know my nerves and I know such an operation might cause me anxiety. If by chance he should come, tell me what I can ask: 500 francs, that is to say 1,000 francs for the two? It seems an enormous amount to me!

Morisot's reluctance to market her work aggressively should be seen not so much as another form of self-deprecation but as a strategic feminine fiction. Morisot made all kinds of concessions in order to protect herself from interference. Paradoxically, the behavior that seemed superficially the least professional was exactly what enabled a truly professional artistic production.

Among the greatest of her concessions was her studio. When

in 1873 the family moved to another Passy address, 7 rue Guichard, a brand-new four-story apartment building, Morisot did not arrange another studio for herself. The one she had shared with Edma seems to have been furnished in the standard studio way, with a red sofa and a central pouf, and to have been cluttered, both on the walls and on the floor, with canvases in various states of completion. In the rue Guichard apartment, Morisot confined her work to her room, and not even a room evidently given over to painting. The artist and writer Jacques-Émile Blanche visited it as a small boy and later left us this description:

> A bourgeois apartment, but in this apartment, a young lady's room is the studio of a great artist. White slipcovers, curtains, portfolios, straw "shepherdess" hats, a green gauze butterfly net, a cage with parakeets; and no bric-a-brac, no art objects, only a few sketches, a wall papered in gray striped moiré, a Corot landscape, a silver scumble.[1]

A light, cool place devoid of self-consciously laborious or artsy trappings. When Blanche asked Morisot for a painting, she told him (somewhat falsely) that she destroyed everything she made, oils were too difficult anyway, and moreover, she had no watercolors available. Yet despite the modesty of her workplace and manner, her personality could not be entirely concealed. She had developed an austere elegance and a mysterious aura. "An art lover! a distinguished person! an eccentric but very stylish!" pronounced her Passy neighbors. Black and white clothes may be sober, but a woman who wears nothing else is always noticed. Blanche recalled:

> How she scared me . . . with her "strange" dress, always in black or white, her dark and burning eyes, her angular, thin, pale face, the curt, abrupt, nervous words, and the way she laughed when I asked to see what she hid in "her notebook."[2]

Without renouncing Passy or its values, Morisot found other places for herself. She spent several months in 1871, 1872, 1873, and 1874 with the Pontillons, first in Cherbourg and then in Maurecourt, away from Paris and her parents. However much

Maurecourt may have been an exercise in nostalgia for the summers she and Edma had spent painting together, and however much the company of her sister's husband and two children might have reminded her of options seemingly foreclosed, the visits at least provided an unobtrusive and respectable working situation. No one could object to Morisot's setting up her easel in her sister's private garden or painting her sister playing with her babies. The Pontillon family could even accompany—that is, chaperone—her while she worked at the seaside.

Morisot began to imagine even greater distances, linking in an 1871 letter to Edma her hopes for sales, her dreams of travel, and her desire for independence:

> The watercolor looks quite well framed; the dealer, who is, apparently, one of the best-known in Paris, told me how much he liked it, saying it had been noticed by all the artists who had come by. I didn't dare ask if he wanted to buy. I'm waiting till I have others to offer him. It seems Fantin is making a fortune in London. Tissot is earning a lot of money over there; little Clauss is delighted with her trip there. They're all stealing my idea. Write me very seriously what you would do in my place. . . . I'd like to create a sort of independence for myself; sometimes I have glimmers of hope, but they fade so quickly.[3]

Rather than London, Morisot chose St.-Jean-de-Luz on the Basque coast, Toledo, and Madrid to visit in 1872. She was, of course, escorted, this time by her sister Yves Gobillard, to whom she was becoming somewhat closer after years of an exclusive relationship with Edma. Partway through the trip, they acquired a knowledgeable guide in the person of Zacharie Astruc, a critic in Manet's orbit. Manet himself had made a similar trip years before, steeping himself in the work of Goya and Velázquez. Morisot echoed his admiration for the two Spanish masters, as well as his lack of enthusiasm for Spain as a whole. She longed to return to northern France. Nonetheless, as she paid homage to the Old Masters from whose work Manet drew inspiration for his stylistic and thematic innovations (including those of *The Balcony,* with its references to Goya's *Majas on a Balcony*), she accomplished a painter's rite of passage.

Having fulfilled her pilgrimage to Manet's sources, Morisot could better take her distance from him. She wrote to Edma in 1871 about a picture she was working on of their sister and her daughter: "as a composition it looks like a Manet; I'm aware of it and it annoys me." Actually, Morisot's work in these years imitated Manet's work no more than his copied hers; her "anxiety of influence" stemmed from an increasingly acute awareness of her own artistic ambitions and the originality of her vision.

In previous years, her exceptional gifts had brought her loneliness and confusion. At the end of 1871 her entourage began to notice an altered demeanor and the glimmerings of self-confidence. The paintings she produced in those months won, as they win now, undivided admiration. Her single most famous painting was produced around this time: *The Cradle,* a picture of Edma Pontillon solemnly contemplating her infant daughter.

The artist's achievement radiated through the woman. Morisot's peers began to comment on her aura. Puvis wrote: "it's not for nothing you're a thoroughbred artist, as our friend Stevens says." Even Mme Morisot had to report: "And now she's come to be regarded as a consummate artist by all these great men!"

"[Édouard Manet] finds me not too ugly and would like to have me back as a model; I'm so bored I might even suggest it to him myself." With this wry statement Morisot announced Manet's 1872 portraits of her. Of one of them, *Berthe Morisot with a Bouquet of Violets,* no less an authority than Paul Valéry would later say that since Vermeer there had been nothing finer. Looking at the picture, it is hard not to agree. The image, small but riveting, depicts a woman who utterly engages our attention without seducing, subjecting, or challenging us. Or perhaps she does all these things at once, but so subtly, so elegantly, so discreetly that we hardly feel the pull. Her intelligence seems to emanate with the painting's limpid light, just as a humorous and delicate strength curves deftly along the silhouette of her black dress, hat, and ribbons. Morisot's eyes, as in *The Balcony*, transfix us, here less intently, more invitingly.

At the opening of her corsage she wears a small bouquet of violets: a token, contemporary texts tell us, exchanged between lovers. What does it mean, then, that Manet takes up this bouquet again in a coda to his portrait? In gratitude for her time, Manet

imagined a brilliant pictorial conceit. He made a tiny painting
of that same bouquet, placed casually with the red fan Morisot
had held in *The Balcony,* beside a partly folded note on which
some words can be read and others not: "To Mlle Berthe, . . . ?
Manet." He gave the picture to her. An extraordinary thank-you
note. A note in which words fail, disappear, become an image,
appeal to the tokens of her time, to the signs of her femininity,
to the emblems of her charm. Is it a form of payment? Tribute,
more accurately—the apposition of her name and his, her "signa-
ture," both bouquet and fan, next to his, both word and image.

Art-historical gossip has speculated feverishly on the exact
nature of Morisot and Manet's relationship. The *Bouquet of Vio-
lets,* freighted as it is with connotations, does call for some com-
ment. Morisot and Manet may have been drawn to each other,
not for purely sexual reasons but because of the alliance of sexu-
ality, intelligence, and creativity each perceived in the other. We
have no indication, however, that their mutual attraction im-
plied any frustration or unfulfilled desire. Convention, of course,
kept them apart. Manet, after all, was married, while Morisot
belonged to a class of women who chose either marriage or
celibacy. More fundamentally, the ability each had to see the
other as a complete person argued against any union. Men like
Manet did not tend to want to have sexual relationships with
women who challenged as well as charmed them. Morisot had
often complained about Manet's feckless vagaries, and she
meant what she said. His talent and his vitality exhilarated her,
but she remained lucid about the rest of his character. It's one
thing to be excited by someone's painting. It's quite another to
live with him on a daily basis. Morisot never did anything for
short-run gains. She measured in long distances.

Ordinary roles are the easiest to play, however little they corre-
spond to inner conviction. Masculine/feminine, dallying
painter/willing model, and last but not least for the artist, the
Old Master. *Berthe Morisot with a Pink Shoe* plays traditional
games: Morisot adopts the feminine stance of a coy model vis-à-
vis Manet's role as the flirtatious masculine painter: one pink-
shod foot advances invitingly from beneath Morisot's black
dress. Those pink slippers and stockings were her trademark; she
hated the laced black boots decreed for day wear. The same

Spanish flirtation, paired with Manet's pictorial pastiche of Goya, marks *Berthe Morisot with a Fan.* She hides her face with a raised and unfurled fan. He paints the fan as a mask, the black of the fan merging with the black of her hair, forming a strange and hieratic headdress.

Manet's portraits trace Morisot's evolving sense of self. In comparison with his 1868–69 images of her, these 1872 pictures show a more stable, more self-confident woman. He understood something about her in 1872 that no one else seems to have understood. Out of Morisot's years of crisis had come decisions and strategies that were about to resolve all her conflicts.

9

Joining the
Impressionist Movement

1 8 7 3 – 1 8 7 4

Impressionism will always be debated: as a concept, as a series of exhibitions, as a set of personalities. Still, art critics recognized a central group from the first Impressionist exhibition. Over and over they referred to six figures: Edgar Degas, Claude Monet, Camille Pissarro, Pierre-Auguste Renoir, Alfred Sisley, and Berthe Morisot. Paul Cézanne certainly began his career with the Impressionists, and Gustave Caillebotte and Mary Cassatt joined the movement along the way, but six core members, in their own eyes and in the eyes of others, constituted the heart of the Impressionist movement.

The first we hear of anything like a "movement" comes from Bazille, who would not live to see the fulfillment of his own project. The painter wrote to his parents in 1867 that he and several friends, frustrated by the Academy's administration of

the Salon, planned to hold an exhibition of their own. They would bypass the Salon and appeal directly for an audience. Morisot probably knew Bazille by 1869. In her description of the 1869 Salon, she wrote to Edma about the painting she admired by "big Bazille," an appellation familiar and specific enough to imply personal acquaintance. Bazille frequented the home of Mme Lejosne, the same Mme Lejosne Manet paired in his *Concert aux Tuileries* with another hostess, Mme Loubens, whose evenings the Morisot family attended.

While the extent of her acquaintance with Bazille remains uncertain, Morisot's professional relationship with Degas, though less well documented than her ties to Manet, developed steadily from 1868 onward. Not only did Degas come to the Morisots' both to socialize and to paint Yves Morisot Gobillard, but hints appear in Morisot's correspondence that Degas's artistic influence may have waxed as Manet's waned. Morisot complained when her pictures looked like Manet's; when Degas offered her a fan to copy during the war, she gladly accepted.

We have no record of Morisot's first meeting with Monet, Pissarro, Renoir, Sisley, or Cézanne. She may have met Monet through Gustave Manet. We do know how the male Impressionists met each other and hatched their first exhibition. At Gleyre's painting studio, through Zola and other mutual friends, at the Académie Suisse, and especially at the Café Guerbois, they gradually came to realize they had more in common with each other than with official art institutions.

One innovation suggested another. Egging each other on, these young men began to contest all Academy principles. Their ideas had analogues and precedents. Naturalist literature and republican politics were also challenging established institutions and their doctrines. Precursors could be found for every stylistic, marketing, or ideological Impressionist tenet. Individual artists like Corot had experimented with freer brushwork, more contemporary subject matter, and smaller formats. Courbet's and Manet's exhibitions of their own work had competed with official government painting displays. Dealers had begun to cultivate middle-class collectors. The Impressionists gathered all these scattered reforms into a coherent program.

Most obviously, the Impressionists reacted against the tight

facture and slick, melodramatic colors of successful Salon paint-
ings. "Finishing" a picture was supposed to be part of the
painter's craft. What did "finished" mean? The great Delacroix,
for instance, was often accused of not "finishing" properly. He
felt his colors and forms would be more vivid if left for the
viewer's eye to resolve. In his wake, Courbet, Manet, and then the
Impressionists decided they could do without glazes and var-
nishes, and leave their brushstrokes distinct. In this way, they
believed, they would catch the effect of the passing moment and
transmit the experience of the instant to their audience. Time
was perceived in fleeting snatches, they reasoned, so it should be
represented that way.

If the Impressionists' definition of sensation was grounded in
physiology, why had the Academy not recognized this truth? The
Academy defended a very different kind of truth, founded on
immutability and fixed canons of beauty. Emulation, not impres-
sion, produced great art, Academy supporters claimed; drawing,
not color, the permanent, not the ephemeral, built an art whose
test of time lasted longer than a glance.

The Impressionist style was more than a question of pigments
and brushstrokes; it ushered into the visual arts a new set of
values. It proposed aesthetic criteria based on individual experi-
ence rather than promulgated laws. The Academic system cre-
ated, defended, and perpetuated hierarchies of importance
based on classical erudition and the ideological imperatives of
a monarchist or imperial state backed by the Catholic Church.

Ranking subject matter had been among the Academy's chief
preoccupations since its foundation. Mythological, religious, his-
torical, or allegorical subjects headed the list, followed by, in
order of diminishing prestige: portraits, landscapes, genre
scenes, and still lifes. Decades before the Impressionists adopted
a programmatic position on subject matter, market pressures
had begun to erode this hierarchy's viability: pictures that con-
tinued to benefit from state patronage did not necessarily enjoy
the favor of middle-class viewers and buyers. On the whole (and
of course there were exceptions), the state commissioned "uplift-
ing" works of the academic type, the larger the better, since
larger could be construed as grander. Though impressed with
the edifying picture, the average buyer preferred genre scenes:

images of everyday life in the present or the past, usually on a smaller scale; sometimes the smaller the better, for a miniature scale gave evidence of pleasingly cunning craft. Morisot's friends Stevens and Tissot, for example, plied the genre trade lucratively well.

An Impressionist conception of *la peinture de la vie moderne* (the painting of modern life) (to use Baudelaire's famous phrase) differed from that of someone like Stevens or Tissot in several respects. Salon genre painters did not challenge traditional categories; they merely expanded the profits gained in a minor but established category. Whereas the Impressionists abolished categories altogether and replaced them with images of contemporary life, among which there were no distinctions by either size or subject.

Nor did the core Impressionists so much illustrate as analyze the world they lived in. They strove to understand, not just to record. Many of Stevens's pictures, for instance, depict stories, and a great part of the pleasure of looking at a Stevens painting lies in the mental reconstruction of its "before" and "after." Impressionist pictures rarely tell stories; they show how things look. Not just what things look like but *how* they look and sometimes, in the keenest Impressionist paintings, why things look the way they do and why we see them as we do. Degas explains with visual analogies, appositions, or comparisons how ballet dancers create illusions of art and femininity; Monet demonstrates the restfully ordered appeal of nature transformed into a suburban garden.

By "modern life" the Impressionists meant modern urban bourgeois life. They painted the spectacles of the middle class: the spectacles the middle class made of themselves and the ones they enjoyed as paying customers. City scenes and their suburban extensions, along with the occasional picturesque peasant; scenes of home and workplace, private domesticity and public entertainment, interiors and gardens, transactions at the brothel or on the stock exchange, Sunday afternoons by the Seine or Wednesday afternoons in the parlor, women of fashion, men of the world—such were the places, the pastimes, and the images of the bourgeoisie the Impressionists chose to immortalize. Themes worthy of high art? Not according to tradition.

In ways that went well beyond pictures themselves, the Impressionists challenged accepted art world practices. In a simple sense, their decision to display their work on their own initiative broke the Academy's near monopoly on exhibition. But the Impressionist Exhibitions undermined the fundamental economic assumptions of the Salon's operation in more complex ways. Free agents who entered by contract into a corporation (in the strictest legal sense of the word), the Impressionist painters each risked their own capital, time, and product in a market neither sanctioned nor protected by state, church, or institutional privilege. Their ventures were geared to the demands of an emerging market: the paintings were novel in concept, designed to appeal to personal experience, and sized for a middle-class private home. They were for direct sale to consumers; their vendors scoffed at prizes, medals, and sinecures.

None of the founding members of the Impressionist movement had attended the Academy's École des Beaux-Arts. None had won any medals at the Salon; Cézanne had never once been accepted by the Salon jury. Though the men had all passed through established studios at least briefly, it was clear that their ideas and techniques had come primarily from contact with each other and secondarily from revered older painters like Manet, Corot, and Courbet, who themselves were not graduates of the Academy system. The Academy's pedagogic dominance was therefore as threatened as its economic hegemony. With its power to train new members of the profession would disappear its power to define the limits and standards of the profession as a whole.

No market is completely free. Durand-Ruel and other dealers who backed the Impressionists introduced commercial principles founded on untrammeled production and consumption. But as we have seen, dealers did organize their sources and manipulate their audience. Likewise, the press, which purported to mediate objectively between paintings and public, hardly judged art exhibitions in a neutral way. Dealers functioned, along with painters, critics, and collectors, through a network of mutual interests. Each party fostered the advancement of the others by pushing forward its own: in economics the principle would be called capitalism; in politics, individualism. Each magazine or

newspaper defended a political and cultural position; each critic praised friends, attacked enemies, and evaluated work according to prior allegiances.

Impressionism was as class-specific as any art had been before it. While in theory anyone could become an Impressionist painter; while in theory anyone who had earned money could own Impressionist pictures; while in theory the Impressionists impartially painted whatever came into their field of vision, in practice their system was almost impermeably middle class. All kinds of social obstacles prevented the vast majority of the French population from acceding to the creation, the contemplation, or the ownership of Impressionist work. The difference was that Impressionism represented—in the fullest sense of the word "represent"—a class exponentially broader and more diverse than any previous ruling class.

Impressionism provided cultural opportunities for new sorts of people, including some it had never intended to enfranchise. Like women. Morisot understood immediately how each and every aspect of Impressionism gave women a chance at artistic careers. Impressionism ignored the artistic institutions to which women had little or no access, and it advocated a kind of art potentially consonant with the sort of painting women—middle-class women, at least—had been allowed and even encouraged to pursue. Impressionism, Morisot realized, offered her the opportunity to negotiate a compromise between personal and professional imperatives.

For a woman to become any sort of artist, let alone a painter, was rare enough. In 1883 the feminist *Gazette des Femmes* estimated the actual number of French women "artists, painters, and sculptors" at 3,000.[1] Four years before, the sympathetic critic Jean Alesson, writing in the same magazine, had counted a total of 2,150 women "having more or less exhibited at the Salon." Of these, he calculated, 107 had braved the male bastion of sculpture; 602 painted in oils, considered the pictorial norm; 193 painted miniatures, 754 were ceramicists, and 494 worked in various media like pastel, charcoal, watercolor, and made various objects such as fans.[2] In other words, the women who pretended to the prestigious branches of art (painting and sculpture) constituted a small minority of a small minority of artists.

Despite these difficulties, conventional avenues had offered women some signs of recognition. Rosa Bonheur had been awarded the Legion of Honor. In 1879, again according to Alesson, fourteen women had won first-class Salon medals, nineteen women second-class medals, and thirty-nine women third-class medals. The number of women exhibiting at the Salon increased every year. Was it strange that women should cling to these meager rewards? So much of their energy was expended on entering the profession that little was left over to judge it critically. Feminist activists in the arts, notably Louise Bertaux, continued for decades to militate for obsolete rights. As late as 1890 (but still almost a decade before her demands were met) Bertaux wrote longingly of an Academic shelter, its coveted Prix de Rome, of the "proof of a talent for high art" it promised, of the École des Beaux-Arts as a "family that adopts you, offers without charge the broadest education by the most eminent professors, supports you at first, encourages you afterward, and protects you always."

If Morisot had been younger, perhaps she would have hoped as much from state institutions. In her generation, Bertaux's dream of equal access belonged to an almost unimaginable future. Marcello's example, moreover, was taking an ominous turn. Her willingness to play the game by the usual rules of the artistic establishment had hardly been rewarded. Powerful friends had turned into squandered time, not patrons, and Marcello had to struggle to disentangle an artistic reputation from the brilliant web of her social connections and noble rank. She was, professionally speaking, going nowhere fast. Critics praised but also condescended; medals were not awarded, on one pretext or another.

Morisot sought other kinds of solutions to the dilemmas of her feminine condition. Rather than seek the putative security of academic respectability, she gave Impressionist responses to material and social obstacles.

The École des Beaux-Arts took no women students? The Impressionists rejected Beaux-Arts training in favor of learning in the field (literally). Bourgeois women couldn't study from a nude model, male or female? Or acquire a classical education? The Impressionists rejected classical subjects with their scantily

draped heroines and heroes in favor of a clothed modernity. Twelve-foot canvases too big for the parlor? Equipment too cumbersome for the corseted woman to carry? In order to work out of doors, to study the bourgeoisie in its apartments and on its boardwalks, the Impressionists resorted to portable gear, especially the pliable paint tube, invented the same year Morisot was born. A twelve-foot-square canvas is a considerable liability on a cliff in a high wind. Besides, Impressionist pictures were not intended to hang on palace or church walls but on the living-room and dining-room walls of middle-class homes. Where, after all, amateur women had hung their work for quite some time.

All of a sudden, the scenes women experienced in the course of ordinary life, the formats and style they could logistically manage, the sites they had already colonized, were being lauded as the most advanced, the most intellectually exciting prospects for painting. Women had participated in professional art-making for centuries—almost always as anonymous hands in family workshops, usually for obscure usages, often in supposedly minor genres or media. More recently, women amateurs had proliferated throughout Europe, acquiring a widespread basic visual literacy. The young men at the Café Guerbois changed the definition of "high art" in a way that included—just barely—the way women worked.

To accomplish what she did, Morisot had to work on the margins of Impressionism, itself on the margins of the art world. The themes Morisot restricted herself to had not been considered suitable subjects by high art institutions, critics, or artists. Impressionism brought them within the boundary of the acceptable but also introduced new definitions of importance Morisot could not meet. It would have been unthinkable for her to paint the kinds of brothel scenes Degas did, or even pictures of train stations like Monet's. She had to forgo prestige and persevere in her quieter way. All the Impressionists took their turn at the scenes a middle-class woman could safely sign her name to: the domestic interior, the park or garden, the vacation spot, portraits of family or friends. But they produced other kinds of pictures as well.

Morisot accepted the conditions of her success. She specialized

in a very few subjects. Toward the end of her career she made a few attempts at more professionally ambitious themes, like nudes. But her best work, virtually all her work until the 1890s, cleaves to a feminine pattern set for decades by amateur women painters: the daughters, sisters, and wives of the bourgeoisie playing their appointed roles. Perhaps a more constructive way to think of Morisot's subject matter in the context of her biography would be in terms of a strategy. Despite the conventional character of her subjects, nothing about Morisot's choices was easy or safe. Regardless of the content of the subject matter, women were simply not supposed to paint at all. By choosing safely feminine themes, Morisot made it possible to cling tenaciously to an extremely daring unfeminine career while making minimal personal sacrifices.

Morisot consciously chose her professional constraints. It seems from a few surviving pictures that her earliest work imitated Barbizon models both stylistically and thematically. Pictures of cows grazing in fields, pictures of semi-imaginary pastoral landscapes, forest glades: scenes of the sort her teachers Corot and Oudinot painted. She turned against them in the late 1860s and destroyed almost all the signs of her artistic apprenticeship. She repudiated Oudinot and began anew. *The Harbor at Lorient,* given to Manet, and *Mother and Sister of the Artist,* so embarrassingly but enthusiastically daubed on by him, announce Morisot's pictorial maturity. From that time on, for the rest of her life, she represented only scenes of contemporary femininity.

Amateur paintings by countless women of her class, fashion plates by the thousands, innumerable lithographs and engravings of women at work, play, and home—Morisot had plenty to look at that fell within a feminine scope. Burgeoning press and fashion industries generated an escalating quantity of mass-reproduced images aimed at a female audience. Advertisements, women's magazines, and cheap photographic portraits put at women's disposal an imagery at once banal and powerful. They created a feminine visual culture that women both identified with and were identified by. To this culture Morisot turned her pictorial attention. She retooled and rethought feminine popular

imagery just as her fellow Impressionists reworked a wider range of equally prevalent images.

Manet, Degas, Bazille, or Monet did not cause her to paint as she did and what she did. Their call for a painting of modern life may have incited her to ask what modern life might mean in the feminine case. Her answers to that question, made in the form of paintings, would always be unique. Nineteenth-century European culture assigned women and men very different educations and roles; inevitably Morisot perceived the world both as she was trained to and as her individual character inflected a feminine paradigm. None of the other Impressionists brought to their art that dual point of view. When Mary Cassatt later joined the group, it became all the more evident that Morisot had invested her feminine images with her own strong personality; for Cassatt's and Morisot's images are quite different from each other, though both represent feminine themes. Convinced individualists, all of the Impressionists interrogated their subjects according to their own experience of them. Morisot brought to hers a searching, questioning, analytical intelligence, sometimes sad but always stoic, sensitive to elegance and grace, tenderly respectful of her family and friends.

Not every group of men would have tolerated, much less encouraged, a woman to develop her character. In fact, virtually none allowed women to join them in any way. In 1881 the art critic Louis Enault reported on the fashionable *Cercles Artistiques.* These organizations had been the precursors of the Impressionists inasmuch as they constituted private alliances of artists, critics, and dealers and had initiated the practice of independent art exhibitions. Connoisseurs, dilettantes, "the elite of high society," flocked to these exhibitions, Enault claimed; but as he pointed out, no woman's painting was on display, for the *Cercles* showed only their own members' work, and the *Cercles* did not admit women.

Like the *Cercles,* the provincial Associations of Friends of the Arts functioned as men's clubs, often surrogate social or political clubs at a time when sociability and politics were intimately linked but, during the Empire, largely proscribed. The Impressionists banded together to reform the art world, aesthetically

and ideologically. Though their ideas were still embryonic, partially inherited from Courbet, Corot, and Manet, partially postulated orally by Degas and Pissarro, they were starting to add up to a radical platform.

The Impressionist cast included each of the types present in all Parisian revolutions since 1789. Their interaction had proved incendiary before, and it would again in 1874. Three sorts of agitating outsiders, each willing for very different reasons to shake up the bourgeois establishment: Edgar Degas—sardonic aristocrat, disdainful of bourgeois stodginess and financially capable of the bravura gesture, *noblesse oblige;* Camille Pissarro—a socialist and a Jew, committed to collective solidarity and opposed to the state; Berthe Morisot—a woman, denied access to existing institutions, socially and financially secure enough to risk herself without incurring immediate ostracism. And two ambitious characters looking for a shortcut to the inside: Claude Monet—solidly middle class but with social pretensions, expensive tastes, and a spectacular talent chafing at the pace of official procedures; Pierre-Auguste Renoir—the only child of the artisanal class, on the edge of bourgeois respectability and hoping to cross the boundary. Plus Alfred Sisley, following amiably along in the wake of the others. Three outsiders accustomed to marginality and therefore with little to lose; three would-be insiders with something to lose but a coveted benefit to gain. The stage was set.

IO

The First
Impressionist Exhibition

1 8 7 4

Once France staggered to its feet after the disasters of 1870–71, the old institutions lurched back into place. The new republican regime did not bring about reforms in the art world analogous to those in government. Perhaps it was fitting that in a republican France, the art world should have to detach itself from the state on its own initiative.

Charles Blanc, a moderate republican, had become, under Thiers, the Third Republic's first Director of Fine Arts. Edmond Duranty judged him, "though republican, very authoritarian, very papist, very infallibilist."[1] The most progressive project the Ministry of Fine Arts could imagine was a Musée des Copies, a museum containing nothing but copies of the classics. As this glaring instance of turgid state policy prepared to open its doors in the spring of 1873, Jules-Antoine Castagnary, another friend

of the future Impressionists, fumed: "M. Thiers is on the side of the ruling classes in art as in politics; he sees the rising tide of a naturalist democracy menacing the ideal of his youth, and here he comes with a Copies Museum."[2]

When Thiers's government fell in 1873, Blanc was replaced by Chennevières, a real royalist. Castagnary summarized: "for the four years and more that we've had a republic, not one republican principle has penetrated the fine arts administration . . . it's the monarchic regime perpetuating itself."[3]

Durand-Ruel, once again, led the way. Around 1870 he began exhibiting in London, improvising group shows with his Paris picture stock. The Society of French Artists, as he called these shows, probably included a Morisot in the May 1873 exhibit. The most prophetic was the winter 1873 show, which under the honorific aegis of Corot and Daubigny brought together pictures by Morisot, Degas, Monet, Pissarro, and Sisley.

Monet, Pissarro, Cézanne, and Renoir had all come to Paris from the provinces or colonies, determined from an early age to paint in a new way. Monet from Le Havre on the Norman coast, Renoir from Limoges in central France, Cézanne from Aix in the south, and Pissarro from the Caribbean island of Saint Thomas—all both instinctively and under the tutelage of the Barbizon school had rejected Academic precepts and begun to practice outdoor painting. They had all suffered rejections by the Salon, which had only fueled their angry discussions at the Café Guerbois. All were struggling financially by middle-class standards (though not, of course, by working-class standards) and more or less sacrificing their private lives to their aesthetic principles.

Monet, Cézanne, and Pissarro came from solid middle-class families who did not approve of radical artistic careers. Monet was in the process of depleting both his inheritance and his mistress Camille's, given to them both rather like severance pay. Pissarro, in the eyes of his family, had forfeited any claim to inheritance because he had married their maid; together with their rapidly increasing number of children, Camille and Julie Pissarro eked out a living in an inexpensive suburb. Renoir's father had been a tailor, and painting could therefore have made the son upwardly mobile if he had not deviated from the straight

and narrow Academic path to material success. Each of these three most active participants in the new movement drew different personal conclusions from his relative poverty. Pissarro became convinced that wealth was everywhere unfairly distributed, and he converted to socialism. Monet refused to compromise his art but needed to replace his capital. Renoir began to see the advantages of being middle class. But all three agreed with Degas, who had no such financial concerns, that they could best serve both their artistic and their material ends by circumventing the Academy.

Manet, however, was tending in the opposite direction. Though politically he and Eugène remained loyal to the radical cause by supporting their brother Gustave when he served as delegate to a Radical Republican Congress in 1873, in artistic matters he was becoming more conservative. He still hankered after official honors. In his mind, only the Salon really counted; no other kind of success could match it. A medal at the 1873 Salon fostered (false) hopes of further recognition. Though his style and subject matter showed the influence of Morisot and the Café Guerbois group, and though he maintained friendly relations with all of them, he began to distance himself from their more adventurous schemes. But the world at large was slow to perceive this, and Salon reviews both hostile and sympathetic were beginning to designate him as the leader of young radicals. How awkward for someone on the verge of finally placating wary authorities.

Morisot, on the other hand, was gaining faith in her individuality. One boost to her professional self-esteem came around this time in the form of the eight hundred francs—a hefty sum indeed—paid by her friend Stevens for a double oil portrait of her cousin Maria Boursier holding hands with her daughter. Stevens made the gesture, moreover, of buying the picture through Durand-Ruel, thus emphasizing the transaction's professional nature.

Manet revealed Morisot's new confidence in his 1873 portrait *Berthe Morisot Reclining*—"reclining" because originally he pictured her lying sideways on a sofa, only to crop away the right-hand and lower parts of the canvas to leave an image of Morisot's head and shoulders only. Her recumbent posture may have of-

fended strict notions of propriety, or Manet may, as he had with
other pictures, suddenly have become dissatisfied with the com-
position as a whole. Gone are the coy gestures of 1872. In 1873
Morisot gazes out less invitingly, more straightforwardly. She
appears completely self-possessed, her alert intelligence and sen-
sual beauty presented simply, without promises or reticence.
This is, among all Manet's portraits, the one Degas, Mallarmé,
and her daughter, Julie, judged the most like her, the one they
chose to use as the frontispiece of her posthumous exhibition
catalogue.

A Salon des Refusés opened in May 1873, but too late. By this
time the more rebellious painters wanted new institutions, not
insulting consolations. That same month, Monet announced to
the press that a group of painters planned to organize their own
independent exhibition. The list he gave of participants did not
include Morisot. Months went by. The project took shape slowly.
On December 27 a final list was drawn up. This list did include
Morisot.

How had Morisot joined, or even learned of the project, if she
could not attend organizational meetings at the Café Guerbois?
Degas had written an undated letter, not to her but to her
mother, asking if she would consider participating. Apparently
he had spoken to Morisot directly first, but specifically how or
when we do not know. He made abundantly clear his admiration
for her work. He had already recommended the exhibition to
her, he said, because it had "a scope realist enough so that no one
who is a realist can exempt himself. —And then, we think that
Miss Berthe Morisot's name and talent are too important to us
to do without." Allegations of Degas's misogyny to the contrary,
he also appealed to Edma via Mme Morisot: "I don't know if
Mme Pontillon is with you and if she would like to remember,
as regards the exhibition, that she was a painter like her sister
and could be again." Since he referred uneasily to Manet's objec-
tions to the exhibition and asked Mme Morisot to intercede with
her daughter on the Impressionists' behalf, Manet must have
been lobbying Morisot against the exhibition, and Degas felt he
had to counteract his possible influence.

Part of Degas's crucial letter has unfortunately been lost. But
the most important thing about what remains of the letter may

be what it does not say. It does not even mention her sex, as if it simply wasn't an issue. Equally eloquent is the silence on this subject of all the other Impressionists, not only in the effervescent beginnings of the movement but throughout its history. As Degas put it, the issue to them was Morisot's talent and reputation as an artist; he refers vaguely to a "we" who valued her work.

Compare, for example, Degas's attitude to Puvis de Chavannes's. In his note, Degas simply said that Morisot's work was good and therefore she should launch herself into a future that would do her justice. Meanwhile Puvis, though he believed himself entirely sympathetic with Morisot's aims, found endless reasons why she should be content with the way things were. His letter of April 7 arrived shortly after the Salon jury had turned down Morisot's oil paintings.

Puvis was tremendously successful in an academic way, but he was liberal enough to deplore the rigors of that year's Salon jury. "Civil War," he called it, "a stupid war if there ever was one." But basically he did not question the Academy's strength: "Unfortunately you don't have the heavy artillery on your side." He urged patience rather than rebellion, alleging that "the great exhibition is the only real door." He was fundamentally afraid of difference: "With a public like ours one mustn't single oneself out, one must do as others do." She should stay aloof from the independent exhibition. The only way to succeed was on the Academy's terms—and his.

Puvis did not subscribe so completely to Academy standards that he condoned its treatment of Manet. Manet, however, did not purport to overthrow the Academy; on the contrary, Manet like Puvis opposed an independent exhibition. Puvis said he approved of the exhibition in principle but had "a few reservations." In fact, he had objections to everything about it: the location, the timing, and the admission fee, not to mention its underlying principle of independence.

He supported Morisot's work, blaming the jury's rejection of her oils entirely on their association with Manet's work. But at the same time he assumed that her case should be compared with Marcello's and with Eva Gonzalès's, making exactly the assumption that Degas had not, which was that art by women was women's art. The fond but sententious condescension of his

conclusion diminished her as much as it encouraged her. "I won't insult you with commiseration; resume your studies with tranquillity, and onward. Next year it will be as if nothing happened. Goodbye, dear mademoiselle, write me a note to tell me if you are calm. Devotedly."

Puvis was undeniably devoted. At this point in her career Morisot needed the bracing invitation of the Impressionists much more than the solicitous and self-conscious advice of Puvis or even Édouard Manet. Of course, Puvis and Manet, who knew Morisot well and belonged to her social milieu, would have been acutely aware of the personal risks the independent exhibition entailed. It is possible that, of the Impressionists, only Degas knew Morisot personally before the spring of 1874. Monet, Pissarro, Renoir, Cézanne, and Sisley may have been swayed exclusively by the paintings that had been shown at the Salon or in shops. Pissarro might also have heard of Morisot professionally through their mutual teacher, Corot. The records tell us frustratingly little. But even if the Impressionists had known her personally, they were so wrapped up in what then seemed like a fresh and heroic artistic struggle that they might not have had time for the delicacies of Morisot's feminine scruples. They had little to lose by exhibiting independently and could assume she felt the same way.

Then on January 24, 1874, Tiburce Morisot senior died. He had been suffering from heart disease for several years. Morisot had never been very close to him, but she went into mourning, and felt a sorrow recorded in another Manet portrait, *Berthe Morisot in a Mourning Hat.* He dramatically contrasted her waxen pallor to her mourning veil and dress with broad swaths of light and dark. Manet rarely used paint so freely, so expressionistically; no other picture of his leaves such an intense impression of a woman's inner emotion.

Morisot grieved, yet her father's death must also have relieved her. By custom, the last unmarried daughter of a nineteenth-century family assumed responsibility for the full-time care of her parents. Many an example could be cited of daughters who spent the better part of their adult lives caring for aging mothers or fathers. Edme Tiburce Morisot's death left his daughter freer

to pursue her own interests. She could, for instance, worry less about adverse publicity surrounding the forthcoming exhibition.

In January three leading journals published the charter of a newly formed Société Anonyme Coopérative. Sixty francs a year bought an artist the right to exhibit and a share of the profits. Anyone could join. Preparations continued as more artists were recruited. Morisot remained discreet about her role. Or else she and Puvis were quite estranged, for he wrote her about the exhibition on April 7, only eight days before it opened, as if her participation were still an open question. At that point her oil paintings had been rejected only recently by the Salon jury, while the fate of her watercolors had not yet been announced. These dates indicate that Morisot almost certainly agreed to join the Société Anonyme as a free choice and not because she knew she had no place else to exhibit.

The first Impressionist Exhibition opened on April 15 at 35 boulevard des Capucines. The building, on a busy commercial and tourist avenue, belonged to Nadar, the eminent photographer. More than two hundred works hung on reddish-brown walls, in places decided by canvas size and within size categories by lot. The pictures were arranged in only one or two rows, as opposed to the floor-to-ceiling Salon mode, "which makes connoisseurs' appraisal easier," noted one critic approvingly. Two hundred people came the first day, about half that number each day after, adding up to approximately 3,500 by May 15, closing day—a respectable attendance figure. The exhibitors put equally respectable prices on their work. Pissarro and Monet asked one thousand francs for each of their pictures, and Morisot asked eight hundred for *The Cradle*.

The mixed if not hostile response to the exhibition has passed into legend. Less well known is the fact that while many critics loathed the style dubbed "Impressionist" by their colleague Louis Leroy, virtually all of them applauded the project as an administrative and economic enterprise. Léon de Lora, for instance, described the reason to buy in material terms:

> The public, visiting the galleries on the boulevard des Capucines, will be tempted to make some purchases directly from corporation members: for the painter forgoes ten per-

cent of the sale price, which contributes toward an increase in the organization's capital.[4]

Press coverage was excellent as far as quantity went. And as Oscar Wilde later quipped: "There is only one thing worse than being talked about—not being talked about." Besides approval of the exhibition as an organization, the critics dwelt perceptively on another theme worth emphasizing here. From the very start, virtually all the critics effected a draconian triage among the exhibitors. In order to boost the Société Anonyme's budget and produce a broader and more reassuring roster, the founders had assembled a total of thirty artists. No one was fooled. The critics immediately homed in on the group's essential members. Morisot was among them. Castagnary mocked conservatives' horror of "these terrible revolutionaries, so monstrous and subversive of the social order":

> These are four young men and a woman who for five or six years made the jury tremble! Barring their path for all that time, the jury became more and more ridiculous, compromising itself so much before the public that there is hardly a man in France who dares speak in its favor.[5]

To no woman artist had such power ever before been ascribed, even in jest. One reason Impressionism was perceived as being so radical was undoubtedly that it included a woman, the caliber of whose work made her impossible to ignore. The press assigned Morisot a place at the forefront of the Impressionist movement. Whether all the exhibitors had intended her to occupy this prominent position is unclear. After the first exhibition it was a fait accompli.

Of all conservative reactions against the exhibition, one of the most droll came as a letter from Morisot's old teacher Guichard to Mme Morisot.

> By examining, by conscientiously analyzing, admittedly, one finds excellent passages here and there, but all are more or less mentally cross-eyed . . . how can one expose an artistic delicacy as exquisite as hers to being almost elbowed by *The Bachelor's Dream* [one of Cézanne's blunter early paintings]? The two canvases almost touch each other.

That a young lady should destroy letters reminding her of a painful disappointment, I can understand, such ashes are justified, but to destroy all the efforts, all the aspirations of past dreams, that is madness! Indeed, it is almost impiety.

As painter friend and doctor, here is my prescription: go to the Louvre twice a week.

"Mlle Berthe," "this interesting artist," was no longer taking orders from "painter friends" or "doctors" or anyone else. She had entered the history of art in her own right.

II

Eugène Manet

1 8 7 4

> I'm reading Darwin; it's hardly subject matter for a woman,
> even less for an unmarried woman; what I do see clearly is
> that my situation is unbearable from every point of view.

So Morisot concluded in 1873. At the age of thirty-two, an
accomplished and notorious painter, she was still regarded as a
fille, an unmarried woman, for whom a book like Darwin's *On
the Origin of Species* constituted "unsuitable" reading. Pro-
scribed books and places, dangerous friendships, constant chap-
erones—as she matured and her career blossomed, the con-
straints of her situation began to weigh heavily against the
advantages of staying single.

Meanwhile Eugène Manet's appeal grew. Cornélie Morisot's
objections to him remained the same. He had inherited enough

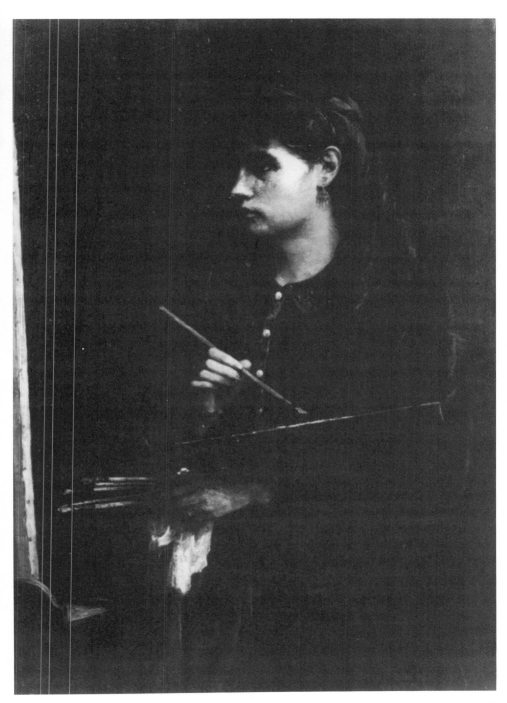

Edma Morisot, *Portrait of Berthe Morisot*, 1865–68. Oil on canvas. *(private collection; courtesy of Galerie Hopkins Thomas, Paris)*

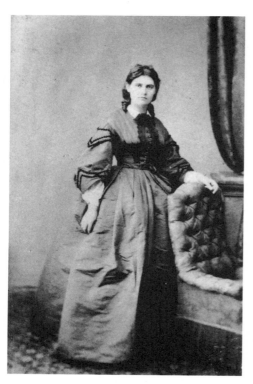

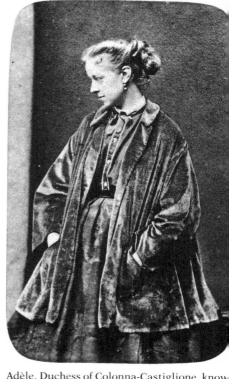

Berthe Morisot, about 1858–60. *(private collection)*

Adèle, Duchess of Colonna-Castiglione, known as Marcello. *(Fribourg, Musée d'Art et d'Histoire)*

Camille Corot in the Forest of Fontainebleau, about 1862. *(Paris, Collection Gérard Lévy)*

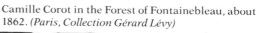

Georges Ardant du Masjambost, *Portrait of Edme Tiburce Morisot*, 1848. Oil on canvas. *(Limoges, Musée Municipal de l'Evêché)*

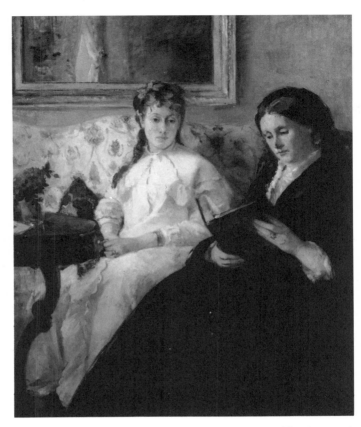

Berthe Morisot, *Portraits of Edma Morisot Pontillon and Cornélie Thomas Morisot* (the sister and mother of the artist), 1869–70. Oil on canvas. *(Washington, D.C., National Gallery of Art)*

Edgar Degas, *Portrait of Madame Théodore Gobillard* (Edma Morisot Gobillard), 1869–70. Oil on canvas. *(New York, The Metropolitan Museum of Art. Bequest of Mrs. H. O. Havemeyer, 1920. **The H. O. Havemeyer Collection. [29.100.45]])*

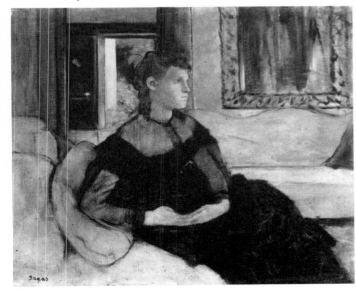

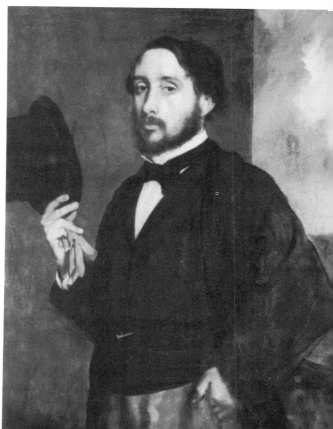

Edgar Degas, *Self-Portrait*, 1863.
Oil on canvas. *(Paris, Musée
Carnavalet/Edimedia)*

Pierre Puvis de Chavannes, *Self-Portrait* (detail), 1857–58. Oil on
canvas. *(Paris, Musée du Petit Palais)*

Édouard Manet, *Madame Manet at the
Piano* (Suzanne Leenhoff Manet), 1867–68.
Oil on canvas. *(Paris, Musée d'Orsay)*

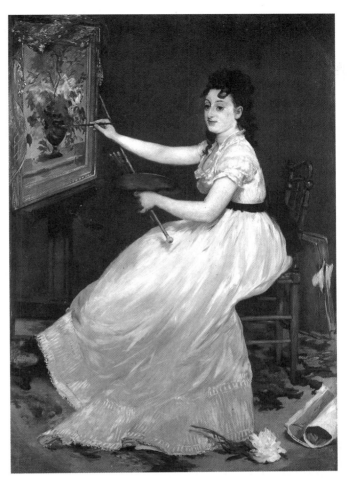

Édouard Manet, *Portrait of Éva Gonzalès*, 1870. Oil on canvas.
(London, National Gallery)

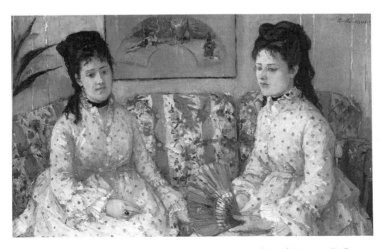

Berthe Morisot, *The Sisters*, 1869. Oil on canvas. *(Washington, D.C.,
National Gallery of Art)* Probably a portrait of Edma Morisot on the
left and a self-portrait on the right.

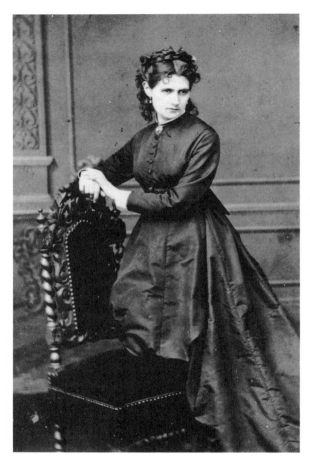

Berthe Morisot, about 1868–69.
(private collection)

Gustave Manet. *(private collection)*

Henri Fantin-Latour, *The Batignolles Studio*, 1870. Oil on
canvas. *(Paris, Musée d'Orsay)*

Édouard Manet, *The Balcony*, 1869–69. Oil on canvas. *(Paris, Musée d'Orsay)*

Berthe Morisot, *Eugène Manet and his Daughter in the Garden,* 1883. Oil on canvas. *(private collection)*

Berthe Morisot, *Eugène Manet on the Isle of Wight,* 1875. Oil on canvas. *(private collection)*

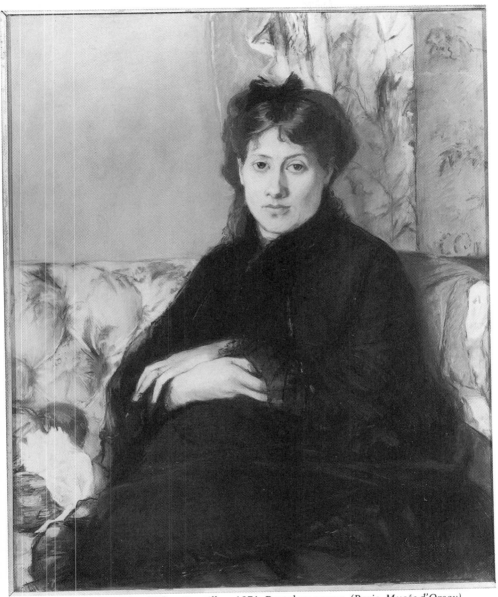

Berthe Morisot, *Portrait of Edma Pontillon*, 1871. Pastel on paper. *(Paris, Musée d'Orsay)*

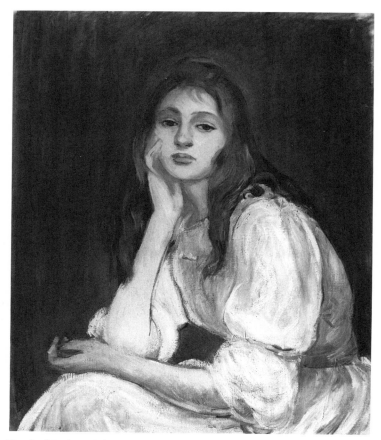

Berthe Morisot, *Julie Dreaming*, 1894. Oil on canvas. *(private collection)*

Berthe Morisot, *The Piano*, 1888. Pastel on paper. *(private collection)*

Édouard Manet, *Berthe Morisot with a Fan*, 1872. Oil on canvas. *(Paris, Musée d'Orsay)*

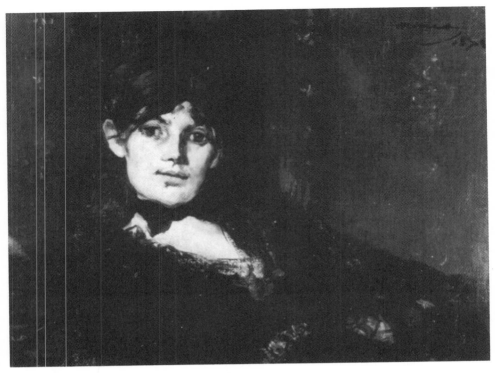

Édouard Manet, *Berthe Morisot Reclining*, 1873. Oil on canvas. *(private collection)*

Édouard Manet, *Berthe Morisot in a Mourning Hat*, 1874. Oil on canvas. *(Zurich, private collection)*

Édouard Manet, *Berthe Morisot in Three-Quarters View*, 1874. *(Zurich, private collection)*

Edgar Degas, *Portrait of Eugène Manet*, 1874. Oil on canvas. *(private collection)*

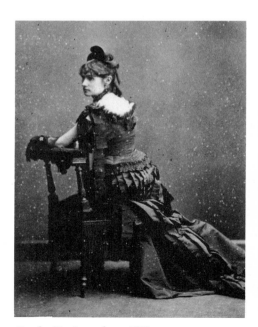

Berthe Morisot, about 1875.

Eugène Manet, Julie Manet, and Berthe Morisot at Bougival in 1882. *(private collection)*

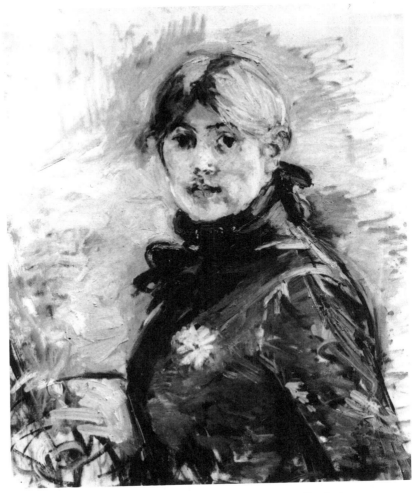

Berthe Morisot, *Self-Portrait*, 1885. Oil on canvas. *(private collection)*

Berthe Morisot's home from 1852 to 1873, rue Franklin, Paris.

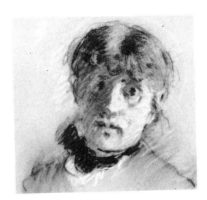

Berthe Morisot, *Self-Portrait*, 1885. Pastel on blue laid paper. *(47.5 x 37.5 cm, Regenstein Collection, 1965.685 © 1989 The Art Institute of Chicago)*

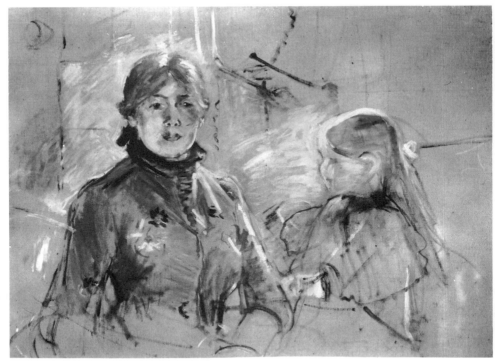

Berthe Morisot, *Self-Portrait with Julie Manet*, 1885. Oil on canvas. *(private collection, photo Bernheim-Jeune)*

Berthe Morisot, *Portrait of Paule Gobillard* (detail), 1880–84. Oil on canvas. *(private collection)*

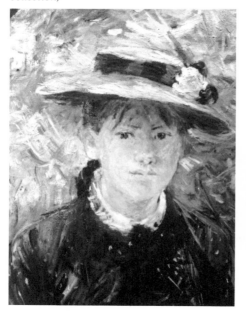

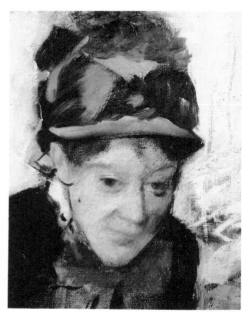

Edgar Degas, *Portrait of Mary Cassatt* (detail), 1880–84. Oil on canvas. *(Washington, D.C., National Portrait Gallery, Smithsonian Institution)*

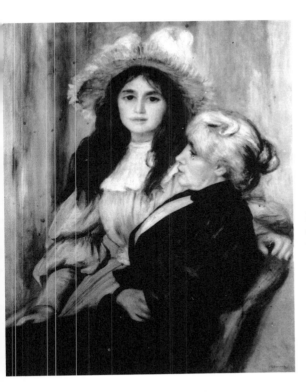

Pierre-August Renoir, *Portraits of Julie Manet and Berthe Morisot*, around 1893. Oil on canvas. *(private collection; courtesy of Galerie Hopkins Thomas, Paris)*

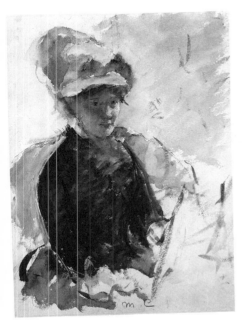

Mary Cassatt, *Self-Portrait*, c. 1880. Watercolor on paper. *(Washington, D.C., National Portrait Gallery, Smithsonian Institution)*

Berthe Morisot at the Château de Vassé in 1892, after the death of Eugène Manet.

Berthe Morisot, about 1893. *(private collection)*

money to live comfortably without earning an income, but she perceived his unwillingness to pursue a career as a moral failing, as well as an alarming indication of too high-strung a temperament or ill health. Mme Morisot felt more strongly about the issue of health than was quite reasonable, for she had just spent the past few years caring for Tiburce Morisot and was trying to ensure that her daughter's later years would not be burdened by the same task.

Few descriptions of Eugène by anyone outside his family have come down to us. He was by all accounts an exceedingly private man, who hated the sort of publicity his two brothers basked in. Henri de Régnier, poet and frequent guest of Morisot and Eugène Manet, was to write later:

> Eugène Manet, Berthe Morisot's husband, was not unlike his brother Édouard. He was a courteous and cultivated man, but visibly high-strung. Like his wife, he was reserved and willingly self-effacing.[1]

Always described as Morisot's husband or Édouard Manet's brother, Eugène deserves better. Throughout his adult life he sustained his gifted family and friends both morally and materially. He had the insight to recognize their talents, the generosity to advance their projects, the forbearance to tolerate their quirky if not exacting personalities, and the discretion to play his role in their shadows. Without such a friend, how many talents falter or atrophy?

Eugène Manet had durable qualities. He was much less flashy than his brother Édouard, both intellectually and physically. In her day-to-day life, however, Morisot needed steady support much more. Sexual excitement alone does not sustain a marriage long and might even have been confusing or frightening to a nineteenth-century woman trained to avoid it. Rather than confronting her with his own needs and achievements, Eugène gave Morisot a more neutral foundation on which they could build a life together and on which her professional life could depend.

He proved his qualities in the early months of 1874. By this time he had known Degas well for several years. When Édouard Manet and Degas parted ways over the Impressionist Exhibition

project, Eugène sided with Degas against his brother, just as Morisot had. Or was Eugène Manet siding with Morisot? The earliest written evidence we have of Eugène Manet's attitude to Morisot's painting dates from the summer of 1874. At that point, clearly, he appreciated the value of her work. Whether the exhibition convinced him, or he had recognized her talent earlier, what mattered in the spring of 1874 was that he supported her work in spite of the uproar over the exhibition. She had publicly joined a radical art movement; her work had suffered the ridicule of the press; she had made, in conventional terms, a "spectacle of herself."

Impressionism had few supporters. Women artists had few supporters. But here was a man whose loyalty did not falter, whose esteem did not dwindle. Nor did he act out of ignorance or blind devotion. He too painted, in an amateur way, sketching sprightly modern figures in pastel or watercolor. He knew enough to criticize constructively. Back in the late 1860s, Morisot had believed Fantin-Latour's compliments because he also pointed out flaws. Apparently she felt the same way about Eugène Manet's judgment. Because he could be severe, she believed him when he admired.

What appealed to him in her? The answer seems obvious today: her talent, her accomplishments, her intelligence, and her beauty. But in Morisot's time the first two traits were considered liabilities; marriage to a professional woman, especially one who claimed to have artistic gifts, doomed a man to neglect and mockery. Eugène, apparently, saw things differently. His novel *Victims!* gives us an indication of his priorities.

Victims!, though written in 1889 and ostensibly fictional, is transparently autobiographical in many respects. Its plot and characters bear little circumstantial resemblance to Eugène Manet or his life, but myriad details do. Most glaringly, the hero is called Eugène. A first-person narrator repeatedly interjects his opinions.

Eugène Mallot, whose beard is fine and blond (Eugène and Édouard both had fine blond beards), goes from one heroic sacrifice for the Republic to another. He shares his political convictions with his father and his brother, Numa. His emotional support comes from the women in his life: his mother and his

fiancée. Lengthy passages describe their feminine virtues: beauty, patience, altruism, modesty, and so on. But the story takes an unexpected twist when it comes to the heroine's intellectual and political character.

Jeanne had been raised by an extraordinary man: "he had neglected nothing to make his daughter a strong woman, immune to the thousand weaknesses of her sex."[2] Jeanne grows up to be a determined and independent adult. Placed after her father's death under the tutelage of an odiously royalist aunt and uncle, she bravely maintains her republican convictions despite avuncular threats. She remains an "independent mind" who resists "generally accepted ideas."[3] Along with her political opinions goes her agnosticism; Catholicism is, for her, a form of superstition and the Church an oppressive institution founded on hypocrisy. Jeanne plays the piano brilliantly. At her instrument, her "dark eyes filled with liquid flame had a look of ineffable tenderness."[4] Jeanne also has the temerity to make a cross-class engagement, the loyalty to stay faithful to Eugène through years of separation, and the courage to join her lover in the South American jungle. (Alas, he dies almost immediately—in her arms—from tortures suffered on Napoleon's hellish penal colony, Devil's Island. She takes poison given to her by a kindly native. They expire together, he murmuring "Jeanne . . . Liberty . . . France" and she "Eugène . . . France.")

Clearly Eugène Manet had a romantic side to him. But aside from his literary purple streak, he keenly appreciated delicate taste. Garish interiors, clothing, or scenery pained him. In *Victims!* he describes Jeanne's room: "furnished simply, but with the exquisite taste that characterized everything the young woman did."[5] Elsewhere Eugène wrote approvingly of "the cult of woman," by which he meant a veneration of women whose charm resided in their refinement. He contrasted "graceful vision" and "that perfume of feminine mystery as gentle as a secret," with brazen seduction: "some women leave behind them a trail like an animal's musk." In Berthe Morisot he found a woman who united the qualities he valued most highly: strength of character, courage, elegance of person.

For three years Morisot and Eugène Manet had been drawing closer. The denouement came in the summer of 1874. Their

families were vacationing together at Fécamp in Normandy. One day, Morisot and Manet were painting side by side near a naval construction site. By the end of the painting session they had agreed to marry.

Family tradition holds that Édouard Manet made one last portrait of Morisot after her engagement or shortly after her marriage. She sits on a sofa, her face turned three quarters to the side, and with an arching gesture she holds open a fan. Prominently placed near the center of the image is a gold band on her finger. Morisot had been wearing such a ring for years, but Manet's attention to the ring, a device he used in several other pictures of wives, may indicate his acknowledgment of her new marital status.

Not to be outdone, Degas also gave the couple a commemorative portrait, for once of Eugène. Degas shows him sitting in a landscape, long legs outstretched, his face thoughtfully inclined. A certain disjuncture between figure and landscape corroborates the theory that Degas painted the two parts of the picture separately, perhaps adding the landscape as a kind of souvenir of the place where Morisot and Manet had settled their relationship.

Morisot did not immediately transform her life. After Fécamp she went off as planned to Maurecourt to spend time with Edma and her family. Eugène wrote her charmingly whimsical letters, skipping lightly from one subject to the next, inaugurating terms of endearment and gossiping about the art world they both moved in.

> Did you know that Durand-Ruel has sold 180,000 francs' worth of painting? To anyone wise enough to take note, greetings. Greetings too to the lovely painter. . . .
>
> How I miss Fécamp and the pretty walks we took. There at least we were always sure to meet. I've run all over Paris today and didn't so much as catch a glimpse of the little shoe with the rosette that I know so well.
>
> Paris abounds with painting but of the worst sort. . . . Your pictures would be very successful. I wouldn't mind though if you complimented me a little on my painting. Someday I'll show you some sketches that, I hope, will raise me in your esteem. . . .
>
> When will I be able to see you again? I'm down to exiguous rations after having been spoiled. From now on I'll use

paper that will allow me to write at greater length. This small format bears no relation whatsoever to my feelings. . . .

Eugène addressed his next letter to "Thonjoun"—Turkish, he claimed, for "my lamb." He was immensely pleased with Morisot's much-awaited reply, "a letter of compliments without periods or commas; truly, it's enough to make a man more robust than I lose his breath." He vowed in return to make her "the most adored, the most cherished woman on earth." He could be patient for fifteen hundred years, he assured her, if only he could see her "at least once a week." In fact, there were less than six months to wait.

Morisot and Manet married on December 22, 1874. She was thirty-three years old. Following French custom, a civil ceremony took place at the *mairie* and a religious one at the local church, Notre Dame de Grâce in Passy.

Morisot described her wedding with her usual self-deprecation in a letter to her brother Tiburce: "I went through this ceremony without the least pomp, in a plain dress and hat, like the old woman that I am and with no guests." It was characteristic of both bride and groom to shun ostentatious celebration. Also, thirty-three was, it is true, an unusually advanced age for a woman's first marriage, and the couple shared a skepticism concerning religious sacraments. Manet was deeply anticlerical. Morisot, raised religiously, had become completely agnostic by the end of her life. How Catholic she felt in 1874 we do not know; in any event, to have forgone a religious ceremony altogether would have been a melodramatic social gesture and an affront to her family. The Manets and Morisots joined in the celebration. Thiers was not a witness at this daughter's wedding. He was replaced by Morisot's uncle on the Thomas (maternal) side and by Edma's husband, Adolphe Pontillon. Eugène Manet's trusted cousin Paul-Albert Bartholomé de Jouy spoke for him, along with his brother Édouard. On the church register, Eugène described himself as a "man of property." Morisot wrote "no profession."

She wrote to Tiburce at the end of January 1875:

> I've found an honest and excellent young man who, I believe, sincerely loves me. I've entered into the positive side of life after having lived for a long time by chimeras.

IV

ALLIANCE

1875-1878

12

Artistic Events

Do you remember an exhibition that took place on the boulevard des Capucines, on the old premises of Nadar-the-Great? There schismatic painters raised a new altar against the old and undertook a struggle against the Salon. The struggle was not successful. Nonetheless four of these bold folk (one a woman) have organized an auction at the Hôtel Drouot [France's most important auction house]. This new school is called the School of Impressionism.[1]

Le Charivari paid this flattering attention to the group's newest endeavor. Lest anyone believe their exhibition to have been a random gesture, four among the most adamant of the Impressionists came back before the public within a year. Monet, Morisot, Renoir, and Sisley put about seventy paintings up for sale at Drouot. Hardly had Morisot married—"Have I been married for

123

a month already, it's strange, isn't it?"—than she plunged back into the artistic fray.

Financial need helped motivate Monet, Renoir, and Sisley, though the price a painting commanded on the market was so tightly linked to its reputation that the publicity value of a sale at Drouot might be worth as much as the sale itself. For Morisot, who did not need extra cash, the auction sealed her allegiance to the Impressionist movement. Merely displaying her work with a group could have been explained away as an amateur's eccentricity. To commit her work to the marketplace in as blatant a manner as the auction block meant business.

The private viewing opened March 22, 1875. A public viewing followed the next day. The day after that the sale began. So did the hue and cry. A crowd had gathered. The bids were absurdly low, the catcalls offensively loud. Tempers flared. Jean Renoir later claimed that a cry of "Shameless hussy!" was directed at Morisot. Jean Renoir's stories about Impressionism are more colorful than reliable, but this one provides the only evidence we have that Morisot was present at the sale. If so, she witnessed the indignities suffered by her colleagues. Bids for their work came in disastrously low. Her own twelve pictures sold fairly well, mostly to friends and family. One of her oils, the small but luminous *Interior,* fetched the day's highest price: 480 francs. A pastel, *On the Grass,* despite its informal medium, garnered the next-best sum: 320 francs. Hoschedé, a mercurial business magnate and early admirer of the Impressionist clan, bought *Interior;* Degas may have incited his friend Henri Rouart to purchase her oil *At the Seaside* as well as a watercolor; her cousin Gabriel Thomas bought a pastel; and Gustave Manet, in a fine show of in-law loyalty, bought two pictures.

So heated were emotions surrounding the sale that Pillet, the auctioneer, afterward received spirited mail both for and against it. One anonymous letter charged him with vending "monstrosities," while the critic Arsène Houssaye declaimed: "Bold moves in art should always be encouraged when they are founded on sincerity and when they are illuminating."

Morisot's old friends and family did not so much see her casting away the shadows as fiercely estranged from the ordinary. Puvis de Chavannes wrote wistfully after the closing of the 1875

Salon, "where I didn't meet you once—it's really too much—of course as an intransigeant you had no reason to idle in the philistine camp." Mme Morisot recommended that Berthe go to England, on the grounds that there "eccentricity" was tolerated. But she did dutifully read the Zola novel her daughter recommended, hoping to find a literary analogy to Morisot's style. She soon gave up and wrote Berthe that "your M. Zola" weighed on her stomach like a heavy rock: "No, definitely, I don't belong to the new school yet!" And she concluded:

> I'm so happy at my little Bertat's success; the dear child is saved by the very delicacy of her character and because she couldn't be vulgar, but I do sometimes deplore some of her admirations, which I absolutely cannot understand.

Morisot's relationship with her mother had entered a last and happy phase. Now that her daughter was safely married, Cornélie Morisot could accept her painting even if she did not understand its artistic intentions. Her letters ceased nagging and instead alternated between congratulations and supportive suggestions for adjusting to married life and to her in-laws. In January 1875 she wrote: "Congratulations on your successes and especially on the contentment you seem to feel in your new life." In February she counseled her daughter to enjoy her youth, to combat her "sensitivity" and "melancholy," and to dress up and please others in order to please her husband: "Such is my prescription." Classic advice. Cornélie had always played the sensible, sturdy role, attributing her imperturbable good sense to her Thomas ancestry, contrasting it with a Morisot moodiness and sensitivity, most acute in Berthe.

Meanwhile Berthe wrote to Tiburce that the only flaw in her married life was her concern for their mother. Had she done the right thing? Was her mother lonely? Mme Morisot provided an answer herself in another February letter:

> All the hardships we suffered together, my poor child, strengthen the already strong bonds between mother and daughter. That's what I feel about you and it's with all my heart, I promise you, that I'm ready to feel as warmly about your husband since, from now on, he's a part of you and must come first in your affection.

Mme Morisot wrote these letters from the provinces. She had given her rue Guichard apartment to the new couple and was visiting relatives. Morisot took advantage of being in Paris during the first months of the year and of her marriage to begin new friendships and shore up old ones. She went on visiting Édouard Manet's studio, which, like many artists', was open to anyone, even while he worked. Friends came to meet casually, exchange banter, or watch Manet in action. He strolled around as he worked, as witty and quick verbally as he was artistically.

It was probably there, perhaps as early as 1874 but no later than 1876, that Morisot met Stéphane Mallarmé, who dropped by frequently after his workday. Although he was slowly becoming recognized as one of Europe's great poets, he still made his living teaching English in an ordinary public high school. Mallarmé once said of his life that it was without anecdote. Very much like Morisot, he had chosen to live a quiet, middle-class personal life in order to devote all his energies to poetry. Manet had captured on canvas the tenor of Mallarmé's imaginative gift, just as he had conveyed something elusive about Morisot. Manet pictured Mallarmé sitting by a table on which a book lies open. At first the poet's pose seems diffident, his gaze turned shyly away from ours. But then, following his gaze, we realize how very firm his gesture is. His fingers, rigorously aligned along the book's edges, hold a cigar, whose smoke seems to emanate from the blank pages as if they were somehow, impossibly, invisibly, on fire. If Édouard Manet would always both attract and annoy Morisot because he was temperamentally so much her opposite, in Mallarmé she had met her like. They shared the same extremely refined and reserved manner that hid an implacable will.

Marcello also attended Manet's studio sessions around this time. Perhaps it was there, inspired by Manet's portraits of Morisot, that she decided to do one also. Marcello remained torn between her admiration for Morisot's beauty, elegance, and talent on the one hand and her own prejudices on the other. Much of Marcello's frustration in life came from her inability to reconcile her intellectual judgment and her social prejudices. She found artists too uncouth, socialites too uncultured. Always dis-

satisfied, she shuttled between two worlds, dissipating her energies to no avail. Morisot had made the sorts of compromises Marcello disdained: she had accepted the bonds of marriage and had relinquished the honors of the Salon. In so doing, she had gained what Marcello had failed to achieve by 1875: personal security and a professional vocation whose prestige increased rather than diminished with the years. But could Morisot have made her choices with such unerring wisdom if she had not had Marcello's example to learn from?

Marcello perceived, through Morisot, where painting was headed. In a letter to Morisot in January 1876, she sent regards to Manet, Degas, and Desboutins, a friend of the Impressionists who posed for Manet and that year would etch Morisot's portrait as part of a series on contemporary artists. In the same letter she wrote supportively and perceptively: "my very dear Berthe, I hope you're working, and producing those paintings so true in their effects that they seem to be a window open onto nature."

Yet when Manet had asked Marcello to pose for him in 1875, she refused. As she wrote to her mother on January 23: "Manet asked to do my portrait for exhibition. I replied that I already had so many enemies I didn't want to add his to mine. He seemed shocked by this."[2]

For her to paint Morisot's portrait seemed less dangerous. In 1873 she had made a small watercolor portrait of her friend. She worked on two drawings the next year and finally, in the first weeks of 1875, on what she hoped would be a definitive oil portrait. The result looks rather unlike Manet's portraits and unlike a series of photographs taken of Morisot at the same time. Marcello kept one of these in her collection. Dressed in a black evening gown, Morisot sits with her back to the viewer, her face turned back toward us, giving us the strong-jawed profile so familiar from Manet's images. In Marcello's portrait, Morisot also wears evening dress, a plain but uncharacteristically pink gown, yet unlike Manet, Marcello emphasized a conventionally feminine appearance, fleshy and yielding. Marcello showed the portrait to Bonnat, a finicky and immensely successful portraitist who was then giving her professional advice (and who, it turned out, had been for years a secret admirer of Morisot's

work); he judged Marcello's picture charming but unfinishable. She hoped nonetheless to submit it to the 1875 or 1876 Salon, but in the next months the two women were too often far from each other, and Morisot's portrait never reached the completion Marcello dreamed of.

13

A New Bond

After Marcello returned to her native Switzerland, Morisot spent her first weeks alone with Eugène at the Manet family's suburban house in Gennevilliers. There she painted the liminal places between city and country, showing houses, gardens, and laundry lines edged up against fields and forest. She went out of her way to meet local inhabitants, who remembered her favorably long afterward.

Morisot and Manet then spent the summer months in England, perching at Cowes, on the Isle of Wight, and visiting Ryde several times, before moving on to London. They both spoke English, though imperfectly. Much of their time was spent painting. They would set up their easels in their hotel rooms or in nearby fields (sometimes chased off by gaggles of curious children or irate proprietors). Morisot even convinced the recalci-

trant Manet to pose for her, looking out the window to amuse himself during the weary hours. Morisot wrote to Edma: "I began something in the sitting room with Eugène; poor Eugène is taking your place; but he's a much less accommodating model; he's quickly had enough."

Indeed, Manet was replacing Edma in many ways. He rarely posed for his wife again, but he did take Edma's role as companion on the rare occasions when Morisot felt the need to work outside her own garden or a local park. More fundamentally, during these months abroad, Morisot began to adjust to a shared life. She missed Edma's company: "You should write me a little. Cowes is very pretty, but not always fun; and I'm still not used to family life. Eugène is quieter than I am."

Devising acceptable compromises between the demands of work and those of feminine elegance became more imperative around Eugène, and it was not always easy to sacrifice one to the other in deference to his priorities.

> I've worked a bit, but what rain all week! Today we went to Ryde; I set off with my bag, my portfolio, determined to do a watercolor on the spot, but once I got there, a terrible wind, my hat blown off, my hair in my eyes; Eugène in a bad mood as always when my hair is disheveled; finally, three hours after setting out, we were back again at Globe Cottage.

Minor concessions had to be made, but on larger issues husband and wife agreed effortlessly. Her governess, Louisa, had given Morisot a strong case of anglophilia (a common condition among Parisians at the time). She imagined English life idealistically, and English art as well. Like many French artists, she may have been deeply impressed by Bonington's watercolors and Constable's technique, which, like Corot's, seemed to the Impressionist generation to be even more striking in his studies than in his finished works. She hoped to find an English audience receptive to her watercolors and her images of contemporary life. To market her pictures she needed letters of introduction, which, at Eugène's behest, she obtained from Marcello, who was, after all, a duchess. For a time Morisot and Manet were enchanted by the spectacle of aristocratic high life—what she called "la Fash-

ion"—even if only as onlookers, and Morisot admitted to Edma she was spending too much money. In London the new couple did pay some calls. They saw Tissot several times, Tissot "who does some very pretty things which he sells quite well and who is set up like a prince."

On the whole, though, both Manet and Morisot realized they cared much less for gallivanting than they had thought. Often they rose late and spent part of the day in their boardinghouse. Manet much preferred boating on the Thames to courting prominent personalities. Most of their outings were to museums, especially to the National Gallery, where Morisot admired Turner ("Whistler whom we so much admired imitates him enormously"), Gainsborough, Hogarth, and Wilkie. Contemporary English watercolors were not what Morisot had imagined. She pronounced patriotically:

> In Ryde there are lots of shops, even a picture dealer . . . abominable stuff. No feeling for nature; these people who live on the water can't even see it; it makes me shed some illusions about the possibility of success in England. The only decent thing, rather pretty even, in the whole shop was by a Frenchman; but that kind of thing doesn't sell, says the dealer.

Inevitably, as Morisot and Manet cleaved to each other, previous bonds weakened. Their primary loyalties had been, on each side, to their siblings and parents. Eugène's mother complained of filial neglect. On the Morisot side, by June 9, when Berthe was in Gennevilliers, it was Edma's turn to complain:

> What are you up to, my dear Berthe, not a word from you, not a visit for almost a fortnight now. It's as though you were alienating yourself from me. . . . I'd like to know how you are and not live as if we were a hundred leagues apart from each other.

Throughout the spring, summer, and early fall, Morisot and her mother exchanged frequent letters. Tiburce was squandering his money and generally dissipating himself. Mme Morisot had been left in charge of marketing Morisot's Gennevilliers pictures, which she tried valiantly but unsuccessfully to sell through

dealers: "Nothing new if not the increasingly marked bad will of dealers to help you." While some clients raved but didn't buy, others said the canvases would have been better left blank.

Mme Morisot fussed about Eugène's career. As their friend Duret put it, Morisot and Manet were "each rich on their own" and "found themselves as a couple on a brilliant financial footing."[1] Mme Morisot nonetheless continued to ferret about for possible jobs, none of which Manet ever seriously pursued, partly because they involved moving away from Paris. As Marcello wrote the next winter:

> What, I won't be able to finish your portrait, and you seem always about to leave for some other place in the world where I'll never be able to see you again! But people are quite right to say that one shouldn't anticipate misfortune in advance; for the moment you adorn Paris with your fascinating grace, and I believe you'll stay there, for it's your true environment. The rest of the world is merely provincial, I assure you.

Mme Morisot, ever reasonable, conceded in a letter written August 28, 1875, that only a really good job would be worth a major move, that Eugène was "too honest" to make a fortune abroad anyway, and that both husband's and wife's health would suffer from foreign climates. Morisot's health problems were the same as before: a general frailty related to her eating difficulties. Manet suffered from severe headaches, the exact nature of which we do not know.

Morisot also confided to her mother anxieties about her in-laws. She had married Eugène, but once the match was determined, she had to contend with the entire Manet family. Morisot and Édouard Manet had always gotten along, even when they sparred; and Édouard had been very active—too active, Mme Morisot claimed—in promoting the Manet-Morisot marriage. Morisot's relationship with Gustave was always cordial. But Mme Manet, like many mothers-in-law, felt possessive about her sons and tried to retain some control over them even after their marriages. Suzanne Leenhoff had assiduously courted Mme Manet's favor. Morisot, who felt some contempt for her new sister-in-law, perhaps for this very reason, held much more

aloof. She had a career, which precluded a complete investment of herself in family affairs. Clearly Morisot's professional commitments were even harder for Mme Manet to accept than Leenhoff's past sexual dalliance. Unlike Leenhoff, however, Morisot refused to appease or compensate for any supposed liabilities.

Morisot reacted passively by letting Eugène's letters to his mother lapse and not writing much herself. Mme Manet commented acidly that Suzanne wrote to her every day when she was away from Paris. Mme Morisot tried to smooth ruffled feathers: "I was careful to say that your ink was more precious than your blood" and to point out that Eugène rarely wrote her. Mme Manet retorted "that it was more in the role of the woman to take up the pen." On July 20 Mme Morisot counseled her daughter to take another tack, advocating a politic acceleration of correspondence and reassuring Morisot that any ill will she sensed on the part of the Manet family would dwindle with time:

> I can't recommend too much, my dear child, or advise you too strongly, to put aside the misgivings you may have conceived against the entire family at the time of a marriage that I have to concede it was loath to accept, but I don't think Suzanne's marriage seemed any better to them and you can see the place she's made for herself among them.

Morisot's resentment of the Manets may have been a defensive reaction, against what she perceived as their hostility toward her intrusion into the family as well as their inadequate estimation of her husband's qualities. Mme Morisot responded that since Berthe loved her husband so much, she should try to be nice to his mother for his sake. She added placatingly on July 27: "I readily admit he's a cut above the rest of the family," and reassured her daughter on September 7 that her sister-in-law was no competition: "really, you're so superior to Suzanne that you shouldn't pay her any more heed than if her plump person were not of this world."

Back from England, Berthe joined Edma and Yves in Cambrai. Eugène Manet lamented from Paris: "I'm feeling very forlorn without you; I miss your pretty warbling, your pretty plumage very much." Who was a husband to interfere with the sisters'

reunion, Mme Morisot exclaimed on September 11. Unless, of course, she added, it was Berthe who missed Eugène.

> What! So you wouldn't enjoy the pleasure of your reunion and this rascal of a Eugène who talked about 3 weeks or a month should turn out to be so much like his dear brother Édouard? Unless it's you who can't do without him; if so, then I'm not complaining and all is for the best.

Morisot's family grumped indulgently, like her grandfather Thomas, who had said in late May: "As if the Manets were living on thin air, thoughts about the art of the future, and their pure love, I almost never see them and hardly ever hear from them!"

Morisot, meantime, was hoping for a child. So much so that for the only time in her life she referred in letters to her physical condition. Only a month after her wedding, she announced elliptically to her brother: "Since then I've been waiting on events and till now fortune hasn't favored us." She confided her desire to Marcello, who queried a year later: "Please tell me if there's been any addition to the family." To Edma she wrote explicitly in the summer of 1875:

> I'm horribly sad this evening, tired, nervous, in poor spirits and having had proof once again that the joys of maternity are not for me. Now that's a misfortune you wouldn't have reconciled yourself to and despite all my philosophy, there are days when I'm disposed to complain bitterly of fate's injustice.
>
> I'm working badly, which is no consolation.

Just as in 1872 Morisot had written: "I've really worked badly; I'm ashamed of what I'm bringing back in terms of both quality and quantity," in 1875 she claimed: "I'm not doing much and . . . the little I do seems awful." Throughout her life Morisot was her own worst advertiser. Had all her paintings somehow vanished, leaving only her letters and notebooks, we would assume she had spent a career sporadically producing a few crabbed works. Had all her writings disappeared, the 860-odd paintings she left behind would evoke an effortless stream of lyric sensibility. Neither impression would be accurate. In the discrepancies between her verbal and visual self-description we

can sense something of Morisot's intractable compulsion. On the one hand: full participation in the most advanced art movement of her time, and a level of sheer productivity respectable by any professional standards for someone dead at fifty-four who had destroyed most of what she made before the age of twenty-eight, let alone someone who fulfilled as many family and social obligations as Morisot. On the other: a relentless self-criticism. Driven ever onward by her own implacable will, impelled by her impossibly high standards, minimizing her achievements in order to exact from herself renewed efforts, Morisot could never rest.

Who would have guessed from her 1875 letters that she brought back from Gennevilliers and England masterpieces of observation and technique? Her pictures, so light-drenched, so sprightly, so cleverly composed, and so chromatically audacious, bear no resemblance to her accounts of them. Between their conception and their execution some catharsis had taken place on the canvas. The act of painting transformed Morisot's turbulent sensations into aesthetic order. Where there had been doubt there was a painterly touch unerringly descriptive despite its calligraphic flourish; where there had been somber disclaimer there was brilliant color.

While Morisot stayed in Cambrai, Eugène proudly promoted her work. He suggested that she send pictures to the Dudley Gallery in London and offered to take care of all the details, as well as obtain a second opinion:

> If you want I'll show them to Édouard. I'll order the frames. . . . You'll tell me what you want to do. . . .
>
> Master Poussin [a dealer] showed me your paintings yesterday, your Gennevilliers harvest, with much solemnity; he hasn't sold any, but he must have received a lot of praise, judging from the way he showed them to me. It was a great pleasure to see them again; they're really delightful and they seemed to me even better than before. . . .
>
> My letter was interrupted by a visit from the two mothers-in-law. I paraded all the paintings in front of them. Huge success. . . . I've been asked to pass on to you my mother's many compliments. . . . I must bring Édouard over to see them.

Dealers and mothers-in-law both fell under the pictures' sway. Eugène reported with some gloating that Édouard had decided to match the Impressionists by painting out-of-doors himself: "Not a drop of black; it seems as if Turner appeared to him in a dream." Or perhaps he had just been looking at his sister-in-law's work.

Eugène wrote his wife:

> My dear friend, your Sunday letter was very sweet, I hope you'll follow it up with others of the same ink. . . .
>
> . . . you're spoiling me, your letters are so affectionate and so kind. Don't measure my affection by the frequency or the length of mine.

And he hinted gently: "It seems to me you're taking a long vacation."

14

Impressionism Comes of Age

> Dear Madame, I don't know if you've been told that now is the time to send your pictures. We open Thursday morning, the 30th of this month; it's urgent therefore that you send them on Monday or Tuesday and that you come yourself if possible, to oversee your placement.

Degas wrote in April 1876 to Morisot as to someone fully aware of the opening at the end of the month but to someone who was not attending organizational meetings. The event was the second Impressionist Exhibition. Apparently, while all concerned assumed Morisot would participate, once again she acted from a feminine distance.

Her nineteen contributions were ready. The central committee had decided the exhibition would make more sense if, this

time, each artist grouped all her or his work together. Because Degas and Morisot were showing works both on paper and on canvas, however, they ended up dividing their pictures by media. Morisot's drawings, watercolors, and pastels hung in the first of the three rooms at 11 rue Le Peletier, while her oil paintings hung in the second room.

Among the new recruits was Gustave Caillebotte, a wealthy young man whose considerable artistic attainments had previously found no outlet. He strengthened Impressionism materially, for he generously brought to the movement his financial resources and his organizational stamina. His paintings were impressive as well, but confusing to critics. For while they clamped with grim realism onto scenes from contemporary life, they recalled Salon-style pictures in their massive dimensions and meticulous realism. Degas's draftsmanship could be as precise, and his subjects as little glamorous, but he also took many liberties with realism for expressive purposes and leavened his pictures with a dry wit. Caillebotte's work has a relentless quality about it; an eerie oppression emanates from his claustrophobic bourgeois interiors laden with looming objects and from the plunging perspectives that carve his pictorial spaces into tight canyons. Caillebotte himself brooded for years over an imagined imminent death, which caused him to prepare a superb legacy of Impressionist pictures for the French nation, with which he planned to force the doors of the Luxembourg Museum. The only core Impressionist's work he did not collect was Morisot's. On the other hand, when he made a will in November 1876, providing funds for an 1878 Impressionist Exhibition, he stipulated that Morisot be included, along with Cézanne, Degas, Monet, Pissarro, Renoir, and Sisley. For reasons unknown, he was the only active Impressionist Morisot did not cultivate socially. She virtually never mentions him in her correspondence or notebooks.

Critics were not fooled by the neutral title Second Exhibition of Messrs . . . , nor by the spacious premises (which in fact were Durand-Ruel's galleries), nor by the lavish gold frames. Inside those frames were more of the outrageous pictures they had seen two years before at Nadar's. Fewer people came to ogle, but the press reacted twice as much and twice as loudly as it had in 1874.

More positively in some cases, and in others more negatively.

One of the most rabid reviews came from the powerful critic for *Le Figaro*, Albert Wolff, who characterized the Impressionists as "five or six lunatics of which one is a woman." On Morisot in particular he had this to say:

> There's also a woman in the group, as in most notorious gangs; she's called Berthe Morisot and is curious to note. In her case, a feminine grace is maintained amid the outpourings of a delirious mind.[1]

Eugène Manet almost challenged Wolff to a duel.

Morisot did not protect herself from such attacks with anonymity. She showed her pictures under her own name. In 1874 she had been unmarried; the pictures she sold at the 1875 Drouot auction had been, for the most part, made while she was still unmarried. In 1876 her use of her maiden name became a conscious choice. She and her family alleged she signed her pictures "Berthe Morisot" to avoid possible confusion with her brother-in-law should she have signed herself "Berthe Manet." Her decision, however, had broader implications. She could have chosen a pseudonym, however transparent or androgynous, like her friend Adèle Colonna, who called herself Marcello. She could even have chosen a male pseudonym, like the writers Marie d'Agoult or Aurore Dupin, better known as Daniel Stern and George Sand. More than a signature, "Berthe Morisot" designated an independent sense of self based on work. Critics and contemporaries called her Berthe Morisot, even when they knew her married name and even in some personal contexts. Those who wished to show her respect both as a married woman and as an artist called her Mme Morisot. Friends close to both her and her husband called her Mme Manet. She herself often signed her letters with the ambiguous "Berthe M." After her death, her family paid tribute to her self-fashioned identity by inscribing on her gravestone "Berthe Morisot. Widow of Eugène Manet."

A feisty sense of independence emerges from a letter written about the 1876 exhibition. Morisot brazenly refers her correspondent, an aunt, to the description of herself as a lunatic, mocks the entire readership of the conservative *Figaro*, and

notes that Édouard Manet's deference to authority had won him nothing.

> If you read some of the Parisian newspapers, among others the *Figaro,* so beloved of the right-thinking public, you must have learned that I am part of a group of artists who opened a private exhibition, and you must also have seen what favor this exhibition enjoys in the eyes of these gentlemen. On the other hand, we have been praised in radical [i.e., left-wing republican] newspapers; but you don't read those! Well, people pay attention to us and we have so much self-esteem that we're all very pleased. My brother-in-law isn't with us. Speaking of success, he's just been rejected by the Salon; he takes his failure too with the greatest good humor.

News of the Impressionist Exhibition was spreading abroad. Zola reviewed the show for Russian readers in *Le Messager de l'Europe* and predicted:

> One cannot doubt that we are witnessing the birth of a new school. In this group a revolutionary ferment is revealed which will little by little win over the Academy of Beaux-Arts itself, and in twenty years will transform the Salon from which today the innovators are excluded. We can say that Manet, the first, set the example.[2]

Zola was wrong only inasmuch as Impressionism and its successors would not "win over" the Academy or "transform" the Salon; they would render them irrelevant. Zola himself became increasingly conservative on artistic issues, till finally he blurted out *L'Oeuvre,* a novel dedicated to, among other things, demonstrating that the painters of the new school were destined to impotence, suicide, and oblivion. Cézanne, Zola's childhood friend and one of the models for the antihero, politely congratulated him on the appearance of the book and never spoke to him again.

Meanwhile Impressionism gained two more important and informed champions: Edmond Duranty and Stéphane Mallarmé. Duranty's famous pamphlet "The New Painting: Concerning the Group of Artists Exhibiting in Durand-Ruel's Galleries" began as a review of the 1876 exhibition. Thirty-eight pages long,

printed at the author's expense in an edition of 750, "The New Painting" set out for the first time an Impressionist program. Some art historians believe Degas fed Duranty ideas as well as examples, though the Café Guerbois discussions might have sufficed. In any case, Duranty, unlike some hack journalists, knew his subject. He explained Impressionism's relationship to the realist tradition, a heritage at once invoked and superseded, as well as its positions on plein air painting, color notation, and especially contemporary subject matter.

> If from having been dark it becomes light, if from black it becomes white, if from depth it resurfaces, if from pliant it becomes taut, if from glossy it turns matte, and goes from chiaroscuro to Japanese paper, you've seen enough to learn there's a spirit here that has changed settings and a studio that has opened itself to the light of the street.[3]

In September a second manifesto appeared, this one written by Mallarmé. Destined for an English periodical, *Art Monthly Review*, "The Impressionists and Édouard Manet" exists only in an English translation, the French manuscript having been lost. Mallarmé diverged from Duranty by giving more space to a discussion of individual artists and their variations on a common program. One was Berthe "Morizot": "more given to render, and very succinctly, the aspect of things, but with a new charm infused by feminine vision."[4] Clearly Mallarmé knew Morisot fairly well, or at least her work, by the summer of 1876.

Mallarmé's conclusion suggests who introduced them to each other. While the poet ascribed to the Impressionists intentions defined by their medium, "the clear and durable mirror of painting," nourished by a "creative artistic instinct," he analyzed their endeavor as an integral part of a larger movement.

> The participation of a hitherto ignored people in the political life of France is a social fact that will honour the whole of the close of the nineteenth century. A parallel is found in artistic matters, the way being prepared by an evolution which the public with rare prescience dubbed, from its first appearance, Intransigeant, which in political language means radical and democratic.
>
> ... today the multitude demands to see with its own eyes.[5]

An unusual kind of opinion for Mallarmé. All the more so because, as we have seen, the words "intransigeant," "radical," and "democratic" had a very specific political meaning in the France of 1876. In their English translation they sounded vaguely leftist or idealistic. In their French context they referred to the radical republican platform, whose adherents had always been known as the Intransigeants. Mallarmé was not, at least overtly, among them. Édouard, Eugène, and Gustave Manet were.

That year, in fact, Gustave ran for office in the Clignancourt ward of the eighteenth arrondissement, under the patronage of the local leader of the radical party, Georges Clémenceau. Among those who campaigned on his behalf were the free-thinker Paul Dubois and the venerable republican Victor Hugo's militant son-in-law, Édouard Lockroy. Gustave won a seat on the municipal council. The next year he, in turn, campaigned with the party against MacMahon's authoritarian 16 May coup. In 1878 he stood successfully for reelection.[6]

We know that in later years Mallarmé was as friendly with Eugène Manet as he was with Morisot. Had Édouard and Eugène Manet primed Mallarmé for his article just as Degas prepared Duranty? It seems likely.

Mallarmé was entering the social constellations both con-stituted by and shaping the Impressionist movement. Each of the Impressionists had separate lives. Of differing backgrounds and tastes, the Intransigeants all had friends, family, and even pa-trons of their own. Professional disagreements erupted periodi-cally; Pissarro's adamant socialism, for instance, affected his attitude to exhibition organization in a way that often made his colleagues impatient. Some individuals had particular loyalties within the group, like Monet and Renoir, who had gone off to-gether on painting sprees in their younger years. Morisot and Degas moved in the same social circles. Still, all in all, they maintained a network that kept them together more than it kept them apart. They continued, on the whole, to subscribe to the Impressionist program, each in his or her own way, and as they grew older, a certain nostalgia for a common youthful struggle helped gloss over divergences.

Long after their early struggles the Intransigeants became like

old war buddies whose affection comes not just from shared experience itself but also from a steady and mutual cultivation of memory. Three factors abetted Impressionism's longevity. The Intransigeants had a dealer in common, Durand-Ruel; during their formative professional years all other commercial venues for their work remained marginal. Art critics, and soon art historians, perceived them as a group, inducing from the outside a sense of coherence and encouraging the continuation of Impressionist affiliations. And most simply, the Intransigeants respected each other's work and enjoyed each other's company. Though in the late 1870s and 1880s most moved centrifugally away from Paris, they continued to visit one another in their new homes or reunite in Paris, for social reasons as much as for professional ones.

Morisot was in large part responsible for this last factor. She had more invested in Impressionism as a personal network than any of the other Intransigeants. Unlike them, she was drawn by marriage even closer to the movement, not just because (as past art historians have emphasized) their erstwhile leader, Édouard Manet, became her brother-in-law but because Eugène Manet was an Impressionist supporter. Moreover, Impressionism took off just as Morisot became truly independent, both circumstantially and psychologically. Her sisters married and living in the provinces, Marcello away in Switzerland or Italy, her father dead, her mother resigned to her daughter's wishes, Morisot was free around 1875 to build new friendships. She did so entirely within the Impressionist group. Pissarro somewhat dismayed her but always commanded her respect. With Monet and Sisley she was on very cordial terms. Eugène and Édouard Manet, of course, were now members of her family, but they were also her intellectual companions. Degas, Mallarmé, and Renoir became almost as close, especially in her later years. Morisot helped keep all these men together with her encouragement of their friendships, the forum she provided in her home for their encounters, and her eagerness to continue the Impressionist Exhibitions.

In a sense, Morisot was transposing a traditionally feminine role. Women were supposed to be the nurturing, conciliating ones, the ones who provided a personal base from which men could sally forth and do business in the outside world. Before

1870 Bazille had filled this role more than anyone else; then in the early seventies the Café Guerbois, and later the Café de la Nouvelle Athènes, provided a place for the future Impressionists to meet and scheme. Manet's painting indicated the pictorial direction to be followed, while the critical abuse he suffered pushed his younger friends to rebellion. But once this initial burst of resentful energy passed, a place, a program, and anger were not enough to keep such belligerent personalities from fighting almost as much with each other as with official art institutions. Morisot did as much as she could to reconcile and reunite.

In 1876 and 1877 Morisot was still feeling unsettled herself. After another summer stay with Edma, presumably at Maurecourt, Morisot returned to a Paris where, as Eugène had put it in a letter, "The entire painters' clan is in distress." France's economic situation was squeezing dealers and painters alike. The couple moved back into the rue Guichard apartment, newly cleared and cleaned. Cornélie Morisot would have no more use for it; she was dying. On December 15 her acute and protracted suffering ended. Friends wrote sensitive letters of condolence, understanding how much Morisot grieved not only for her mother's death but also for the pain that had marred her last weeks of life. Again Morisot and Manet moved, this time to the slightly more urban neighborhood just beyond Passy toward the Arc de Triomphe, where they rented an apartment at 9 avenue d'Eylau (now avenue Victor Hugo).

Early in 1877 Caillebotte took it upon himself to launch the 1877 Impressionist Exhibition. He hosted an evening planning session, to which he did not invite Morisot, perhaps because she was in mourning, perhaps because she was busy moving, perhaps because it seemed improper to him. Degas, Monet, Pissarro, Renoir, Sisley, and Édouard Manet assembled to debate the modalities of a third group show.

Caillebotte rallied the dispirited painters with all the proverbial ardor of the neophyte. The object of the first exhibitions had not been achieved. Impressionism had not conquered the art world. Sales had proved slim, prices had slumped, and critical reaction had been mixed. Tempers were beginning to wear thin as each of the Impressionists wondered if the others were to

blame for his problems. Newly arrived on the art scene, and calculating with cooler logic that current resistance augured future acclaim, Caillebotte urged perseverance and solidarity. More than any of the original Intransigeants, he had faith in Impressionism as a movement. And he was both methodical and idealistic enough to attempt the application of his beliefs. If Manet was the leader of the new school, he should be convinced to exhibit with them.

Diplomatically, Caillebotte reminded each of the others how much they all still had to gain by exhibiting together. He finally managed to negotiate a plan everyone except Édouard Manet could agree to. At issue were costs, distribution of profits, hanging policy, timing, location, and admission: all the usual practical aspects of any exhibition, which any group as temperamentally, financially, and socially diverse as the Impressionists would have a hard time agreeing on, let alone a group whose self-confidence was waning.

Changing atmosphere but staying in the same busy commercial neighborhood, Caillebotte rented rooms right across the street from the last exhibition, at 6 rue Le Peletier. The rooms, though very large, were domestic in intention and promised therefore to display the Impressionists' paintings in a particularly appropriate setting. Only after the lease had been arranged did Caillebotte, together with Renoir, write Morisot with news of the exhibition: "We're pleased to think you will want to participate as usual." They promised to keep her in touch with whatever transpired but also invited her to a meeting to be held on the premises of Legrand, an art dealer participating in the show's administration. Degas reiterated the invitation, voicing his main concern—"can one exhibit in the Salon and with us? Very serious!"—and reminding Eugène of a past promise to join the group. Eugène declined.

In the end, eighteen artists contributed a total of 241 works. Twelve were by Morisot. Most of her pictures hung in the third of five rooms, together with two dominant paintings by Renoir and Pissarro, and all of Cézanne's contribution. Morisot's oil pictures may have been grouped on one wall. Her two drawings and three watercolors were in the last room, with Degas's paintings, pastels, and prints. A hanging committee composed of Cail-

lebotte, Monet, Pissarro, and Renoir had decided the overall scheme. Pissarro and Degas placed white rather than gilded frames around some of their works. Another tradition flouted.

Heavily advertised by banners, the exhibition drew as many as five hundred people a day. Perhaps around eight thousand in all attended. Again press coverage increased. Though hardly convinced, critics tended to react less hysterically than to the first and second exhibitions. One of them, Paul Mantz, wrote in *Le Temps:* "The truth is that there's only one Impressionist in the rue Le Peletier group: that is Berthe Morisot."[7] By which he meant that only her style corresponded fully and consistently to his idea of the archetypal Impressionist technique: a summary, calligraphic, and color-saturated notation of transient light effects. Many critics and historians would echo Mantz over the years.

Was Mantz right in terms of content as well as style? Did Morisot contribute something essential to the Impressionist movement? Was she an integral part but still the lowest common denominator? Or was she marginal? Each of these positions has been held by various art historians, some of whom made their point simply by neglecting her. Rather than tread in the dangerously ineffable domain of aesthetic value, one might more usefully consider the opinion of Morisot's peers: Though they did not attribute to her the degree of "genius" they accorded to Manet, Monet, Renoir, and Degas, painters, writers, and critics in Morisot's own lifetime all agreed on her central role in avant-garde art. Or one could consider whether one of Impressionism's historical achievements was the powerfully public place it gave women's point of view.

Morisot was no feminist in the political sense of the term. She never joined any organizations, even arts organizations, that demanded equal rights for women. Yet she effectively captured those rights for herself. Without ever openly criticizing women's condition, she nevertheless did not accept it.

Morisot's pictures of women, at their best, attempt to rethink their subjects. Take, for example, the pictures she showed in the 1877 Impressionist Exhibition. One of them was a portrait of a young woman in a ball gown, holding a fan. The motif had been used countless times before. But in most versions, the ball setting

provides an excuse for fashion illustration, and the moment tends to be depicted as one of flirtation or seduction between a woman and a seen or implied masculine viewer. Whereas Morisot focused on the young woman herself, largely ignored her costume and accessories, and concentrated on her thoughtful face. Similarly, in the two pictures she showed of women at their toilette, Morisot tried to find a different way of representing a traditional image, one that could convey what it was like for a woman to be both the observer and the observed.

Through the diaphanous white peignoirs and chemises of nineteenth-century confection, most painters provided erotic glimpses of female flesh. Tightly laced corsets evoked at once pleasure and bondage. A mirror and sundry cosmetic knick-knacks set the scene and enabled artists to stage women in acts of sexual provocation or passivity. Édouard Manet showed just such an image in 1877: his famous *Nana*. *Nana* has always been hailed as a masterpiece for its formal bravura and brilliant wit. Morisot's toilette scenes cannot match those standards. Nor can Morisot's images stand a purely formal or traditional comparison with a painting like Renoir's *The Ball at the Moulin de la Galette*, with which it hung at the 1877 Impressionist exhibition. Renoir's picture is so much larger, so much grander, so much more at ease with its materials and its message.

But what about other grounds? For Morisot was trying to do something different. She was trying to understand the effects of self-consciousness. Her women are preparing for the kind of scrutiny Manet and Renoir engaged in. They cannot ignore the masculine gaze that will be turned on them. But for the moment they are looking at themselves; their attention is concentrated on their appearance and the fabrication of that appearance with the tools at hand: cosmetics, mirror, and costume. They are not yet, and never simply, objects for masculine consumption.

How difficult is it to restate, however magnificently, a statement made many times before and accepted by almost everyone? Manet and Renoir (among others) were restating, albeit in innovative and undeniably powerful formal terms, uncontested and traditional ideas about women. In trying to say something different, no doubt Morisot sometimes stuttered or murmured. Although some of her pictures are "masterpieces" by any stan-

dards, many others have to be estimated on their own terms. The challenges and the obstacles she faced began well before she ever reached the easel and picked up a paintbrush; they were everywhere around her, in the idea that "genius" was a function of masculinity, in the dearth of role models for her to follow, in the niggardly logistical restrictions she encountered on a day-to-day basis, in the minds of others and in her own mind. What reached the canvas, let alone the gallery wall, may have been at times only a formal beginning; to have arrived there at all required a kind of imagination and innovation men were not obliged to summon. The generosity and enlightenment with which the male Impressionists eased Morisot's way were not the least of their many qualities.

Caillebotte began almost immediately planning for the next exhibition, which was not to take place for another two years. Meanwhile the first history of Impressionism appeared in May of 1878. Théodore Duret's *Les Peintres Impressionnistes* discussed in intelligent and glowing terms the movement's origins, intentions, and accomplishments. For him the real "Impressionists" were five painters: Monet, Pissarro, Renoir, Sisley, and Morisot. Duret's tribute notwithstanding, times were hard for Morisot and her friends. By summer one of their few loyal collectors, Ernest Hoschedé, had gone bankrupt, and the pitiful auction of his collection on June 5 and 6 seemed to summarize the cultural climate. Morisot, however, had other things on her mind. Since February she had been expecting a child.

15

Fulfillment

1 8 7 8 – 1 8 8 3

On November 14, 1878, occurred the single most important event of Morisot's life. She gave birth to her daughter, Julie. Years of waiting and doubt had ended; her most passionate relationship had begun.

No letters by or descriptions of Morisot survive from her first months of maternity. Family tradition recalls a difficult recovery from the birth. Morisot was, after all, thirty-seven—at the time quite an advanced age for a first child—and she had not been in the best of health since her late twenties.

However physically trying the birth was, it may also have been physically fulfilling. Morisot was typical of her time and class in her extreme reticence about any sexual matters, and she extended this attitude to almost everything about her body. Maternity, however, was entirely sanctioned by middle-class morality,

and all physical bonds between mother and child came under this protection. We think of nineteenth-century middle-class women as being sexually repressed, yet we forget what full scope was then given to one of women's richest and most pleasurable physical experiences. Morisot was in love with Julie: mesmerized by her every feature, identifying with her every need, endlessly and happily occupied by her development. She could and did express these feelings openly, allowing herself this one public emotional outlet. After 1878 Morisot's letters, diaries, drawings, and paintings revolve around Julie. She identified herself as a mother and made her daughter the focal point of her existence.

The earliest letter we have dates from late July of 1879. Morisot at once exults to her sister Yves and tried to conceal her joy with token critical comments. The pride she takes in her child's Manet parentage was a theme that would recur many times. Understandably enough, for not only was Morisot in love with Eugène Manet and acutely aware of Édouard Manet's place in art history, but Julie's birth consolidated her place in the Manet family. Mme Manet was delighted at the appearance of her first (and last) grandchild, nicknamed Bibi; suddenly Morisot was every bit as much a cherished daughter-in-law as Suzanne Leenhoff Manet.

> Oh well! I'm just like everybody else! I regret that Bibi isn't a boy; first of all because she looks like one, secondly because she would carry on an illustrious name, and, basically, quite simply, because we all, men and women, love the male sex. . . . Your Bibi is a darling; you'll find mine rather ugly by comparison.

Yves's Bibi was her daughter Jeannie, very close in age to Julie. The two cousins early on became each other's favorite playmates; Jeannie came often to stay for visits. She may have been the original Bibi, but her nickname soon changed to Nini.

Morisot wrote to Edma, hinting at the anticlerical Manets' disapproval of Julie's baptism.

> she's been baptized (much to some people's dismay) and vaccinated. Two fine chores accomplished. . . . [Julie] is a Manet to the tips of her fingers; she's already like her uncles, not a bit like me.

She coyly introduced Julie to her favorite niece, Blanche Pon-
tillon, pleading that her Bibi was "much less ugly in the flesh
than in her photograph and as sweet as can be, though she has
a horrible temper."

At the same time she paused, in her letter to Yves, to mourn
the passing of Marcello, Duchess Colonna, dead of consumption
on July 14, at the untimely age of forty-three.

> Don't accuse me of negligence, my dear friend, I think of
> you and your children, constantly, but my life is becoming
> complicated, leaving me little time to take up a pen for fear
> of being dull. The death of the poor dear duchess put me
> through one of those bad phases. Mme Carré [a Passy neigh-
> bor and long-standing family friend] told me the other day:
> I think you've lived too much. Well, it's true! Since I'm
> seeing all I've known and loved disappear, I have lived too
> much! Departed friends can no longer be replaced at my
> age and the emptiness is so great.

It seems scarcely credible that a woman of thirty-eight, so
dynamically involved in a vital art movement, should feel old or
that she had "lived too much." Morisot's life was filled with many
joys, many sorrows, and much hard work. Though we can see
from the outside that this full experience was essential both to
her personality and to her art, from her point of view the costs
were high. She felt every death in her family or among her
friends as if it were the first. She approached every canvas as if
it were her first. Had she become more callous, she would have
suffered less. Her temperament took as big a toll as her age.

In 1879 Morisot had much to contend with. A return to work
helped fill the void left by Marcello's death as well as her
mother's death, also counterbalancing the upheavals of new
motherhood. Work, however, also began to bring its own kind
of drama. As Caillebotte's plans for another Impressionist Exhi-
bition accelerated, it became apparent that Impressionism was
entering a new phase.

After solidarity came discord. Efforts to organize an 1879 exhi-
bition revealed how idiosyncratic each Impressionist could be,
and how recalcitrant. No one could assert his or her authority
without alienating someone else. In the early years of the move-
ment, all were united by their opposition to the Salon, the Acad-

emy, and *grandes machines*. Their ideas were also very much in the process of formation, and similarities could be deceiving. Monet and Renoir, for instance, could go off painting together, set up their easels side by side at the "Grenouillère" watering hole, and come back with pictures that seem at first glance almost identical, both of them experiments in conveying the effects of sunlight on rippling water and rustling leaves. But in fact each picture is marked by differences in temperament and technique that became increasingly accentuated with the years. By 1879, a decade after they had discovered shared objectives, each of the Impressionists had developed a distinct personality. They were reaching forty and were impatient for success.

In the absence of any administrative continuity, every Impressionist Exhibition was organized by whoever had the will and energy to take on the task. The six original Intransigeants, along with their new colleague, Caillebotte, had the most incentive to do this. But three—Sisley, Monet, and Renoir—had no inclinations to administer anything.

Sisley was not a leader. He never voiced opinions of his own and never tried to influence anybody. He just went on quietly painting in the same style, varying his subjects but little, living modestly in the suburbs, and tending in whatever direction Monet, Renoir, or Durand-Ruel suggested.

Nor was Monet a leader, though he certainly had a strong will of his own. He was acutely and accurately aware of his talent and the material rewards it might bring if he handled his career correctly. He had always relished the amenities money could buy: suburban villas, seaside vacations, fine clothes. For Monet, exhibitions were market strategies much more than aesthetic statements. Outlaw status did not appeal to him. He was also completely self-absorbed and proved himself willing and able to ignore any responsibilities, anyone else's needs, for the sake of his art. This was not a man who would devote time or energy to the promotion of other people's work.

Renoir cultivated a life entirely apart from his colleagues, almost leading a double existence. He dressed and behaved like a bourgeois, catered to middle-class patrons, and sincerely liked his middle-class friends, yet he refused to relinquish his working-class habits, haunts, and companions. His work seems so

harmonious and carefree, so sensuously relaxed, yet he himself was skinny and nervous. He did not like to commit himself, and for many years refused to tie himself down either with marriage or with real estate. He railed against capitalism and yearned nostalgically for an imaginary time when class conflicts did not exist. Since he so disliked bureaucracy, he was certainly not about to create one himself, no matter how provisional and artistic.

Caillebotte, however, liked making rules. And Degas liked pushing people around. Caillebotte had had his turn in 1877. Now it was Degas's. Since Impressionism had no official adherents, the participants in each exhibition were simply whichever painters the organizer in question could rally that year. The assumption was always that the original six Intransigeants would be invited, but beginning in 1879 the invitations were not open and not always accepted. Degas imposed conditions that offended many of his friends and for several years splintered the movement.

Degas had always held in contempt the Salon, as well as anyone who aspired to its honors. He could afford to. He looked down from his aristocratic heights on its staid middlebrow pretensions. Pissarro also disdained capitalism, but from the different position of a committed socialist. As for Morisot, she was aware that she had little to lose professionally by renouncing the Salon, for she was unlikely to reap the honors and commissions Salon exhibition could lead to. As a woman, she had little hope they would be offered to her, and as a very private person she had no desire for their brand of pomp and circumstance. The Impressionist Exhibitions suited not only her aesthetic but also her way of life. They were at once public and private, historically significant and yet always organized by friends in personal ways.

In 1879 Degas repeated his 1877 proposal that no one could both exhibit as an Impressionist and submit to the Salon, but this time the proposal was couched as an ultimatum. Once again a meeting was called at Legrand's, which Morisot, for whatever reason, did not attend. Degas called on her at home to obtain her pledge. "She renounces sending to the Salon," he crowed to Caillebotte in late March 1879.[1] He jotted down her name in his private list of exhibitors.

Degas's certainty was premature; Morisot may have agreed with him about dates and principles, but she wondered whether or not she would participate in the exhibition at all. Degas wrote in another note to Caillebotte around the same time: "Mlle Cassatt is seeing Mlle Morisot tomorrow and will know her decision." Cézanne, Renoir, and Sisley had already made theirs. They abstained from the exhibition. The Salon held its financial attractions, and they did not like being dictated to by Degas. Cézanne had always been somewhat marginal to Impressionism, for his painting was almost problematically forceful and he held himself gruffly aloof; he withdrew from the group to become even more pictorially radical. But the loss of Renoir and Sisley weakened the Impressionist Exhibition at its heart.

This is the first we hear of Mary Cassatt in connection with Morisot. By March of 1879 Cassatt clearly knew Morisot well enough for Degas to think she was the one to conduct an important bit of diplomacy. Mary Cassatt, the angular and feisty daughter of a wealthy Philadelphia family, had settled in France, bringing her parents and her sister, Lydia, in her wake. Degas's work had been a revelation to her, and hers to him. With his encouragement she had been counting on this exhibition for more than a year. She and Morisot had much in common. Besides the obvious similarities of sex, class, talent, and courage, they were both, in the late 1870s and the 1880s, exploring the subject of contemporary quotidian feminine experience. Each woman, for instance, made pictures of her mother and sister, of women at their toilette, of mothers with their children. Their characters were different enough to keep them from becoming very close personally, but professionally they stood on the same ground and knew it.

Cassatt and Morisot, each in her own way, both as professionals and in their art, were making new claims for women. By the very persistence of their endeavors, as well as by their high pictorial standards, they demonstrated that women could participate fully and continuously in the most rigorous avant-garde art movements. Morisot showed that such a career could be reconciled with marriage and maternity, Cassatt that women need not necessarily be married or mothers in order to be fulfilled. While Morisot's dual life implicitly contradicted the conventions of

femininity, Cassatt more overtly contested gender roles by supporting women's rights. What is important about Cassatt's and Morisot's examples is precisely that they were not alike. These two women proved that no one model could explain all women's aspirations and achievements any more than one model could explain all men's. Where Morisot was elegant and discreet, Cassatt was brusque and frank; where Morisot's painting was suggestive, Cassatt's was descriptive. Morisot wanted to invest herself in a family and friends; Cassatt wanted to be independent.

Despite Cassatt's putative plea, Morisot decided at the last minute to abstain from the exhibition. She may have been alarmed by Renoir's and Sisley's defections, though the late recruitment of the newcomer Paul Gauguin helped fill the void, but the timing of the exhibit was clearly a problem. She would enter later shows despite Degas's high-handedness, but in this case, the exhibition was to open only five months after Julie's birth: the original June date had been moved up to April. Coping with the aftermath of pregnancy and delivery and with the care of a tiny infant, Morisot was probably suffering the usual exhaustion of a new mother. An opening date in June would have given her two precious months' respite and, perhaps more important, some time to paint. She'd had little chance to produce much new work beyond some watercolor fans, and she was doubtless reluctant to be represented only by these. Degas and Pissarro were also showing fans, but along with other, more substantial, work.

The fourth Impressionist Exhibition opened on April 10 without Morisot, although she doubtless attended. Cassatt's contributions attracted much comment, favorable or at least flatteringly attentive, as did her bold use of red and green frames. The original group proudly adopted her, citing her as the most positive consequence of Degas's bullying. The exhibition's material success also helped mitigate the group's concern over his alienating tactics. For once, participants turned a profit, almost 450 francs apiece. More than 15,400 visitors had trooped through the galleries at 28 avenue de l'Opéra. Many of the painters nursed the hope of an Impressionist reunion. Caillebotte concluded a grateful answer to a favorable review by "Montjoyeux" (Jules Poignard) with the words: "P.S. I much regret that you forgot Miss Cassatt and a word for this year's absentees: Cézanne, Renoir,

Sisley, and Mlle Morizot [*sic*]. Thank you all the same."[2]

The success of the fourth exhibition may have been an added incentive for Morisot. She made up for lost time in the following months, summering at Beuzeval-Houlgate before returning to Paris. When plans were laid for a fifth exhibition, she was ready. This time her participation was never in doubt. Cassatt wrote her in the fall:

> I am so happy that you have done so much work, you will reclaim your place at the exposition with *éclat,* I am very envious of your talent I assure you. . . .
>
> Many kisses to Miss Julie and a thousand best wishes to her mother from their
>
> Affectionate friend
> Mary Cassatt[3]

Morisot's loyalty to the group was all the more remarkable in that the rifts of 1879 were widening. Not only did Cézanne, Renoir, and Sisley again opt for the Salon in 1880, but Monet joined them. Impressionism's center had split along its original fault line. The three would-be insiders—Monet, Renoir, and Sisley—gave preference to the Salon while the outsiders—Degas, Morisot, and Pissarro, joined by Caillebotte and Cassatt—remained committed to independent exhibition. The idea of a concerted movement in art was new, too new to inspire a strong esprit de corps. Monet, Renoir, and Sisley were not initially committed to Impressionism as a theory, and in 1880 independent exhibition did not seem to have fulfilled the material purpose of encouraging sales. The Salon still seemed to control the art market, and each of the insiders at that point wanted to succeed financially. Their objections to the Salon had been less principled than practical, and if the Salon would accept their work, they were willing to show there.

Degas, Caillebotte, and Cassatt, however, were committed to Impressionism as an art movement, as well as to the practice of independent exhibition. Morisot and Pissarro felt loyal to the past and to the idea of collective endeavor. Pissarro, moreover, the oldest of the group and the most nurturing, was devoted to the encouragement of younger talents. With prophetic confidence he would champion in turn Cézanne, Gauguin, Van Gogh, and the pointillistes, led by Seurat. Degas added second-rate

artists to the exhibitions' rosters in order to control their agenda; Pissarro would not abandon the exhibitions because he wanted to maintain a forum for unknown first-rate artists.

Carried forward by the momentum of the previous year's exhibition, Degas quickly proceeded to organize another for 1880. Caillebotte tried to mitigate Degas's autocracy, but Degas seemed bent on asserting his will regardless of aesthetic or personal consequences. Every issue was fought with acrimony and settled hastily. Degas brought in painters he did not fully respect. He insisted they all bill themselves as a "Group of Independent Artists," as if to justify his ban on the Salon. Even the poster aroused controversy. Caillebotte wanted to list the exhibitors' names. Degas objected to such vulgar individualism and favored a poster design more purely aesthetic in effect. He finally gave in, on the condition that the women be spared what he considered the ignominy of advertisement. He exclaimed to Félix Bracquemond in late March 1880:

> When on earth will they stop the headlines? Mlle Cassatt and Mme Morisot did not insist on being on the posters. It was done the same way as last year and Mme Bracquemond's name will not appear—it is idiotic. All the good reasons and the good taste in the world can achieve nothing against the inertia of the others and the obstinacy of Caillebotte.[4]

Indeed, Morisot and Cassatt were joined in the 1880 exhibition by a third woman, Marie Bracquemond, the wife of the man who had introduced Morisot to Fantin-Latour more than a decade earlier. Like Morisot and Cassatt, Marie Bracquemond wanted to represent images of contemporary feminine life, and like them, she had a strong and supportive sister who urged her on. It was at this 1880 exhibition that she really had a chance to demonstrate her gifts. In the course of her career she had made two tactical errors: she never fully joined the avant-garde, which would have been the best forum for the sort of pictures she wanted to make; and she married a man who could not tolerate her ambitions. Neither free like Cassatt nor seconded like Morisot, deprived of a congenial professional framework, she would see her career atrophy and die.

But in 1880 all three women acquitted themselves admirably.

Marie Bracquemond's three paintings were barely Impressionist in style, a fact critics noted, but they were impressive exercises nonetheless. Cassatt showed superb works, including the splendid and witty *Five O'Clock Tea,* now in the Boston Museum of Fine Arts. Morisot contributed one fan, four watercolors, and ten oil paintings, including another toilette image, perhaps the most subtle and analytical of that series, the *Woman at Her Dressing Table,* now in the Art Institute of Chicago. Most reviews judged Morisot's work among the finest in the entire exhibition, lauding her subtlety and skill. She won high praise even from the notorious *Figaro* critic Albert Wolff, who still could not approve Édouard Manet's work.

The exhibition on the whole, however, did not go well. Rooms had been chosen in a building, on the rue des Pyramides, still under construction. Banging and sawing noises filled the air, making it hard to concentrate on 232 pictures by eighteen artists. Although the show ran for the entire month of April, it won no converts among the public and created further dissent among the artists. By the end of the show Caillebotte was furious at Degas, convinced that he was perversely undermining the integrity, if not the existence, of an art movement Caillebotte had deeply invested himself in. Everyone except Cassatt was fed up with Degas's machinations, yet no one else stepped forward to take his place.

None of this had been resolved by the next year; in fact, Caillebotte joined Monet, Renoir, and Sisley in their abstention. Degas was left to dominate the 1881 exhibition. Once more he imposed painters none of the core Impressionists really respected. And again the locale was poorly chosen, critics tepid, exhibitors dismayed. The Impressionist movement had reached its nadir. Four of its eight principal protagonists had seceded. Thirteen artists crowded their 170 pictures into cramped, dim mezzanine rooms at the back of 35 boulevard des Capucines. What a sorry contrast to the optimism and the spacious galleries of the first exhibition, which, ironically, had been held at the same address.

The only artists who fared well were Cassatt and Morisot. Critics responded with almost unfailing praise to Cassatt's eleven pictures and Morisot's seven catalogued and three uncatalogued

contributions. Degas as usual attracted the most attention, but of a controversial and contested sort. Both women had reached turning points in their art since the previous year.

During the summer of 1880, Morisot had made frequent visits to Cassatt and her family at their Marly-le-Roi villa. Morisot had also returned to Beuzeval-Houlgate. The following fall brought the sad but not startling death of her ninety-two-year-old Thomas grandfather. In January 1881 Morisot received Édouard Manet's touchingly respectful gift of a special easel for pastels. New year, new easel, new subject matter. Both Cassatt and Morisot showed pictures of mothers and children in the sixth Impressionist Exhibition. Both would concentrate more and more on that theme in the years to come. Their 1881 pictures already indicate how each woman would interpret maternity.

Cassatt showed a mother and baby joined in a close and tangible embrace, smooth cheek to smooth cheek, tiny arm around maternal neck, tender hand pressed against little back. Morisot showed a picture of a wet nurse feeding Julie. Morisot's image seems to scatter before our gaze, brushstrokes flying in every direction; only the round and rosy Julie coheres.

Morisot wanted to paint her child from her earliest days. The project was by no means as easy as it seemed. Centuries of Madonna images with their sacred aura dominated the theme. Few stereotypes have been as persistent as the image of a young woman holding a baby, of the physical bond between mother and infant, which we understand to mean "maternity." The image is just that—an image. All children grow up, and their relationships to their mothers do not remain dependent. The child has to change, has to leave the mother, even as the mother still nurtures the child and steers it into adulthood. No one, though, had ever tried to represent those maternal experiences. For one thing, virtually no mothers ever became painters. Madonnas were images made by men. Even Cassatt never knew motherhood herself, though as a woman raised in the nineteenth century she identified with other women's experience in a way men could not.

Morisot had experienced maternity herself. And what she knew demanded some other kind of image. *Nursemaid and Child,* her 1881 picture, reflects temporary disarray. In some

ways Morisot has reverted to type and shown her child with a female figure who fulfills an archetypal maternal function. But the woman is emphatically shown as hired help. The real mother is not in the picture. The real mother is making the picture, and in the separation of painter from subject Morisot has confronted the separation between mother and child. In a second picture shown in the 1881 exhibition, Morisot has accepted her position. The painting is of Julie alone and returns to the assured style of Morisot's earlier work. From then on, Morisot pictured her child with tender care but as an independent person.

Thus begins a series of images unlike any that had gone before. With the pictures Morisot displayed in 1881 begins the most extensive and profound visual exploration we have of a mother-daughter relationship. In the eyes of this mother, the relationship is both intimate and respectful, one in which mother and daughter respond to each other but learn from their differences, one in which a daughter does grow up. Paradoxically, perhaps, these paintings brought mother and daughter still closer together. For as Morisot relinquished the joys of physical union with her child, she discovered new and more durable ones: the pleasures of intellectual communion and shared values.

Berthe Morisot and Eugène Manet decided in 1881 to settle down, buy property, and build a house. Again moving a few blocks northeastward from Passy, they chose a lot on what was then the rue de Villejust and is now the rue Paul Valéry. It was part of a trend. Many Parisians invested in real estate and chose to build for themselves. After the annexation of its immediately surrounding suburbs in 1860, Paris witnessed a building boom in the Auteuil and Passy areas, prime land previously under-developed. Morisot and Manet were among many property owners who planned both to live in their new buildings and to rent out apartments, generating income that in this case would help them pay back a bank loan. It was a sizable project. For two years design and construction preoccupied both Morisot and Manet as they negotiated with their architect, Morize, over endless details. Unlike many couples, they agreed easily between themselves on what they wanted; while Morisot was away from

Paris, Manet kept her apprised of every question and constantly asked for her opinions; she responded with ideas but also with consistently expressed confidence in his judgment.

Until the building was completed, however, the household had no fixed home. Taking advantage of their flexibility, Morisot and Manet rented a house in Bougival, a hilly, open, and flowered suburb just west of Paris. The house, at 4 rue de la Princesse, had a convenient veranda for a painter, with a glass wall giving onto greenery and a few houses beyond, as well as a luxuriant garden with green, rose-covered trellises. There Morisot worked steadily, producing iridescent paintings of Julie, the house, and the garden, deftly manipulating color nuances to build volumes, expertly playing surface brilliance against optical recession.

Reading the rare explanation she gave of her work to an unnamed friend, who would have guessed what she was accomplishing and how rich her friendships were? As usual, she mixed words on art with news of Julie, who is referred to as both Bibi and Chichi.

> How grateful I am to you for your affection for my darling Chichi. . . .
>
> Mummy is much less interesting than her daughter; she's visibly aging and works all the time.
>
> Dear friend, you have everything still to learn; the love of art, as you call it, or simply the love, or a taste for, whatever work, does not diminish with the years. It's really what best enables us to bear wrinkles and white hair.
>
> Chichi is delightful, but as an intellectual resource, she still leaves something to be desired; and I live in such solitude that I would deserve to be pitied if I couldn't occupy myself. You know I've always needed to be kept busy, which I am now by little other than work, Bibi, and reading. There's no longer any question of friends of either sex; some have turned away, whereas you're so far away! And I've lost the dear Duchess.

Morisot wanted to push on from Bougival to Nice and from there to Italy. At the end of the winter the family traveled to Genoa, to Pisa, and then to Florence, hoping to end up in Venice. In Florence, however, Julie contracted bronchitis, sending her parents back with her to Nice in a panic. Édouard Manet warned

them in late January: "You would do better, in the future, not to scare my mother unduly about Bibi's health; it puts her in a frightful state."

He also told of Impressionist dissent: "As it happens, I've just had a visit from the terrible Pissarro, who spoke with me about your forthcoming exhibition." Degas, possibly with his old school friend Henri Rouart (himself a very talented if part-time painter), had been planning for a seventh Impressionist Exhibition since November 1881. Rouart offered to pay the rent for a space. The problem was Degas, who reiterated demands on behalf of painters uncongenial to Caillebotte, Monet, Renoir, and Sisley. Durand-Ruel intervened. Encouraged in his substantial investment by a seemingly favorable economic climate, two years earlier he had begun buying pictures from Monet, Pissarro, Renoir, and Sisley again. In January 1882, however, the economy took another downward turn, with a slump in the stock market and, most relevantly, the failure of the Union Générale Bank, from which Durand-Ruel had borrowed a large sum. Suddenly he needed to sell his collection.

Durand-Ruel understood something in 1882 that no one had quite realized before, which was that an Impressionist identity could be a precious commodity. Even Monet and Renoir, whose signatures were already becoming marketable, could profit from association with a group whose collective reputation was about to soar. Basically, Durand-Ruel told Monet and Renoir that even if they did not agree to exhibit, he would display the pictures of theirs that he owned. Renoir wrote to him on February 24: "With Monet, Sisley, Mlle Morizot [sic], Pissarro, I would accept, but only with them."[5] In other words, Renoir was reasserting the original 1874 group, with the obvious exception of Degas, who had forfeited his place by betraying the group's integrity. The projected opening date was less than a week away. Degas withdrew, and with him Cassatt and sundry others. Sisley followed Monet and Renoir back into the Impressionist fold, along with Caillebotte and Gauguin. Morisot and Pissarro could always be counted on.

Morisot, however, was still in Nice, and Julie was not yet well. Eugène Manet came to the rescue at the last minute. He took the train back to Paris and organized Morisot's contribution. They

did not like to be apart, but their separation occasioned a remarkable exchange of letters. No other source so clearly documents the tone of the couple's relationship, as well as Eugène's extraordinary devotion to his wife's career. The exchange begins March 1, 1882, the day after Eugène arrived in Paris, the very day the show opened at 251 rue Saint-Honoré, in a space originally dedicated to a panorama depicting the battle of Reichshoffen, one of France's defeats in 1870.

> My dear friend, I'm telegraphing you to let you know in brief what I've done for your exhibition. Having arrived in Paris, I went straight to the Panoramas gallery. I found the whole brilliant bevy of Impressionists working in an immense gallery hanging quantities of canvases. I was warmly welcomed by all and urged to have you exhibit.

Back and forth Eugène went that day, from the exhibition to Bougival, to the frame shop to the picture dealer and back again, carrying paintings and pastels himself, all under a "driving rain." "I can't get over how much you did in that first day; it seems to me you're killing yourself with exhaustion, and on my account, which touches me and bothers me all at the same time," Morisot responded.

Eugène was staying with Gustave and kept in close contact with Édouard. The three Manet brothers all went to the exhibition, and both Gustave and Édouard loyally announced that Morisot's pictures were among the best. Eugène proudly reported their opinions, knowing how much they mattered to his wife, and urged Morisot to work harder: "Do something for the poor public." All she had to do was paint—he would make sure the pictures were properly framed and hung. Morisot alleged disruptions, visits—"you know how I like that while I'm working"—but her husband retorted: "Turn your visitors away, establish visiting hours in the evening and close the door while you work."

"I miss you very much," wrote Morisot, and reported that Julie also missed her "Papa," while Manet pleaded: "write me every day, as you promised to," and looked forward to a family reunion. Mother and child had settled down to a steady routine of quiet meals together, which, as Morisot reported: "delights her

and as for myself, I'm glad to escape my neighbors' insipid chatter. I also think my stomach will feel less upset with this change of diet." She and Julie wrote frequent letters to the entire Manet family: "I'll write to your mother tonight or tomorrow morning. Bibi is writing to Uncle Édouard."

Manet passed on Impressionist news. Durand-Ruel was selling Sisleys for high prices, Renoir was doing even better, Pissarro had asked Édouard to join the exhibition, but Manet again declined in favor of the Salon. Eugène was convinced that the Impressionists had never produced finer paintings, that Morisot's work looked splendid, and he proudly put high prices on his wife's pictures.

About her own work Morisot was as self-effacing as usual: "Aren't I making a fool of myself there? I've got that kind of feeling, but I'm becoming very philosophical. These sorts of things don't give me the heartache they used to." She was sure her husband had handled everything perfectly: "I trust you absolutely"; "There isn't anything I would change." She was not displeased that Sisley and Pissarro had won critical praise, but thought Monet should as well. She didn't take all critics seriously. When the copy of the *Figaro* with the hated Wolff's article was accidentally destroyed, she pronounced that it "only got what it deserved. Is it possible to have less artistic sensibility than that creature and to have a more insufferable self-confidence?" She particularly asked after Cassatt, regretting her abstention without knowing its cause.

But above all Morisot fretted about her husband and his wellbeing, eager to hear he was comfortable and panicked by reports of even a cough. She who notoriously neglected herself tried to set a good example.

> Do as I do: I take care of myself. I find remedies all by myself that work and I'm sure you're not doing anything to make yourself feel better. . . .
> I can't tell you how upset I am to know you're not well. Write me and *tell me how you are.*
>
> With love,
> Berthe

Morisot underlined "tell me how you are" twice. Husband and wife were equally reserved. Only such slight emphases punctuate

the calmly affectionate and trusting tone of their correspondence. Each understood how much such hints could mean.

The Impressionist Exhibition was a mixed success. After an initial flurry of visitors, attendance dropped off, and in the end all the exhibitors lost money. Critical reaction, on the other hand, was by and large favorable. Pissarro could write to his niece on March 20: "We are very pleased with the result, our reputation is affirmed more and more, we are taking our definitive place in the great movement of modern art."[6]

Eugène Manet ran into Cassatt at the show. Making it clear that her refusal to exhibit had no bearing on her relationship with Morisot, Cassatt proposed painting Morisot's and Julie's portraits. Manet agreed on the condition that Morisot paint hers. Unfortunately, these projects were never carried out. As Eugène understood, they were a pretext to "cultivate closer relations."

V

ENDURANCE

1883 - 1895

16

Loss

1 8 8 3 – 1 8 8 6

By May 3, 1882, the Morisot-Manet family was back in the rue de la Princesse house in Bougival, where they would stay until their new home was finished at the end of the winter. A few weeks had been spent in a furnished apartment at 3 rue du Mont-Thabor, near the Tuileries gardens. In Bougival they were not far from Édouard and Suzanne Manet in Rueil. Édouard was very ill with nervous ataxia. He tried gaily to pretend he would get better, painting sensuous pictures of beautiful women and flowers. In his Rueil garden he also sketched Julie. The picture was what one could expect for an hour's effort, but Morisot cherished it. It was the last token of their relationship.

He sickened in the following months and, after vain attempts to halt gangrene with the amputation of a leg, died on April 30.

169

Morisot, closer than ever to the Manet family, had witnessed Édouard Manet's final weeks. She wrote to Edma, comparing his death to their mother's:

> These last days have been very difficult: atrociously painful for poor Édouard! His appalling agony! Once again, I've witnessed death at close hand in one of its most dreadful guises.
>
> Add to these almost physical emotions the friendship now of such long standing that bound me to Édouard, an entire past of youth and work collapsing, and you'll understand how shattered I feel. . . .
>
> I'll never forget the old days of friendship and intimacy with him, while I posed for him and while his ever-delightful wit kept me alert for those long hours.

To a friend she wrote: "his was a charming character, such a vital spirit, so young, that it seemed as if death should strike him less than others." Almost simultaneously, Morisot learned that Eva Gonzalès had died after childbirth, as she lay in bed weaving a mortuary crown of flowers for Édouard Manet.

Mme Manet came to stay with Morisot and Eugène in their new home, where friends and colleagues arrived to pay condolence calls. "I'm very close to Eugène and Berthe," she wrote to Suzanne Manet in Holland, "they are both full of care, consideration, and affection for me." She added in her next letter, somewhat ambiguously: "My dear Eugène is so attentive to his terribly unhappy mother! I'm afraid I'm causing them a lot of trouble. All these visits are a great nuisance for Berthe." Apparently Mme Manet still had difficulty accepting her daughter-in-law's professional commitments. Morisot and Eugène bought Édouard's grave plot in the nearby Passy cemetery, already planning to be buried themselves beside him.

As it so often happened in Morisot's life, artistic and personal events counterbalanced each other, as did sorrow and achievement. Just as Édouard Manet's life ended, the two-year building project at 40 rue de Villejust reached completion. Morisot, Eugène, and Julie moved into the ground-floor apartment and rented the floors above. The rooms in their new home, arranged on two levels, were not large, with the exception of a vast and

high-ceilinged living room. This room was to be the center of Morisot's art and social life for the next nine years.

Painted white, edged with classical moldings, the room had high windows, whose cream-colored shades equalized the light that flooded in and reflected off a gleaming parquet floor. Morisot filled the room with Japanese screens, Japanese prints, and Empire furniture that were admired and remembered by many of her guests. In early 1884 Monet offered a decorative panel to place over the main door—"you can guess that I accept with pleasure," she told Edma—but sensing, correctly, how long he might take, she went to the Louvre to copy a portion of Boucher's 1757 *Venus at Vulcan's Forge* to provide herself with some temporary decoration.

It was in this room, to all appearances a normal living room, that Morisot chose to work. She had a closet with a nearly invisible door built behind a wall. When night came or visitors arrived, her equipment was whisked away from sight. The apartment's flower garden offered her a secluded and private bit of nature. Even her dining room, with its faience oven, its sideboard, and its round wood table, occasionally functioned as a painting site. Like many contemporary women writers, who composed their novels in parlors, Morisot was refusing to segregate her work from household life. In her living room, she was at once wife, painter, mother, and hostess. One of Morisot's old friends, Rosalie Riesener, remembered the way she presented herself at the easel, professional but avoiding the dreaded "bluestocking" persona:

> She looked for a long time, her gaze was piercing, her hand skilled at applying the brushstroke on the canvas. . . . She saw everything as a painter while appearing as little like a woman painter as possible.[1]

By the beginning of July 1883 she and Julie had gone back to Bougival for the summer. It was still a magical place. Later she told her daughter of her Bougival days: "It was the happiest time of my life." Eugène could only join them for part of the day and had to spend his nights in Paris: his mother had suffered a paralyzing stroke, and both he and Gustave stayed by her side.

From Bougival, Morisot wrote her ne'er-do-well brother Ti-

burce about a mysterious exhibition of modern art he thought he might organize. The exhibition never took place, but it occasioned a cogent estimation of her peers. Monet and Renoir headed her list: "they're people with immense talent"; Sisley came next, with Degas (but he was so impossible he would contribute nothing, she added); Cassatt should be taken into account. In another category altogether were painters nominally modern but whom Morisot recommended mainly because they were successful in a worldly way: Fantin-Latour, Jean-Charles Henry Cazin, Lerolle, John Singer Sargent.

She delivered her artistic opinions cheerfully; family matters were sadder. Morisot defended herself to Tiburce against his accusations of neglect or indifference, pleading more for Julie than for herself:

> I don't know why everyone feels justified in doubting my feelings, you first among them. I wended my way back from Paris to Bougival very sadly last night, ruminating on the past and the future. . . . Why do you say I never write, when it's you who never writes?
>
> Send me one of your recent photographs, not the one in which you're long, so long, the other one. . . . As for myself, I'll send you Bibi; she's all that I love, all that's left to me of youth and beauty, and I don't want you to forget you have a niece; a niece of whom I'll make a very chic woman.

"Everyone feels justified in doubting my feelings." The theme recurs in Morisot's correspondence throughout the rest of the 1880s, and what she meant by "everyone" was her sisters, her brother, and some of her oldest friends. Edma felt a distance growing between them. Berthe responded: "Is it you? Is it me? I don't know anymore. . . . So let's each say her mea culpa and start the year 1884 under new auspices." Yves would say toward the end of the decade that "for fifteen years and more, a real wall of ice" existed between them, telling of "wounds so ancient I thought they had healed." Berthe answered somewhat impatiently that she "deplored" Yves's expressions, and "You'll recognize your deep injustice when you've grown calm in spirit." A passage in a notebook at about the same time, around 1890, explains something of the tension. Berthe felt that Yves chose to

see only the attractive aspects of her life, "she perceives me and sees me only as a model," whereas "I couldn't accept life if I didn't consider it the trial it has become."

With Yves matters could always be mended, but Berthe became more deeply estranged from Tiburce during this time. She had his stepdaughter, Alice Gamby, to stay for two weeks in the spring of 1890, which only convinced her more fully of her brother's fecklessness and especially his wife's. Nonetheless, after 1892 she bitterly regretted whatever unknown incident had precipitated a break; all we know is that she had chosen to side with her husband.

"Disdainful," "exacting," "cold": these adjectives slip through in some descriptions of Morisot—even eulogious ones. She certainly did have exacting standards of professional and personal behavior—to which she held no one more strictly accountable than herself. In Morisot's private writings, no one is criticized more ruthlessly than herself, no one else's failures are dwelt on at greater length. And what she inflicted on herself would have been daunting to those around her. Even if she said nothing, her rigorous attitudes alone could have been interpreted as a reproach and her own self-discipline perceived as coldness toward others.

Morisot was also very careful with her time. She had priorities: Julie, painting, Eugène, a few selected friends. To protect them from incursions, she resisted the myriad temptations or demands that whittle at everyone's day, especially a woman's, and can end up squandering a lifetime. No doubt Morisot was what the French delicately call *difficile,* or even *impossible,* meaning something like "intractable" or "to be approached gingerly." But a limit had to be drawn somewhere, and the greater the goal, the more tightly the limit had to be drawn.

It can't have been pleasant for Morisot's siblings and childhood friends to realize that they no longer ranked high enough among her priorities to enjoy the same relationship to her they had in the past. It was even more awkward to confront the widening gap between their way of life and hers. Morisot's art brought her ever more closely into a circle of friends who dominated French cultural life, and her marriage had reinforced her professional position and made her substantially more wealthy

than the rest of her family. Also she had developed strong loyal-
ties to the Manet family, which implied more than it might seem.
Eugène, especially, held opinions, notably on religious ques-
tions, squarely opposed to Yves's, Edma's, and Tiburce's. When-
ever any conflict arose, Morisot sided with Eugène, and she re-
sented any imputations raised against him. (Conversely, she was
quick to appreciate any sign of fondness for him.) Morisot never
disavowed her family: on the contrary; but as time went on she
ineluctably had less in common with them.

From this she derived no satisfaction. She had carved out for
her art a space in her life that sometimes seemed vainly ambi-
tious and emptily unproductive. Her discouragement was not
enough to keep her from working, but it caused some nostalgic
sadness for options she herself had foreclosed. She wrote to a
friend, probably in the winter of 1886–87:

> I don't know if it's I who have reason to complain about
> others or they about me,—but the fact is I seem to live
> apart from everything that meant so much to me in my
> youth. . . . We live very much alone. Our little circle is
> becoming empty, some are sick, others have gotten used
> to our distance—well! age is making itself felt to the two
> of us and my poor darling [Julie] doesn't yet exist in the
> eyes of the world. This winter seems long to me, intermi-
> nable. I see Yves very little, I never hear anything from
> Edma—that's that!

Within a year of his brother's death, Gustave Manet too began
to weaken. Eugène tried to rally him with a stay in the Midi in
the late fall of 1884. Morisot and Julie saw them off at the train
station; Julie recalled how "sad" her uncle looked. Morisot wrote
to Eugène: "I embrace you, my dear friend, and I envy you the
mimosas' aroma. Do you recall fond memories, at least?" Gus-
tave died at the end of the year. His mother followed him in
January 1885, unaware of her son's death.

17

La Grand Dame de la Peinture

1 8 8 4 – 1 8 9 1

"I'm beginning to become friends with my Impressionist colleagues." So Morisot wrote to Edma in the beginning of 1884. After more than a decade of common intellectual endeavor and organizational struggle, Morisot was starting to feel comfortable with her fellow painters. It is one thing to be colleagues, even close ones, and another to be friends. As she consolidated her ties to Mallarmé and the Impressionists, Morisot began to assume a more active role in Parisian artistic life.

Édouard Manet had left dozens of canvases in his studio, an impecunious wife, and a reputation still appreciated only by the avant-garde. Morisot joined with Eugène and Gustave in planning a retrospective exhibition of his work at the École des Beaux-Arts and a subsequent studio sale. Édouard had been a

close friend and then her brother-in-law. He represented her youth. When she had had to deal with him on a regular basis, his fecklessly dashing behavior had been frustrating, but now, with distance, as she thought she felt herself aging, his vigor acquired new value. Morisot wrote confidently about the exhibition to Edma on December 31, 1883:

> I think it will be a big success, and that all this young vital painting will make the Beaux-Arts palace vibrate, accustomed as it is to dead art. It will be a revenge for so many disappointments, but revenge the poor boy will take underground.

She exulted after the show's opening on January 3:

> All in all it's a great success. The discerning public is surprised to see the strength his work acquires when shown all together in this way. There's a sureness of execution, a masterly technique, which impresses even the ignorant and stuns us all.
> . . . The morning of the opening, Stevens, Chavannes, Duez were saying: "Not since old Ingres have we seen anything so strong," and we, the true faithful, say: "It's much stronger."

She and the Manet brothers placed high hopes on the sale, to be held February 4 and 5, for financial reasons but also as a confirmation of Édouard Manet's stature. Morisot wrote to Edma: "I believe everything would fetch high prices if we weren't in a time of general crisis," and confided: "I want to buy one, if I can; I even have the ambition to get a large one."

Their hopes were dashed. As Morisot put it to her sister: "The game has been played and badly played. This sale was an extraordinary debacle after the Beaux-Arts success." No museums had put in bids. Almost all the pictures had gone to relatives, close friends, or a small group of already enthusiastic collectors. Gustave, Eugène, and Suzanne Leenhoff Manet, along with Morisot, bidding somewhat transparently through the paintings expert Jacob, had had to buy back twenty thousand francs' worth of pictures in order to maintain prices at a semirespectable level. "The timing isn't good," Morisot wrote, "but all the same, it's a blow."

Her feelings were mixed, however. She felt the affront to
Édouard Manet's memory, and she wondered whether her
daughter would mind in the future that a chunk of her inheri-
tance had been converted into paintings. On the other hand, she
was delighted to have acquired, not the one masterpiece she had
dreamed of, but three. Added to another large picture of his
which she and Eugène already owned, five or six smaller works
also bought at the studio sale, the tiny *Bouquet of Violets,* and
two of his portraits of her, she was now a Manet collector in her
own right. She wrote proudly and prophetically to Edma: "I'm
sure you'll be carried away by *Madame de Callias;* I'm crazy
about it. . . . I shall only let go of it when it's admitted to the
[Louvre] Museum and that will happen, if not in my lifetime,
then in Bibi's."

Perhaps projecting her own gratification, she consoled herself
in the same letter with the idea that prices had been as good as
could be expected in bad times, and that the pictures had gone
to connoisseurs who appreciated their true worth. The future
would bring a more complete rehabilitation, she reasoned, than
what was possible in the present.

Meanwhile Morisot turned her salon-studio into a little Manet
museum. Her own work occupied a very secondary place. She
hung some of her portraits of Julie in her bedroom; a few small
works perhaps could be seen in hallways or staircases. Morisot
kept most of her own paintings unframed and stored.

She had bought a marine painting by Édouard Manet for
Edma and Adolphe Pontillon, thinking the navy man would like
the subject, but he was more offended by a breach of marine
etiquette (the placement of the captain) than impressed by the
picture's formal qualities, so she and Eugène decided to give the
picture instead to Degas, who responded: "You intended to give
me great pleasure and you have succeeded. There is more than
one intention to your gift, the delicacy of which you will allow
me to be feel deeply."

In the interim, Durand-Ruel had continued his 1882 policy by
organizing an Impressionist Exhibition on his own, this one in
London. It opened on April 21, 1883, and included three paint-
ings by Morisot, though his shows that same year in Berlin,
Boston, and Rotterdam apparently included none. Durand-
Ruel's initiatives made the Impressionists uneasily aware of

their reliance on him. As the art historian Martha Ward has pointed out, this feeling incited the Impressionists to hold an exhibition without Durand-Ruel to prove their independence. Who better to turn to, in that spirit, than Morisot and Eugène Manet?

Morisot had never gotten along as well with Durand-Ruel as had Renoir, Monet, Sisley, and even Pissarro. While he had sponsored her work in his group exhibitions, albeit in small numbers, he bought almost nothing from her after 1873. Morisot suspected him of having little respect for her painting, a suspicion probably exacerbated after 1882 when he began to buy in considerable quantity from Mary Cassatt, eliminating the excuse Morisot, or he, may have made that he did not buy her work because she was a woman with an income of her own. Not that Morisot desperately wanted to sell, but she did very much want to be acknowledged. In any case, she and her husband were ready in the fall of 1885 to support an exhibition consciously apart from Durand-Ruel's influence, both financially and administratively.

But what did their independence mean? The Impressionists did not want to escape bondage to the Salon only to fall into the grasp of dealers. Artists in and outside of the group chose different means of resistance. Monet decided that the best foil to a dealer was another dealer. By 1882 he was courting the good graces of Georges Petit, a more fashionable and overtly mercenary man than Durand-Ruel, and more solvent as well. In 1885 Monet received a coveted invitation to participate in one of Petit's International Exhibitions. These shows, held yearly, grouped together artists less controversial and more salable than most Impressionists seemed to be at the time. Exhibiting at one of Petit's shows set the seal of approval on artists and withdrew them from the artistic margins.

Meanwhile, at the opposite end of the political spectrum, artists even more dissident than the Impressionists had formed in 1884 the Société des Indépendants. Large, incoherent, and hedged about with rules, the Société did not give much scope to individuality.

The Impressionists reverted to the model they had devised twelve years before, and Morisot was the first to support it. As early as the winter of 1885 she tried to galvanize her colleagues,

but without success, for the memory of Degas's tyranny was bitter and old grudges persisted. She wrote to Edma, for once giving herself some credit, mixed though it was with self-criticism:

> I'm working, there being the possibility of an exhibition this year; everything I've done for so long seems to me so horribly bad that I would like to have something new and above all better to show the public. This project is very much up in the air, Degas's cantankerousness makes it almost unfeasible; in this little group there are conflicts of pride that make any agreement difficult. It seems to me that I'm just about the only one without a pettiness of mind, which is a compensation for my inferiority as a painter.

No agreements were reached that year. Not until the next fall did the project gather momentum, when it was seconded by Pissarro and Degas. On December 7, 1885, Pissarro cajoled Monet: "The two of us, Degas, Caillebotte, Guillaumin, Mme Berthe Morisot, Miss Cassatt, and two or three others would constitute an excellent basis for an exhibition."[1] The "two or three others" Pissarro tactfully refrained from naming were Seurat, Signac, and Redon, painters of a younger artistic generation whose Post-Impressionist style might have alarmed Monet. On October 30, Guillaumin, the only Impressionist who had joined the Société des Indépendants, had asked Pissarro to call on Morisot to plead his fellow society members' case. She was apparently won over, for Degas soon afterward assumed their participation had been favorably settled. Monet, however, was not won over. He, Renoir, Sisley, and Caillebotte declined to join. Degas had insisted, as was his wont, that no one could exhibit both with the "Impressionists" and with anyone else, meaning, in 1886, not just the Salon but another dealer like Petit. Pissarro wrote his son Lucien on February 16, 1886: "so tell Guillaumin how disheartened I was at what Monet said about the uncertainty of the exhibition, disheartened especially to see that not even Mme Manet was included; this is very serious."[2]

Morisot rallied; Degas, Cassatt, and another backer, Lenoir, joined her and her husband to cover expenses. Degas and Eugène Manet hunted for premises, settling at last on five rooms above

the trendy restaurant Maison Dorée, 1 rue Lafitte, across the street from Édouard Manet's old haunt, the Café Tortoni.

Seurat's and Signac's participation had been agreed on, but controversy revived when it came to which of their paintings they would show. Manet did not like Seurat's monumental *Sunday Afternoon on the Grande Jatte*. Pissarro defended it valiantly and had what he called a "serious quarrel" with Eugène. Degas was won over, pronouncing caustically after Pissarro's enumeration of its qualities: "I would have noticed that myself, only it's so large."[3] When the exhibition opened on May 15, the *Grande Jatte* was there, in a separate room with several other stunning pictures by Seurat and his disciple Signac.

The show ran until June 15, concurrently with the Salon, which was bold timing. Critics drew comparisons with Salon pictures but also, more significantly, between what was displayed at rue Lafitte and what they recalled Impressionism had been. For besides the strong presence of a new group, which would come to be known as the Post-Impressionists—Pissarro (temporarily practicing a pointillist technique), Gauguin, Seurat, Signac, and Redon (whose unassimilable work hung in a corridor)—Degas's work had become more idiosyncratic, convoluted, and self-referential. He showed many pastels, notably of milliners and women washing. As brilliant in execution as in conception, these images defied all aesthetic assumptions and placed Degas in a mystifying category by himself. Cassatt, as one critic astutely put it, "often calls to mind Berthe Morisot in her choice of subjects, though not in the nervous energy of the rendering."[4] Her plump toddlers and fresh-faced girls conveyed a solidity Morisot never sought. Only in Morisot's work—eleven paintings, plus watercolors, drawings, and fans—could critics find with relief the Impressionism they remembered and by now more or less accepted.

Durand-Ruel, meanwhile, undeterred by Paris art politics, was marketing mainstream Impressionism in America. His large and acclaimed exhibition opened April 10, 1886, at the American Art Galleries, was extended a month, then moved to the National Academy of Design. Morisot was represented by eight pictures made in Bougival or Nice. Durand-Ruel was trading in classics. The 1886 rue Lafitte exhibition marked the end of Impression-

ism's youth and the beginning of a new artistic movement. All the Impressionists, including Morisot, had become—at least in the eyes of cognoscenti—Old Masters.

With a beautiful new home of her own, Morisot, in a constructive reaction against isolation and in an affirmation of her artistic stature, began in 1886 to entertain regularly.

Friends were all the more welcome because Eugène could no longer go out to meet the world. Organizing the 1886 exhibition had been his last public effort. That year marked the onset of a lingering illness he would never shake. He left the house less and less. By the winter of 1887–88, Morisot would have to write to a friend: "my husband is coughing badly, almost never leaves his room; just picture to yourself a sick man, sitting on all the furniture, greatly to be pitied and no less high-strung."

Entertaining distracted Eugène, and pleased Morisot for that reason. The protracted illness and confinement of one partner inevitably leads to ambivalent emotions in couples, no matter how much they love each other, if only because dependence upsets the emotional equilibrium of previous reciprocity. Morisot needed a new outlet for her energy and found it in revivifying contact with active friends.

Echoing her mother's and mother-in-law's soirees, she chose a fixed day, Thursday, to give dinners, which became as famous for their refinement as for their company. Her guests appreciated the serene elegance of the decor, the piquant variety of the menus, and above all the caliber of conversation. Guests included artists: the sculptor Paul-Albert Bartholomé, Caillebotte, Cassatt, Degas, Fantin-Latour, Monet, Puvis de Chavannes, Renoir, and Whistler; musicians such as Emmanuel Chabrier; writers such as Mallarmé and Régnier; critics and friends such as Duret, Camille Mauclair, and Zacharie Astruc; politicians, especially Émile Ollivier; together with family members, particularly Eugène Manet's cousin de Jouy, who was taken aback but charmed by Mexican rice or chicken with dates as well as by his dinner companions. Mallarmé, in his essay on Morisot, evoked with his opaque but brilliant prose the exquisite atmosphere of these evenings:

these intimate receptions where, the necessities of work having been banished, even art was far away though immediate in conversation equal to the decor ennobled by the group: for a salon, above all, imposes itself, with a few habitués, by the absence of others . . . knowing that here in this drawing room, rarefied by friendship and beauty, there was something in the air, something strange, that they had come to indicate by their small number: the luxurious exclusion, though they gave it no thought, of everything outside.[5]

Morisot's most faithful guests became her closest friends in these years between 1886 and 1891: Degas, Monet, Renoir, and Mallarmé. Years after her death, Degas, Renoir, and Mallarmé were still tied by their common guardianship of her daughter and nieces. A famous photograph by Degas commemorates the group Morisot brought together, when they were gathered in one of the apartments at 40 rue de Villejust.

Degas had been, of course, a close if exasperating friend of both Morisot's and Eugène Manet's for almost twenty years. He behaved better with them than with almost anybody else. Somehow Morisot even managed to reconcile him with the other Impressionists, who had so much resented his handling of the later exhibitions. Degas grew extremely fond of Julie and her Gobillard cousins. Although he withdrew increasingly from social life, he was in and out of 40 rue de Villejust on a regular basis, grouchy as usual with other guests but delighted, in fact, to meet Renoir and Mallarmé. He sometimes fell asleep during conversations or readings after dinner, a sure sign of feeling quite at home. Just as he had exchanged books with Edma Morisot in their youth, he continued to lend and borrow with the Morisot-Manets. He teasingly told Eugène in a letter to convey "a thousand best wishes to your terrible wife"[6] and mocked himself in another salutation: "trust in my unsufferable friendship."

Monet never became as close, if only because he lived at Giverny, on the Seine north of Paris, and came to town just for visits. Success had arrived, and he was settling into it contentedly. He was married to Alice Hoschedé, Ernest's widow, now a capable matron who brought him a large family and made his life at Giverny very comfortable. In the 1880s Monet was still creating

the Giverny we know today in its restored state. The lily ponds and exuberant flower borders he painted so many times were being planned, planted, or built. His pictures were selling well and reliably, freeing him from all financial anxiety and establishing him as one of France's great nineteenth-century painters.

Morisot keenly appreciated the quality of his work, in front of which she once said: "I always know on which side to lean my parasol." As for the decorative panel for her door: "I'm very afraid," Monet wrote, "that you won't like it." This occasioned an extended and mutually laudatory correspondence between the two, interspersed with invitations to each other's homes, many of which were accepted. Julie, "your sweet little girl," played with Monet's children and stepchildren, whom she would continue to see for the rest of her life. In July of 1890 Morisot brought Mallarmé to Giverny for a long-sought visit. Monet offered the poet a painting; Mallarmé, modest as usual, without Morisot's encouragement would have passed over the one he truly longed for, a landscape of the neighboring countryside with a smoke-spouting train. Riding back to Morisot's house, where he was staying, with the picture on his knees, he pronounced: "One thing that makes me happy is to be living in the same era as Monet." Morisot agreed. Though she confided to her niece one reservation about Monet's work, wishing he would paint more varied subjects "instead of the same repetitions," she couched her criticism positively: "I find he has exhausted the subject of the simple landscape and that no one has the courage to attempt what he has so completely rendered." During his 1888 Goupil show, Monet had written Morisot: "I would be eager to know what your impression was," and Morisot had replied:

> You've conquered it indeed, this recalcitrant public. One only meets with utterly admiring people at Goupil's, and I think there's quite a bit of coquettishness in your query about the impression produced; it's a dazzling sight! and you know it very well.

She finally felt confident enough to write him: "My dear Monet, with your permission, I set aside the Dear Sir and address you as a friend." Monet and Morisot's friendship helped make possible the gift of Édouard Manet's *Olympia* to the state. The

idea occurred to Monet as he visited the room devoted to Manet's work at the 1889 Exposition Universelle. When it had been first shown in 1865, this magisterial image of a courtesan had shocked and offended most viewers and critics. Too threateningly contemporary, too stylistically radical for ordinary tastes, *Olympia* had been immediately acknowledged by an artistic elite as an icon, the painting from which modern art could date its beginnings—a modern art still dismissed by official French art institutions. Monet's idea was to buy *Olympia* for a high price that would demonstrate its value, then donate it to the state on the condition that it hang in the Luxembourg Museum, the most honorific exhibition place for work by living or recently dead artists. Thus the state would be forced to acknowledge modern painting and Manet's role in its history.

Olympia still belonged to Suzanne Leenhoff Manet, who needed money (as usual). But the real purpose of soliciting contributions toward a substantial purchase sum was less to fund Mme Manet than to demonstrate to the state how much support Édouard Manet's painting could muster, and from whom. The campaign began in the fall. Morisot acted as liaison with her sister-in-law, followed every step and orchestrated several herself, personally tapping many of her artistic connections. She and Monet communicated regularly. But she was loath to put herself too far forward, for fear the government would interpret her role as family intriguing rather than professional lobbying. She wrote Monet in the middle of November: "You alone, with your name, your authority, can break down the doors if they can be broken down." Monet raised 19,405 francs, prevailed, and asked her impatiently what she had thought at the sight of *Olympia* hanging in the Musée du Luxembourg. She replied:

> It's true, my dear Monet, that I seem to have forgotten you, but it only seems that way, for I thought of you often during the entire week of the Luxembourg's reopening; believing every morning that you would come eat with us. It's that expectation which kept me from immediately giving you my impressions; and I owed them to you. They are, in fact, absolutely identical to yours . . . she's simply wonderful and the public looks as though it's beginning to realize it. In any

case we've come a long way from the stupid jokes of yester-
year.

Olympia, of course, eventually went from the Luxembourg to
a museum devoted entirely to Impressionism, the Jeu de Paume,
and from there to the present museum of the nineteenth century,
the Musée d'Orsay.

Monet's only rival among living painters in Morisot's esteem
was Renoir. Success had brought him security as well. At last he
had settled down, with Aline Charigot, an extremely pretty and
much younger woman who had modeled for him in the early
days of their relationship. They lived in Montmartre, a hilly
working-class neighborhood of Paris, which was then almost
rural. Renoir still hid this side of his life from middle-class
friends, leaving Montmartre alone in his suit and starched collar
to attend Morisot's receptions.

Julie's parents asked him among all the artists they knew to
paint her portrait in the spring of 1887. Renoir was an intimate
friend of the whole small family's. Morisot pretended he came
to the rue de Villejust only for Julie, and finally he retorted in the
fall of 1890:

> I think you're cruel to yourself and the godfather uncle [de
> Jouy], but since you can't imagine that anyone might come
> to see you, then I'm telling you that I will come, hoping you
> still have with you the young lady with the beautiful hair.
> So there! . . . A thousand best wishes.

He was almost like a relative, always welcome in their home,
always invited for extended stays in their country retreats. He
did come to visit and work with Morisot in 1890 and again in
1891 at Mézy. Like Monet, he encouraged her work, urging her
to finish paintings and exhibit. She often climbed the hill of
Montmartre with Julie to admire his latest paintings and draw-
ings. A milestone was reached in 1890 when Renoir finally intro-
duced his wife and his son Pierre to the Morisot-Manets. Perhaps
only years of friendship could have convinced him that they
were broad enough in their social views to accept a private life
so unlike theirs. Morisot was certainly astonished at Mme Re-
noir's considerable bulk but seemed oblivious to her social ori-

gins; she had no qualms, later, in leaving her precious child to the capacious care of the Renoir family. Morisot's ties to Renoir and to Degas demonstrate that in matters of friendship, talent and human qualities mattered as much to her as class. This became increasingly true in her forties and early fifties, as she moved farther from her own family and class origins toward a social life based on mutual artistic interests.

Of all her friends in the late 1880s and early 1890s, Mallarmé was the dearest. And the most intimate, paradoxically, because he, like she, was so reserved. Two intellects of similar mettle, they understood each other without entering into elaborations or confidences that would have offended their exceptionally acute sensibilities. Gentle and loyal, Mallarmé was Morisot's emotional lodestone, while she personified for him a feminine ideal he could completely respect. All accounts of Mallarmé agree on the depth and the tenor of his admiration for her.

Although he had first come into Morisot's and Eugène Manet's orbit in memory of Édouard Manet, he soon felt as comfortable in Morisot's salon as he had in her brother-in-law's studio. Eugène Manet fervently admired Mallarmé's poetry, apparently undaunted by its alleged obscurity. Morisot admitted to greater difficulty in understanding the poetry; the poet, however, utterly won her. He himself spoke of her "exquisite sensibility," and his friend Régnier remembered "the respectful affection and lively admiration Berthe Morisot inspired in him."[7] Duret said that Mallarmé "had a true devotion to Berthe Morisot. He admired the talent of the artist and felt the charm of the woman."[8]

By the winter of 1886–87, Mallarmé was convinced enough of her artistic gifts to ask her, along with Renoir, Monet, Degas, and the sporting artist John Lewis-Brown, for an illustration to a collection of poems and prose called *The Lacquer Drawer*. Already he had hung a painting of Morisot's in his dining room, where he held his famous literary evenings; two Manets, a Whistler, a Redon, a Rodin plaster, and a Gauguin wood carving also hung there. Morisot's assignment was "The White Water Lily." The project went unrealized but induced Morisot, with the guidance of Lewis-Brown and Cassatt, to experiment briefly with print-making.

Morisot's and Mallarmé's friendship throve on mutual admira-

tion. She wrote to him chidingly: "I want to add my admiration to the public's even though you have such disdain for women." Later she teased him about some dicta of Degas's, hinting finally: "So you want to know Degas's secret: Well, then, it's rather rude about me and flattering about you. Are you happy? and I'm not humiliated at all since it's a question of your superiority."

She joked about his famous Tuesday evenings, meeting place of the (masculine) French literary avant-garde, and her exclusion from them—"Julie and I will dress as men and go to your Tuesday at-home"—until he called her bluff and invited her, at which she hastened to respond half seriously, half mockingly: "No, definitely not, the student bench would really intimidate us."

Mallarmé responded in kind. "Painting? the orchard, the studio, there's so much I'd like to know, of which you may judge me unworthy." After her death, Mallarmé evoked Morisot's austere charm:

> my satisfaction . . . at reading in a fellow comrade the same timidity that I, for so long, felt toward the friendly Medusa, before my happy resolve to force the whole issue by my devotion. "By Madame Manet's side," concluded my paradoxical confidant, a refined conversationalist among the great young poets, and of an easy bearing, "I feel like a boor and a brute."[9]

Mallarmé found Morisot's salon so congenial that he liked to meet his friends there. Hence when Eugène Manet read the eulogy to the poet Villiers de l'Isle-Adam that Mallarmé had first delivered in Belgium, and enthusiastically suggested he give it a first Parisian reading at 40 rue de Villejust, Mallarmé gladly accepted. The French intelligentsia gathered on the evening of February 27, 1890. Monet had responded to his invitation from Giverny: "Of course I'll make the trip, and with pleasure! But then, I'll have to dress for the occasion." In return for their hospitality, Mallarmé sent Manet and Morisot a copy of his talk, signed with a poem.[10]

To one of Mallarmé's recruits, the "paradoxical confidant," the writer Régnier, we owe the most substantial description we have of Morisot during this period.

Tall and slender, extremely distinguished in mind and man-
ner, an artist with the most delicate and nuanced talent,
Berthe Morisot was no longer, when I met her, the strange
dark-haired creature whose features Manet had captured in
his famous painting *The Balcony*. Her hair had gone white,
but her face had retained its enigmatic singularity and its
fine regularity, its expression of taciturn melancholy and its
fierce shyness. Dressed with sophisticated simplicity, she
seemed lofty and distant, with a sort of infinitely intimidat-
ing reserve that she broke only with a few words, but from
her coldness emanated a charm to which you could not
remain indifferent.[11]

A sort of lofty timidity made her refrain from any self-
promotion. She wasn't among those who like to put them-
selves forward. She practiced her art with discretion, ac-
cepted the esteem, the admiration due her talent but did
nothing to provoke it. Berthe Morizot [*sic*] was completely
retiring. Who would have dared address her with any crude
praise or exaggerated eulogy?[12]

His description is echoed by Tiburce Morisot's:

The attitude of her entire life was rather introspective, and,
apart from her daughter certainly, her husband maybe, no
one, I believe, surprised her in any demonstration of feel-
ings, which were all the more keen for being contained.
 She remained meditative, mysterious, like all those in
whom silence is due not to deficiency of thought but to a
disdain for its expression.

18

Art Closer to Home and Farther Abroad

1 8 8 5 – 1 8 9 1

Taking stock of herself in 1885, Morisot made three self-portraits. She had made one or two before, and she would make a few afterward, but none approach those of 1885 in intensity of examination or fullness of execution. These paintings as private acts of self-scrutiny turn Morisot's critically lucid gaze back on herself and leave us with an image of the artist and the woman at a turning point in her career.

A pastel. A fragile thing on paper, with little material substance. This woman who sees herself in the mirror might vanish at any moment. No place, no body, no signs of class or time, almost none of gender—just a questioning gaze, soliciting nothing, remorselessly self-appraising. No flattery, no excuses, no conviction other than the necessity of looking.

An oil painting. This time there is a body, full and strong, erect and poised. The face is fuller, and the gaze only glances past us, attentive to something else. Beside the woman is her child, a sketchy figure by comparison, but clearly there, turned toward her mother.

Another oil. A classic artist's self-portrait, palette in hand. The artist's figure fills the canvas, and she looks right out at us, levelly, coolly, unshakably.

Three images or three aspects of one woman's character: a woman always unsure of herself and her work, and so self-deprecating as to be tedious were it not for the counterpoint—her awe-inspiring effect on others; a woman braced by maternity and in love with her child; and finally a painter persistent and confident in her art, belying in practice everything she claimed in writing. These three elements were held in perfect equilibrium during the years between 1885 and 1891, when artistic events, even more than those before, were inextricable from her personal life. Family outings became artistic expeditions, vacation spots painting sites, moments with Julie pictures. And for the first time we have some sense of Morisot's private estimation of her art and life, and even the relationship between the two. Several notebooks dating from around 1885 have survived, tiny pads in which Morisot jotted down impressions and ideas, and in their pages we can witness the dual development of Morisot's persona. In public she was the grande dame of painting, the inaccessible, aloof arbiter of intellectual life. In private she engaged in an ongoing process of self-examination, revealed in part by her 1885 self-portraits.

Morisot worked while she raised Julie. Not only did she use her child frequently as her model, but she used painting as a form of pedagogy, and as soon as Julie was old enough, mother and daughter painted side by side.

Formal education in a *lycée* had long been customary for boys, but no one yet expected girls to attend school. Morisot sent Julie to a private school for at least the winter of 1887–88, but she and Eugène were responsible for most of their child's learning. Morisot described her ideas on raising children and training their

minds to Edma. She thought it was important for children to learn to express themselves clearly and elegantly in writing as early as possible; nothing, she thought, would inculcate that skill as well as daily practice. She who had disciplined herself so rigorously in visual expression judged her verbal aptitudes long since dissipated.

> I've never known how to write four consecutive lines that make sense, thanks to the indolence of my youth. . . . Well, let Jeannot develop at his own pace; if I were you I would choose reading material with discrimination; no silliness, no sentimentality, no pretentiousness, as much good old French as possible. We're all born monkeys before we become ourselves; therein lies the danger of bad examples.

Elsewhere Morisot recommended against stuffing a child's head with lessons or pushing her too fast, in order that the child's personality be strengthened, not stifled, by intellectual rigor. She wrote an account in her notebook of an educational stroll with Julie in which history, art history, astronomy, morality, and analytical seeing glided together. Julie was then six and a half years old.

> Stroll with Julie in Paris, down the rue Bonaparte. At the photographer's on the corner of the rue de Beaune, looked at reproductions of Botticelli's *Spring,* picture which I saw once in Florence and which didn't give me the same pleasure then, is it because I understand it better now, or does it really gain from being seen in black and white. The colors of the [Botticelli] frescoes in the Louvre, though, are so impressive.
>
> We wander along the quais, the little one questioning me about everything; we looked for a long time at the sun and planets at a map dealer's; then farther on, Debucourt's *Compliment,* Moreau le Jeune's *Little Godparents,* the *Departure from the Opéra* [eighteenth-century prints]. Julie asks for explanations, seeing or thinking she sees the blaze of the fire at the Opéra-Comique [a recent news item] everywhere. I tell her to notice that the costumes are not the same as now, but like those of Marie Antoinette.
>
> Then in the Tuileries [gardens], she recites Théophile Gautier's poetry for me. We look for Coysevox's nymphs, I

think they're all by Coustou [late-seventeenth, early-eigh-teenth-century sculptures]; we sit down, I'm thinking about my painting of the garden, studying the shadows and the light, she sees pink in the light, violet in the shadows.

Morisot was learning at the same time as her daughter, seeing partly through Julie's eyes. She altered her work habits to suit her child's schedule and attention span. The tiny and casual "notepads" of her youth reappeared, accompanying her wher-ever she went just in case an opportunity to sketch might arise. She taught Julie to read partly by making her an illustrated alphabet, each letter or group of letters accompanied by a water-color, many of which later found their way into Morisot's oil paintings. When in 1888 someone offered Julie a box of color crayons, Morisot seized on them as eagerly as Julie and adopted them for her own drawings. As a result, she developed an idio-syncratic drawing style based on color and saturated with vi-brant bright tones of blue, yellow, green, and violet. The crayons joined her watercolor box and sketchpad in her equipment bag.

By this time the advantages of a daughter were becoming clear. A boy would have gone off to school and gradually entered the world of men, becoming less and less like his mother in his habits and tastes, whereas every year Morisot could share more with Julie. Bereft of her closest woman friend, Marcello, and drifting away from her sisters, Morisot found a daily companion in her daughter.

No matter how close a husband and wife might be, the texture of everyday life was perceived differently by men than by women in the nineteenth century. Although she was exception-ally self-reliant in many ways, and in some respects intellectu-ally closest to her male friends, all her life Morisot was sustained by her relationships to women family members or friends. Of course, Julie as a small child required care, imposed responsibil-ities, and could not enter into her mother's adult concerns. But it was in her company that Morisot felt most relaxed and confi-dent, and as she taught her child the basics, she herself was able to reconsider the foundations of her art.

In the fall of 1885, after a summer stay in the forest of Com-piègne at Vieux-Moulin, near Yves (now a widow) and her chil-dren, Morisot felt a longing to see the Venice she had not reached

four years before because of Julie's illness in Florence. She wrote restlessly to Edma:

> I'm disoriented, perhaps it's only because of the change of season, but life seems dull to me, and besides, I'm disappointed; I had made up my mind and I had convinced Eugène to go spend a month in Venice, and now those cursed quarantines make my project impossible. I know from the Italians themselves that they are taking advantage of the opportunity to vent their antipathy toward anything French and creating innumerable vexations. . . . I did so want to get away and to get some sun again, some heat, to wander about the museums, the palaces, to see some different art. The north of Italy is unimaginably rich in that respect; there are of course a thousand things to see in Paris, and whatever one does, something different, and yet, through force of habit, one becomes jaded.

Instead, the family of three went to Belgium and Holland to see the Flemish Old Masters. Amsterdam delighted Morisot, especially its architecture. Rotterdam pleased her less. On the whole, though, as she wrote to Edma:

> I'm entranced by it, but the season is already late, making almost all work outside impossible, while everything that passes before your eyes makes you itch to paint.

Flemish painting received more mixed reviews. Rembrandt's work was not what Morisot had thought it would be; Hals seemed crass. She noted for herself:

> Rubens is the only painter who has rendered the Flemish sky. Hobbema and Ruysdael are heavy; only he has been able to find those tones of veiled light that give so much depth to his landscapes. . . . In Antwerp, in the *Assumption* in the cathedral, the figures of the angels in the sky seem to me to be the highest expression of this matchless genre. I'm sorry I saw them on the run, those paintings; they left a dazzling impression I would have liked to be able to study.

Julie, meanwhile, was bored in museums and, Morisot wrote in her notebook, wanted to be outside, and on the lookout for a toy windmill.

Her earliest surviving comments on the art of the past coin-

cided with the first advice we have of hers to a future painter. Morisot was too retiring and too modest to have had disciples in the public sense of the word. The only people she taught to paint besides her daughter were her nieces Paule and Jeannie Gobillard, Paule especially, to whom Morisot felt increasingly close in the late 1880s and into the 1890s. Paule Gobillard seems to have taken Morisot as her role model at an early age, emulating her art and her independence. Apparently she had written to her aunt in Holland asking for artistic advice, to which Morisot responded realistically: "You haven't come to the end of your struggles with painting. They will be infinitely varied but they will last a lifetime."

Back in Paris the next winter, Morisot reflected on the relationship between painting by her contemporaries and artistic traditions:

> Modern novelists, modern painters bore me, I only like extreme novelty, or else the things of the past; to tell the truth, only one exhibition amuses me: the Independants, and I adore the Louvre.

Could the most contemporary art be reconciled with the classics? Morisot visited Renoir's studio on January 11, 1886, saw his recent monumental paintings of bathers, and decided it could. She wrote in a notebook:

> He's a draftsman of the first order. All these preparatory studies for a painting would be curious to show the public, who generally imagine that the Impressionists work with the greatest speed. . . . He tells me the nude seems to him one of the indispensable forms of art.
>
> I'm very struck, too, by a view of Venice and another of Algiers. There's a very powerful sense of the Orient in these two canvases; all in all, he's a born artist, a great and fine draftsman as well as a colorist with *sensibilities* so exquisite as to be almost pathologically acute.

Inspired by Renoir's example, Morisot looked again at the eighteenth-century art that joined to drawing and meticulous rendition a sensual charm Morisot valued highly, though she admitted it somewhat unwillingly.

> Saw yesterday at a curio merchant's on the faubourg Saint-Germain an engraving after Boucher that was extremely improper and yet adorably graceful. That extraordinary man has every grace and every audacity; you can't imagine anything more voluptuous than this sleeping woman, her breast swollen with love.

Morisot went off to Versailles to copy parts of François Girardon's 1668–70 bas-relief on the fountain of Diana in the Allée des Marmousets, the same bas-relief Renoir had copied to inspire his bather paintings.

As for her contemporaries, she wasn't sure any were truly great, even Renoir and Monet: "All talented and not one a genius!!!" Besides Édouard Manet, only Ingres and Delacroix, above all Delacroix, had made "masterpieces" in recent decades. Thinking about Delacroix and his palette, remembering her brother-in-law's ideas, listening to Degas and Mallarmé, whose opinions she cites over and over, she called the whole idea of "realism" into question.

> On Thursday Degas said the study of nature was trivial; painting being an art of *convention*, it was better to learn to draw after Holbein—that Édouard himself, though he prided himself on slavishly copying nature, was the most mannered painter in the world, never executing a brushstroke without thinking of the Old Masters, not putting fingernails on hands, for instance, because F[ranz] Hals didn't draw them.

> Dinner with Mallarmé.

> Art is falsehood! And he explained how an artist is only sometimes an artist, and only by an effort of the will.

She extended her reasoning to music:

> Music and painting should never be literary, a very subtle distinction according to Renoir. As soon as I try to reproduce an individual in physiognomy and in gesture I become literary. This word "realist" has no meaning; any painter hoping to render nature can call himself a realist and none deserves the name in its absolute sense.

After the last Impressionist Exhibition, in June 1886, Morisot left with her husband and daughter for a summer stay in Gorey, a town on the isle of Jersey in the English Channel. There, as in Bougival, Morisot worked on a veranda looking out toward an open view, and once again she exercised her remarkable skill at rendering the oscillating effects of a very close foreground with a distant background in one corner of the picture. In Gorey, as on the Isle of Wight during her honeymoon, she could see a port out her window. Adjusting to the novelty of the perspective with the advantage of experience, she answered another plea for advice from Paule Gobillard:

> you're at the age of great enthusiasms. A love of nature is a consolation against failure. Old Corot used to say that nature wanted to be *loved,* that she gave herself only to her true lovers. You seem to me to be in excellent circumstances, it's just that right now you're probably confused by a new nature. . . . It's still the same for me every time I change "scenery," as the English say. It's only now that I am beginning to see this landscape. But don't worry about it. Do anything to practice precision, drawing, and tonal exactitude.

Morisot herself was working steadily toward two exhibitions she would participate in during the coming year.

In February five of her paintings figured in the avant-garde Salon of the Twenty in Brussels. Octave Maus, leader of the XX group, spoke of a "flag" under which artists campaigned for a free, sincere, and rigorous modernism: "In Paris, those who have rallied to the flag have been baptized *Impressionists.* In Brussels they're called *Vingtistes.* " Maus had thrilled to the atmosphere of the 1886 Impressionist Exhibition and subsequently invited Morisot, as well as Pissarro and Seurat, to join his group. A newspaper reported from Brussels that the Salon of the Twenty was the artistic event of the year; it was the place to see and be seen, even for opponents of avant-garde art.

Hard on the heels of the XX show came Morisot's first (and last) inclusion in Petit's worldly International Exhibition. Its 1887 installment included Monet, as it had the year before, and also both Pissarro and Sisley, as well as, among others, Rodin

and Whistler. Monet wrote to her in the spring, alluding to Impressionist quarrels the year before:

> I've just learned that Pissarro answered Petit by accepting; so he isn't afraid to be in such bad company anymore and his convictions aren't long-lasting. I daren't hope the same of Degas, unfortunately. Work hard, won't you, so that this time success will be decisive for all of us.

Morisot had asked Monet to ask Rodin if he could give her some advice on sculpture. Paintings, drawings, and prints of Julie had only whetted her mother's appetite. Now Morisot wanted to try a portrait bust. Rodin eventually came to the rue de Villejust and presumably offered sage counsel. Morisot noted: "I'm set on this idea: white plaster." But six days before the opening, disappointed by the translation of the bust from white plaster into terra-cotta, she wrote in her notebook bemoaning her own decision not to exhibit it and send paintings instead:

> Today, May 2, I'm sending my pictures to the *Internationale* with a great fear that they'll all look atrocious. The heartbreak of Julie's bust that turned out so awful in that vulgar pink; I'm in that feverish state that follows illness. God knows what lies in store for me next week. Maybe a magnificent fiasco; though what I really wanted was to exhibit sculpture and I dare not anymore. It's surprising how, when I'm in the grip of something, everything else becomes a matter of indifference.

Sometime after the opening she noted laconically: "Exhibition less bad than I had feared." Pissarro wrote more expansively to his son about Morisot's seven paintings on May 15:

> Madame Morisot does quite well, she hasn't moved, either forward or backward, it's very skillful. . . . Seurat, Signac, Fénéon, all the ranks and rear ranks of the young, look only at my canvases and a bit at Madame Morisot's.[1]

Although the object of exhibiting with Petit was to make money, Morisot did not sell anything; one picture had to be ceded to Petit as payment.

That summer, the summer of 1887, the Morisot-Manets spent several days near the Mallarmé family at the Plâtreries, between

Valvins and Samois in the Forest of Fontainebleau. Afterward they took a trip through the Loire valley, touring, visiting châteaus, and, in Morisot's case, copying paintings in the Tours museum. She later remembered the trip as being a very happy one. The view from Chambord's roof delighted her.

> this landscape that seemed sad to me at first now assumes truly grandiose proportions and becomes the most appropriate setting for this masterpiece of grandeur and elegance; it's rather like a magnificent tapestry from the past.

Blois had the same epiphanal effect: "Delightful terraces; view over the city, the Loire River, country vistas; I finally see what I hadn't seen at first: this landscape suffused with pearly and opalescent light." And on Chenonceaux: "Flowers here have a very great intensity, just as the fruit has great flavor." From there they went to stay with cousins of the Manets, the Vaissières, at their château, Vassé. The two families got along well.

The 1887–88 season passed much as had 1886–87—Morisot stayed in Paris, preparing exhibitions. A flattering advertisement appeared in the January issue of the *Revue Indépendante,* a prominent avant-garde magazine, inviting a list of artists including Morisot to contribute prints. Morisot prepared again for a group show that reunited several of the old Impressionist clan, this time at Durand-Ruel's, 11 rue Le Peletier. Morisot wrote back to Monet on March 14, 1888, after his inquiry about her recovery from a bad case of flu:

> You're very kind to feel any compunction with regard to me; the real truth is that bad weather and the passing years are the only cause of my illnesses; I'm becoming one of those old ladies with bronchitis. Anyway, here I am back on my feet and doing stern battle with my canvases. Don't count on me to cover walls.

The show opened on May 25 and ran for a month. Despite being set back by her flu, Morisot had managed to send three paintings, one pastel, and a watercolor. As usual, everyone praised Morisot, while she dismissed "my miserable pictures" and called her part in the exhibition a "disaster."

The following summer was spent in Paris, and the family de-

cided to winter in Nice again. Rents had gone down, so they were able to take a spacious green-and-white villa in a vast garden, the Villa Ratti, in Cimiez; at the time, Cimiez was, as Morisot put it, the "absolute countryside" on Nice's outskirts. They were installed by the first of November 1888. By the twenty-first, Eugène could write to their friend Lewis-Brown: "My wife is working; she's fallen in love with the aloes, the olive trees, and the orange trees, which reflect light in a spectacular way." Husband and wife invited all their best friends and sent gifts of citrus fruits and dried flowers northward. Renoir almost came but fell suddenly ill. The family, left happily to their own devices, went for excursions into the hills, painted, ate lunch outside. Morisot wrote a friend: "Julie's lessons keep me busy (painting also)." To Edma she explained:

> I wear myself out trying to render the orange trees so that they're not stiff but like those I saw by Botticelli in Florence; it's a dream that won't come true. . . . I can't understand why this country doesn't serve as a great studio to all young landscape painters, for besides its beauty, one benefits from a stable climate that allows the most painstaking research; I wouldn't say that it's easier, because this landscape is diabolical, with a line that doesn't allow any approximation and a light you can never capture.

While in Cimiez, Morisot thought about Corot's painting and went to the Fragonard Museum in Grasse. She also read Stendhal and copied several passages into her notebook. They reveal a side of Morisot's character she hid carefully from the outside world.

> it has always been the case that anything that has been foreign to my passion has meant nothing to me. It fills my every moment, happy or unhappy.
>
> My sensitivity has become too acute. What only touches others lightly wounds me to the core. . . . But I've learned to hide all that beneath an irony imperceptible to the vulgar.
>
> When unhappiness arrives, there's only one way to blunt its point, which is to oppose it with the sharpest courage. The

soul takes pleasure in its strength, and looks toward it, rather than looking toward unhappiness and bitterly feeling all its particulars.

Warmer weather brought the family back to Paris, in time to enjoy the 1889 World's Fair. Morisot's favorite exhibition was an entire Javanese village from the Dutch colony of La Sonde. Sixty Javanese natives had been imported for the benefit of fairgoers, as well as four dancers from the imperial court of Solo, who performed with gestures and music all the more alluring to Europeans because they seemed incomprehensible. The Javanese exhibition was a popular favorite and an even greater success with artists. Rodin made drawings of the dancers, Pissarro called it "a marvel"; Gauguin wrote to his friend Émile Bernard: "The entire art of India is there, and the photographs I have of Cambodia can be found in every detail."[2] Morisot made no such muddled geo-ethnographic claims but admired the same grace and exotic aura as her colleagues had, returning often to see the dancers. She shared her time between the Javanese village and Édouard Manet's pictures in the retrospective exhibition of French painting. The only trip away from Paris that summer was to Vassé.

Sometime that year Eugène published his novel, *Victims!* It seems to have been privately published. Its appearance explains some of his activities during the years since 1886, when illness kept him at home. Around 1880 he had been the president of the Cercle Protecteur des Arts of the eleventh arrondissement. Asked by suspicious police why he had joined (all three Manet brothers had police files, as the result of their political allegiances), Eugène Manet had disingenuously replied that he wanted somewhere to exhibit his pictures. Presumably he had withdrawn from active duty at the Cercle some years before 1889. He had been giving Julie lessons, and it was he who planted the rue de Villejust garden with the flowers and trees that made it look like "a real country garden," according to Julie.

Victims! though, must have kept him busier. The book required some research, for it is set in a real place, the town of Clamecy in the Nièvre (in northeast central France), and describes in some detail Clamecy's main nineteenth-century trade,

river logging, with its corporations and confraternities of boat-men and river loggers; the plot of *Victims!* is also based on a real episode. Between December 2 and December 10, 1851, insurrections flared up all over France in resistance to Louis Napoleon Bonaparte's December 2 coup d'état. A time lag in information between Paris and the provinces facilitated the brutal repression of all popular uprisings. Clamecy rebelled on the fifth, held out on the sixth, faltered on the seventh, and was crushed on the eighth. The young leader of the Clamecy rebels, Eugène Millelot, was among the 26,000 arrested throughout France. Although he had scrupulously defended the law, he was known by Napoleon's agents to be a republican activist, was farcically accused of a murder he had not committed, and was condemned for life to the brutally administered penal colony of Cayenne in French Guiana, a sentence effectively equivalent to slow torture, ending in certain death. By embroidering on Millelot's story, by then thirty-five years old, Eugène gave his political indignation a narrative and historical vehicle.

Eugène Manet was weakening in body if not in spirit. He and Morisot hunted in the early spring of 1890 for a quiet place in the country, where he might feel better. In the course of their search they came by chance to Mézy, a village northwest of Paris. At first it left them indifferent, but on the crest of a hill, called du Gibet, overlooking the valley of the Seine, they found the view they had been looking for, and immediately rented the nearest house, Maison Blotière.

Mallarmé sent a letter to Morisot there addressed with a poem.[3] Morisot replied: "Thank you, dear friend . . . I was quite delighted." They joked about Julie's First Communion, a Catholic sacrament as much of a "chore" as her baptism had been. Morisot wrote: "I was very nervous, very much withdrawn, and the parish priest, who was sick, had been replaced by colleagues who terrified me." Julie's parents' agnosticism, however, was of the sort so genuinely tolerant that they did not impose their point of view on their child. "Our friend Renoir" made several visits—and without warning, he was so sure of his welcome—to paint with Morisot, sharing her models and his ideas.

Cordial friendships and pastoral pleasures occupied the summer and fall superficially. Underneath, Morisot was going

through another crisis. Her husband was clearly very unwell, and it began to occur to her that his illness might be terminal. The prospect of a life without his companionship had to be confronted. In the short run, she had to deal with the frustration and the ambivalence his behavior elicited, on both his part and hers. Of course, his suffering made him more difficult to live with in small ways, particularly for a woman whose physical frailty had never kept her from an exceptionally active and independent intellectual life. Much more wrenching were the larger issues of guilt and responsibility. Morisot had written already to her sister Edma, on January 20:

> Eugène still looks woefully ill; he coughs, he continues to lose weight, he gets cross, I often ask myself if I fulfill all my duties to him as a wife; in any case I can't manage to distract him.
>
> It's a heavy burden to live with a sick person who suffers as much mentally as physically. I sometimes seem to hear my mother telling me at Fécamps that the end of my life would be like hers, bound to an invalid, and pitying me . . . well, let's not stir up all that lies at the bottom of my heart which during these winter days is gloomy.

Illness was drawing Manet into its control. There was nothing Morisot could do to counteract its tightening grip. But it is difficult for a person who loves an invalid to accept that her presence and affection can never completely compensate for the invalid's ebbing strength, especially since the one who is well can't really share the full emotional and physical impact of the illness. The stronger the love, the greater the guilt—that question to which there is no answer and no end: Could I be doing more?

Morisot had two reactions: to shield Julie from her father's condition and her own anxiety, and to plunge farther into work.

Far from being professionally shaken by her personal trials, she forged a more iron resolve and larger ambitions. For the first time in her life, at the age of forty-nine, after thirty-three years of painting, she got a studio of her own. The attic of Maison Blotière was transformed into a place she had to herself, where she could leave ongoing projects out overnight. In her notebooks, a grim determination to do her duty led her to claim the means to carry it out and the credit she deserved.

I want to do my duty now until my death; I would like others not to make that too difficult for me.

I don't think there has ever been a man who treated a woman as an equal, and that's all I would have asked, for I know I'm worth as much as they.

Around the time she made this first declaration of equality she was reading Marie Bashkirtseff, whose journal, published after her death at the age of twenty-four, had caused a sensation in Europe. Bashkirtseff—whose painting, as Morisot pointed out, was utterly conventional—had revealed in her diary a furious desire to achieve artistic success and had denounced the injustices faced by women in the art world. Morisot commented:

My admiration is thwarted by her mediocre painting—her *Meeting* and all the rest of it; it's vulgar, common, almost stupid, very hard to reconcile with this alert style, with so much wit and grace. I associate in my mind these two women's books: *A Sister's Tale*[4] and hers. Really, our value lies in feelings, intentions, and a vision more delicate than those of men; and if, by chance, pretension, pedantry, and affectation don't spoil us, there is much we can do.

She castigated her own work in stronger terms than ever: "The end of a season—sadness, despondency—I hate everything I've done, and its prelude of desolation!!!" She deprecated even her desire to confide her ideas to notebooks: "To think one has so many fine ideas while lying on the couch or in a trance on the omnibus, and to end up writing such nonsense!!!"

Yet she pursued the idea of a spirituality she had defined as feminine, and began to articulate her belief in an elevation beyond material contingencies. All hopes of gain and glory had to be relinquished.

With what resignation one arrives at the end of life, resigned to all the failures of this life, to all the uncertainties of the next. . . . It's been a long time since I hoped for anything, even of others, since the desire for glorification after death seems to me an unreasonable ambition.

Mine is limited to wanting to *capture something that passes;* oh, just something! the least of things. And yet that ambition is still unreasonable! A distinctive pose of Julie, a smile, a flower, a fruit, the branch of a tree, and every once

in a while a more vivid reminder of my family, just one of these would suffice.

All else was vanity. Women, Morisot wrote, were conditioned to believe in love, but its promise could be betrayed by earthly dross and by false expectations.

> It is said over and over again that woman is born to love, and yet that is what is hardest for her. Loving women are the creation of poets, and ever since we've been playing Juliet to ourselves. Not that the desire and the aspiration aren't there too, but everything that approaches realization is very likely to overwhelm the feeling, and the material fact is never anything but a degeneration, even in the moment of its pleasure. I'm convinced that curiosity is the only cause of many experiments.

Material joys were fleeting; life was transient; only art could endure. Morisot turned away from her disappointments and disillusions toward another world, the world of art, where hope was still possible and strength to be found.

> I saw passersby on the avenue with the clarity, the simplicity, and in the style of Japanese prints. I was delighted. I knew with certainty why I had only done bad paintings; so I won't do any more . . . yet I'm fifty years old and at least once a year I have the same joys, the same imperceptible hopes.

A few years before, she had compared works by Édouard Manet with Japanese prints:

> all of an incomparable vitality and lightness of execution. A lot like Japanese art of the best period; only he and they are capable of suggesting a mouth or ears with a single stroke, the rest of the face modeling itself by the accuracy of these indications.

In April 1890 a major exhibition of Japanese prints had opened at the Académie des Beaux-Arts. Cassatt had written to Morisot, urging her: "Seriously, *you must not* miss that. You who want to make color prints, you couldn't dream of anything more beautiful. . . . You *must* see the Japanese—*come as soon as you can.*"[5]

Morisot responded quickly. She went to Paris for the day, met Cassatt, and they saw the Japanese prints together. This visit inaugurated the closest phase of their relationship. Cassatt, who counseled several American collectors, began to urge both friends and family to buy Morisot's work. Morisot was back in Paris by early November, and their friendship even became, briefly, a collaboration. Both women worked on the same motif, a woman combing her hair in front of a mirror. Their initial drawings are so similar they must have been either working from the same model or copying the same prior image, possibly a Japanese print or ink drawing. What is certain is that in this period of collaboration Morisot and Cassatt both, for the first time in their careers, really tried the hallowed genre of the nude. Each woman spurred the other on to more daring feats. Morisot had made halfhearted attempts at nudes before. Cassatt had not. Cassatt, on the other hand, was experimenting with the infinitely rigorous and precise medium of color printing, devising new techniques and producing an unrivaled suite of prints, including one from these joint sessions with Morisot. Though Morisot had been tempted by color printing, she quickly gave it up; but from drawings made in these sessions with Cassatt came the most intellectually sustained and pictorially developed oil painting of the nude she would ever produce: *At the Psyche*.

By now Morisot could afford to turn down professional opportunities. Fond though she was of the younger painter Jacques-Émile Blanche, she had not responded positively to his proposal in January 1889 to join a Society of 33, which planned to exhibit yearly in Petit's gallery. In 1890 she declined Maus's offer to show with the XX again. The next year she told Pissarro she would join the Panel Society if he did, but nothing came of it. Not only was Morisot kept busy in these years with her work and with her husband at home; she herself fell seriously ill with rheumatic heart fever at the end of 1890. She wrote to Edma:

> I'm all right now, but not recovered from my mental shock; I thought I was grappling with death and I've remained terrified at the idea of everything that could happen after my death, for Julie especially. . . .
> You ask what I'm doing: nothing much. . . . So I've arrived

at the end of life in absolutely the same state as a beginner, and meanwhile selling myself short; it's nothing to rejoice about.

She asked her sister to take care of Julie should she and Eugène die; Mallarmé would be the child's legal guardian. Edma responded affirmatively but anxiously. Morisot reassured her: "I've always considered life a very great blessing and I'll do everything I can to conserve it as long as possible."

"Meanwhile selling myself short"—in April of 1891 Morisot exhibited with something resembling an Impressionist group for the last time. Durand-Ruel mounted another show in his galleries. Morisot recounted in a notebook her dismay at his attitude.

> Day in Paris; met Pissarro rue Lafitte. He praised my canvases at Durand's, which made me happy. Cruel disappointment: it's wretched, hung in a hall; Julie looks atrocious, you can only see the unevenness of the treatment. I'm so unpleasantly surprised that I complain to the young d [Durand-Ruel]. He answers that it looked *even* worse in the galleries [*sic*] *"then take them down."* [Puvis de] Ch[avannes] arrives. The entire establishment escorts him around, while P[issarro] and I, standing aside, make philosophical comments on "success."

Out on the street with Puvis, Morisot continued, "I explain to him that this establishment is taking advantage of my good nature and that I've decided to show myself in a different light." The outcome of this particular altercation is unknown, but it was one of several slights that led Morisot to turn her attention to other dealers.

That year Durand-Ruel offered Cassatt her first one-woman show. He had, it was true, commissioned a monograph on Morisot's painting (the first and only such article to appear in her lifetime) from Théodore de Wyzéwa, a friend of Mallarmé's. It came out in the March 28 issue of Durand-Ruel's house organ, *L'Art dans les Deux Mondes.* But an article, however eulogious, is not the same thing as an exhibition.

Early in the spring, Morisot, Manet, and Julie went back to Mézy. Morisot got to work on the most ambitious composition

of her career: a very large painting of two girls picking cherries off a tree. She made more preparatory drawings and studies for it than for any other project, and even produced two full-scale oil versions by 1892. Cassatt's 1891 show had included a picture of a young woman picking fruit, as would her 1892 mural for the 1894 Women's Pavilion at the Chicago World's Columbian Exposition. But then the same image appeared in Puvis de Chavannes's mural *Inter Artes et Naturam,* completed in 1890 for the Rouen fine arts museum. Perhaps the subject was in the air.

Morisot wrote to Mallarmé from Mézy on July 14:

> Your expression "I work and apply myself to aging" fits me perfectly. What if you always spoke for me? I'm not displeased with myself and it's a mistake to say so because it will bring me bad luck.
>
> . . . So I write to you simply, just as a sentimental young girl would, to make you understand how I miss you today and without telling Eugène what I'm doing because he usually accuses me of boring my friends.

And to Edma: "Yet I do constantly bear in mind that life goes on and it might be time to show what is within one's heart. I very often think of life in the old days, of all of us." The summer of 1891 provided a lull, in which Morisot gathered her energies. By the fall she felt ready for Paris and its urban excitement: "At heart," she wrote to Mallarmé, "women never entirely love the countryside."

This may have been true of the countryside itself, but a seventeenth-century manor house could work its charms. Morisot and Manet had been smitten by one at Mézy that summer. Negotiations went back and forth; bids were made and not accepted; Le Mesnil went up for auction and found no buyer; new bids were made. In October the house and its grounds were theirs.

19

Bereavement and Acclaim

1 8 9 2 – 1 8 9 4

Eugène Manet died slowly during the winter and early spring of 1891–92. Morisot divided her time between painting in her salon-studio and keeping her husband company in his room. The end came on April 13. Friends wrote to her, offering their condolence for her loss and for what they realized had been the torment of the last months. The letters she appreciated most were those that praised Manet: "Everyone didn't realize how much kindness and intelligence he had in him."

Morisot's suffering had not yet ended. Eugène Manet's death, though it had been so long anticipated, dragged her into a vortex whose pain forced its expression in words, barely legible, scrawled onto notebook pages.

I don't want to live anymore.

> I want to go down into the depths of pain because it seems to me it must be possible to rise from there; but now for three nights I've wept; mercy—mercy.

Then in her notebook Morisot recounts the story of her friend Marie Hubbard, who had tried to commit suicide after her husband's death and failed: "Suicide, she told me, would have passed as an accident, and I wanted so much not to survive my husband, the best friend of my entire life." But the very intensity of her anguish was the manifestation of life: "never does one feel one's being as much as in the exaltation of deep suffering."

Julie needed her; Mallarmé brought her his wisdom and his "admirable philosophy." Business pressed; she entrusted her affairs to Gustave-Adolphe Hubbard (presumably a relative of Marie's) and to Mallarmé: "I've trailed my widow's veil, my papers, and my grief by all those horrible business people; it couldn't go on." She read Montaigne.

She thought about what she had meant when she said she wanted to die: "I say 'I want to die' but it's not true at all; *I want to become younger.*" To redo the past? She tortured herself with the idea that she could have been a better wife, dredging up the harshest words of Manet's she could find: "[Eugène] said to me one day 'you have the surface of a heart'— Is that true?" Now he could not answer her questions.

> If I were seated on the dock at Dover and he in Calais we would be so close to each other but we wouldn't be able to hold hands or communicate a single idea. Well, that's just what our situation is; between us there's a small sea channel: an entire ocean held in a narrow passage so terribly deep.

> I would like to relive my life and comment on it, tell of my weaknesses; no, that's useless; I've sinned, I've suffered, I've atoned, and I could never produce anything but a bad novel by telling what has been told a thousand times. What I would like would be to recapture the moments when I had strength and vigor, a line of conduct, a rule, a faith; but that's beyond my powers.

The past could not be relived or rewritten. But memory would endure.

Remembrance is the only real imperishable life. What has sunk, what has erased itself was not worth living, and therefore hasn't been. The *sweet* hours, the *terrible* ones, remain unchangeable—and do we need ordinary material objects like relics to relive them? That would be base.

I've often thought that immortality, our mystic life, was the trace we left of our material life. "Many are called and few are chosen." What could be truer! The entire flock dies or wins its eternity by dint of its work; and then there's the life of the heart; to sing of it is the immortality of the humble, something like the affection that makes us live again in the memory of those we love.

That's a tiny prolongation of life, and after? Oh, after, I don't know; that great name of God means nothing to me; as a child, I sometimes thought I saw Him in the clouds; now the word means nothing to me. There are people who have never had a soul—how could it be eternal?

Work would have to be her salvation and her consolation. Perhaps not work glorious in its scope, but work that might, humbly, sing "the life of the heart."

Eugène Manet had left his wife the most healing possible legacy—work to be done. He had instigated negotiations for a show of her own with a rival to both Durand-Ruel and Petit: the Boussod & Valadon gallery. Its manager wrote her apologetically after Manet's death to remind her of a possible opening date of May 15. Morisot decided to follow through. She retired with Julie to Le Mesnil to prepare her first one-woman exhibition. Her grief distracted her even from anxiety about her work. She wrote to Paule Gobillard during her month's retreat:

I see you're getting annoyed at your painting, so it will always be. As for myself I've never ceased [to be troubled by my painting] until now when other troubles haunt me so powerfully that I think about it hardly more than during the actual time of its execution. I imagine it's become totally bad because only my nerves goad me on; for women at least, calm beauty comes only from strength.

Recent pictures were brought to completion, older works taken off her walls, pulled out of closets, borrowed from collectors. Gustave Geffroy, an eminent critic, agreed to write a pref-

ace to the catalogue. Forty oil paintings, plus pastels, watercolors, and drawings, went up on the mezzanine walls of Boussod & Valadon, boulevard Montmartre. The two rooms were relatively small and discreetly lit, making the pictures seem as if they were hanging in the private homes for which they had been intended.

The show opened May 25, only ten days behind schedule, and ran until June 18. Not all the reviews were entirely favorable. One critic wrote condescendingly: "The powder puff has done its work and even the Argenteuil sailboats have been dusted."[1] But this was a minority opinion. Morisot—of course—had foreseen the worst. A combination of her insecurity and her deep mourning caused her to stay away from the opening and to leave Paris the next day. Renoir reassured her that the only failure was the failure of her own predictions. "In short, everyone is pleased and I send you my compliments." Geffroy's preface was effusive. Puvis wrote to congratulate her, family wrote, Monet bought a picture for a more than respectable fifteen hundred francs. One picture fetched twice that. Others sold to connoisseurs. Even Morisot had to acknowledge she was pleased. She wrote to a young admirer:

> Well, I'll tell you very frankly that it all seems less bad than I had anticipated, and some of the very old things actually didn't displease me. Let's hope that twenty years from now the new ones will produce the same effect.

Only Cassatt's silence marred Morisot's pleasure.

A monographic show establishes a painter. In 1892 another eminent critic, Lecomte, evaluated the art scene and listed who he thought were France's most important modern painters.

> No well-educated artist today contests Manet's glory; soon he will be officially consecrated by the Louvre. Likewise, the reputations of Mssrs Degas, Monet, Pissarro, and Renoir have been duly established, and people of taste appreciate the talent of M. Sisley, of Miss Cassatt, and of Mme Morizot [sic].[2]

One of eight.

After her exhibition, Morisot found the courage to make two difficult related decisions. Propriety suggested that a widow

move to a more modest home; Morisot may also have been worried about wasting money she now considered more Julie's than hers. She steeled herself to renting both the rue de Villejust apartment and Le Mesnil. At first it seemed unbearable, but then:

> after sorrow, joy—if I compare today's state of mind with last week's I seem to be another person, and yet what in my life has changed? How could I have been so stupid as to think for one minute that exterior things had any importance, that any bit of my happiness depended on these walls?
>
> I've gotten used to the idea of leaving this home where Julie grew up and I have faded. My memories are within me, imperishable, and after my death will interest no one.

She had repairs made on Le Mesnil, redecorated it a little, and rented it for three years. She emptied out the rue de Villejust apartment. There, in her now-bare salon-studio, during the hot summer days, she went on painting till the last minute.

In the fall she finally took a vacation. With Julie she went back to Tours, where she worked in the museum, and, following a familiar itinerary, to the Vaissières in Touraine. A photograph records her sitting on a bench there in Vassé's park, beneath a tree. She looks thinner than ever, and her hair has become completely white. Her face is grim and lonely, but her gaze remains as piercing as ever. In Tours she thought ceaselessly about death and sorrow, but with a greater distance, feeling to her relief and dismay that she was moving on.

> The duration of our passions doesn't depend on us any more than the duration of our lives.
>
> Salvation and death cannot stare each other in the eye.
>
> We arrive unprepared to each of life's ages and we lack experience in spite of our years.

Should she go on grieving? Her husband was no longer with her as he had been; she had lost her contact with him; he was becoming a memory. "You are healed as you are consoled; you don't have the heart to weep forever, and love forever. There should be in the heart unquenchable sources of sorrow for some losses." But the heart did heal, and "no tenderness, no resilience, no

strength, no effort" could halt the process. Morisot was unsure whether reason or simply human nature had triumphed over suffering, yet she knew she was mending.

Morisot and Julie went back to Paris and moved into an apartment at 10 rue Wéber, about midway between the rue de Villejust and her favorite Bois de Boulogne. As was her wont, Morisot chose a brand-new building. Renoir wrote her empathetically: "It must seem strange to you and I won't find you comfortable yet. It will take time." Her new home included a studio, made by joining together two or three maids' rooms on the building's top story.

She worked steadily, both there and in the Bois de Boulogne, usually with Julie either as model or fellow painter. Camille Mauclair, otherwise an art critic, came to the apartment to give Julie, sometimes with her cousin Jeannie, lessons, none too serious, on disparate subjects. Morisot sent one of her early Fécamp harbor scenes to a spring show with the avant-garde London New English Art Club, and two paintings to the Association pour l'Art show in Antwerp in May. The guests of her Thursday dinners now came to the rue Wéber. She renewed contact with the women friends of her youth: "I do hope we'll see each other again here; now we form a society of old ladies. Isn't life strange? Just think of our having already come to this."

Another trial began. Her sister Yves Morisot Gobillard was dying of mouth cancer, a disease as excruciating as it was disfiguring in a time before sophisticated treatments or analgesics. She died in great pain about June 8; Morisot was with her.

She considered summer trips to the provinces but needed calm and close friends. Between August 24 and September 4, then again between September 18 and September 30, she and Julie went to Valvins in the forest of Fontainebleau, accompanied by Laërte, an extremely elegant little greyhound given to them by Mallarmé. At Valvins they stayed in an inn, spending part of every day painting together and part with the Mallarmé family, walking, boating, touring, or just talking. They spent a day with the Sisleys at Moret; Morisot gave one of her paintings to the Sisley children.

The fall and winter seasons passed quietly and industriously, punctuated by concerts, study in the Louvre, outings to local

parks, and visits to and from fellow painters. On October 30 Morisot and Julie spent a day at Giverny with the Monets, admiring Claude Monet's "Cathedral" series and the very personal style of his house and gardens. Paule and Jeannie Gobillard, then living on the rue Mignard, often came to work and learn in Morisot's studio. Morisot had relaxed her adherence to plein air painting and now worked more often from models. She taught her three pupils as much from Delacroix and Édouard Manet as from nature. Morisot and Julie also seized the opportunity to study Manet's pictures during their frequent visits to his widow.

Caillebotte's death on February 21, 1894, reactivated the Impressionist controversy. His legacy to the state, which included paintings by Manet and the entire group minus Morisot and Cassatt, stipulated that the pictures be displayed in the Luxembourg Museum, not stored. Troglodyte Beaux-Arts painters vociferously announced the degeneration of French culture. The Fine Arts Ministry wanted to behave as all administrations do—cautiously. Poor Renoir, Caillebotte's executor, had to placate everyone and proceed with careful diplomacy. Eventually he managed to have thirty-eight of the sixty-six paintings accepted.

The Manets' cousin de Jouy, Julie's godfather, lay paralyzed and fading. Once more Morisot confronted suffering and death. She went to de Jouy's bedside March 4, 5, and 7, and wrote afterward:

> I went to visit poor de Jouy paralyzed in his bed; he wept, and as I was consoling him, he kissed my hand—it's his first gallant gesture. I can still see his kind face on the pillow. He's so very close to death, can he feel his soul?

De Jouy died on the ninth. "How many memories are accumulating," said Degas.

Morisot stayed for de Jouy's funeral on the twelfth and his burial the next day. That evening she and Julie took the train to Brussels, where Morisot had contributed four pictures to the exhibition of La Libre Esthétique, Maus's new version of the XX. Julie and her mother visited the Brussels museum, saw the city's sights, and went to the show. Julie recorded in her diary: "It's very well arranged. You see some of everything." The Pissarros, father and sons, were represented, as well as Renoir, Maurice

Denis (a fervent admirer of Morisot's work), Redon, and Gauguin. On the sixteenth they attended a concert by the violinist Ysaÿe at La Libre Esthétique, hosted by Maus, who personally escorted Morisot around the exhibition. She and Julie took the train back to Paris that evening, to arrive in time for the public exhibition of Théodore Duret's collection the next day.

Morisot's old friend Duret, short of cash, was auctioning all his pictures. Unlike the last auctions she had been involved in—the 1875 Drouot sale and the 1878 Hoschedé sale—this one brought her professional acclaim. In yet another of the symmetries that structured Morisot's career, the Duret sale marked culminations of her artistic roles as both painter and woman, as both creator and model. Duret's collection included not only Morisot's 1879 *Woman at a Ball* but also Manet's 1869–70 *Repose* and his 1872 *Berthe Morisot with a Bouquet of Violets*.

Duret had admired *Woman at a Ball*, a portrait of a young woman in a white ball dress, at the 1880 Impressionist Exhibition. It was purchased by the painter de Nittis. When de Nittis died, Duret bought it. He hung it in a place of honor in his home, and when Mallarmé came to visit, "we were all in raptures over its charm." As soon as the terms of Caillebotte's will became known, Renoir, Mallarmé, and Duret realized Morisot's work would be unfairly left out of the Impressionists' first museum victory. Duret saw an opportunity to do a friend a service and simultaneously turn himself a profit. He proposed to Mallarmé that *Woman at a Ball* be bought by the state for the Luxembourg. *Buy* an Impressionist picture while the same administration was fighting such pictures as a gift? Mallarmé pulled strings with Roujon, once his disciple, now a director of the Beaux-Arts. Roujon came to Duret's, along with Bénédite, curator of the Luxembourg, and Benoit, curator at the Louvre. "The painting making its own case," as Duret recalled, the purchase was agreed on. In order to guarantee a price commensurate with the picture's ultimate venue, they agreed to bid the picture up to 4,500 francs.

The auction took place on March 19. *Woman at a Ball* was duly bought by the state for 4,500 francs. Morisot, in the meantime, had decided to claim the portraits of her by Manet. She instructed Durand-Ruel to bid for her. Communication was confused over *Repose*, which went to the singer Faure for the very

high price of 11,000 francs. *Berthe Morisot with a Bouquet of Violets* did not escape her. Durand-Ruel paid 5,100 francs for it and turned it over to Morisot for a commission of 225 francs. By the end of the day *Repose* had been singled out as a masterpiece of Manet's, *Berthe Morisot with a Bouquet of Violets* had rejoined its companion *Bouquet of Violets* in Morisot's home, and Morisot's work was on its way to consecration in the Luxembourg. Because the Caillebotte bequest took more than a year to be accepted, it was Morisot who actually led Impressionism into French museums.

Renoir asked if instead of painting a third portrait of Julie alone (he had made a second earlier in the year) he could do a double portrait of mother and daughter. Would they come two mornings a week for three weeks to his studio, rue de Tourlaque, in order to avoid the distractions of their home? Morisot agreed, and the portrait was made, prepared by a pastel sketch. In it Morisot and Julie sit close together, but each with a different attitude toward the viewer. Morisot looks off to the side, poised and solid; Julie looks expectantly outward.

That summer, as Morisot wandered through the Saint-Lazare railway station, a poster advertising Brittany caught her attention. On a whim she decided to set off with Julie and her Gobillard nieces, Jeannie and Paule (and Octavie, the maid). On August 8 they boarded the train and made their way slowly through Saint-Brieuc to Portrieux, where they rented a house called La Roche Plate. The younger ones bathed in the sea, and they all painted. Their weeks were punctuated by outings to Saint-Quay, Étables, and Binic. Mallarmé and Renoir were invited, but could not come, instead keeping up a lively correspondence with, respectively, "one of the most discerning people crossing the Saint-Lazare railway station" and "maman Manet."

On September 8 or 9 sad news reached the women that Adolphe Pontillon, Edma's husband, had died in Paris. On September 15 the little group began to wend its way homeward, through small Breton towns, including Morlaix, where Morisot added to her porcelain collection. Jeannie and Paule proceeded to Paris, leaving Berthe and Julie alone for a few days in the city of Nantes, where they admired Ingres's portrait *Mme de Senonnes*. On September 24 they were back at 10 rue Wéber.

Work, concerts, theater, dinners, visits to and from old friends—the rhythm of the year before resumed. Morisot was producing more pictures than ever. She painted every day, concentrating, never satisfied with what she had done, always striving toward an ideal.

20

Summation

1 8 9 5

... her hair whitened by the abstract purification of the
beautiful rather than aged, with a length of veil, a serene
discernment, whose judgment, under the circumstances,
had no need of death's perspective . . .[1]

So Mallarmé, in his elliptical poetic way, remembered Morisot
in her final months. In photographs taken during her last years,
as well as in Renoir's portrait of her with Julie, she does seem
old. And yet she also seems serene, perhaps more so than she had
ever been. Age distilled Morisot. Time pared away the inessen-
tial. In the three years between her husband's death and her own,
she reflected on the past: "how many silent dead behind us! all
those ancestors, of whom we know nothing, who lived, ate,
drank, slept, without leaving anything to us, their descendants."

She tried to sum up her ideas on art, or rather, her disdain for "ideas" in art.

> Explaining how painting is done might perhaps interest the idly curious because they'll never understand anything. . . . Real painters understand with a brush in their hand . . . besides, is this vulgarization of artistic matters really necessary?
>
> What does anyone do with rules? Nothing worthwhile. What's needed is new sensations; and where to learn those? All painting is copied from nature, of course, but is it the same when copied by Boucher or by Holbein? Each is as true as the other. In drawing as well as in color. . . .
>
> One doesn't train a musician's ear by explaining sound vibrations to him scientifically, any more than one trains a painter's eye by explaining color relationships and linear harmonies to him.
>
> Obviously there are a few simple concepts accessible to everyone; they were well known in the last century and applied with a pretty artistic sense because in those days life was simple; there was time to earn a hundred sous; now, however, these same concepts are gaining currency among the public, thanks to some painters' efforts; and what has it produced? Those terrible primary-color posters so odiously ubiquitous.
>
> Ah, when all France quibbles about painting it will be as if run over by a huge roller of impotence; that would be the triumph of Pissarro! Everyone talented and no one a genius!!!
>
> How we will regret the time when Ingres and Delacroix were painting their masterpieces and when young ladies were satisfied with absurd amateur accomplishments.

Morisot regretted a more leisurely past and criticized modern women's lives.

> Today, young girls take 5 or 6 courses a week, later they come out into society, then they marry and devote themselves to their husbands. So no more models, no more of those lovely moments of leisure, of that picturesque languor; everyone is restless and fidgety, no one understands that there's nothing like 2 hours reclining on a *chaise lounge*—life is a dream—and the dream is more real than

reality; in dreams one is oneself, truly oneself—if one has a soul it's there.

Old age without a soul was pitiful: "Contempt for old age is motivated by this: that to have lived so many years without having manifested the life of the spirit is pitiful." But there was another way to grow old.

> I mean age which has thought, which has suffered, which has eaten little and drunk little, which glimpses the beyond, and which becomes strange in the eyes of the vulgar because of its contempt for ordinary life.

She felt more clearly conscious than she had since childhood. She asked herself why. Why anything? Why write down her ideas? "Everything has been already thought, only words give a new value to things, how sad not to be able to use them." But she went on trying, for writing caught ideas that seemed to evade her otherwise.

> . . . then why scribble? . . . Because any life that reaches its end seeks to recapitulate itself.

> There is a kind of elevation that does not depend on fortune; it's an indefinable air that distinguishes us and seems to destine us for great things; it's the value we give ourselves imperceptibly. Especially to our spirit.

"We all die with our secret," she wrote. The secret of her strength, her will, and her creativity disappeared with her. But in her paintings she left its testimonials and its achievements. Just as at the end of her life she reflected on herself and her past in her notebooks, so she did in her paintings. In a last series of works, she reincorporated into her paintings her favorite portrait of herself by Édouard Manet; another of his paintings; Degas's portrait of Eugène Manet; a photograph of herself, Eugène, and Julie at Bougival; earlier pictures of her own. Folding the past into the present, leaving a heritage to the future, she recapitulated her artistic career and settled all her accounts.

Julie Manet recalled her mother falling sick in the middle of February 1895 and ceasing to paint then. Her memory had compressed time. Morisot wrote to Mallarmé in early January 1895

that Julie was very sick with flu. Morisot nursed her child through the illness. Julie wrote to her friend Geneviève Mallarmé, the poet's daughter, a dated and postmarked letter on January 15 saying that she was just recovering but that her mother had caught her illness: "Maman has a bad cold." For more than a month Morisot felt this cold wear her down, so self-denying she would let no one know how sick she was.

Suddenly at the end of February her illness erupted as pneumonia. She had to write Mallarmé on February 27: "I'm ill, my dear friend, I don't ask you to come because it's impossible for me to speak." Morisot was not "ill"; she was dying. Her sister Edma rushed to her side, bringing her daughters, Blanche and Jeannie, to be with Julie. The doctors came twice a day. Friends asked anxiously for news. On February 28 the pain increased. The next day Morisot could hardly swallow. Julie wrote in her diary the words of all children whose mothers are dying: "oh, my God, heal Maman." The pain grew worse. At three in the afternoon Morisot spoke to Julie for the last time. By seven she could hardly breathe. At ten-thirty she was dead.

Mallarmé sent telegrams to a chosen few:

> I am the bearer of terrible news; our poor friend Mme Eugène Manet, Berthe Morisot, is dead. In her discretion she asked that no announcements be made, but only those who were not strangers be told personally. In no way could I have failed to include you.[2]

Morisot's family buried her in the Passy cemetery, next to Eugène and Édouard Manet. On her death certificate they described her as having "no profession."

She had written a last note to Julie the day before her death:

> My little Julie, I love you as I die; I will love you when I'm dead; please, don't cry; this separation was inevitable; I would have liked to survive till your wedding. . . . Work and be good as you have always been; you haven't made me sad once in your little life. You have beauty and wealth; use them well. I think it would be best if you were to live with your cousins, rue de Villejust, but I prescribe nothing. Give some souvenir of me to Aunt Edma and to your cousins; to your cousin Gabriel, Monet's *Boats Under Repair.* Tell M.

Degas that if he founds a museum he should pick a Manet.
A souvenir to Monet, to Renoir, a drawing of mine to Bar-
tholomé. Give something to the two concierges. Don't cry;
I love you even more than I can say; Jeannie, take care of
Julie.

Morisot's modest hope was to be remembered by a small group
of chosen friends. To them she left her own paintings. To poster-
ity she left something larger than one person's work: her contri-
bution to Impressionism. On her deathbed she imagined Degas
founding a museum to commemorate its achievements, and she
bequeathed to this possibility what she believed was the finest
painting of her generation—Édouard Manet's.

After her death Morisot's work met the fate she seemed to have
decreed for it as she died. Known and appreciated by family,
personal friends, and a few connoisseurs, its reputation gradu-
ally faded among the public. Her role in the Impressionist move-
ment dwindled almost to that of Édouard Manet's sister-in-law
and model. Nearly a century passed before a dramatic reversal
of this trend began. Women's history rediscovered the subjects
to which Morisot had devoted herself. In her images we now find
the secluded and almost invisible world of women's values and
women's lives, of femininity as it was perceived and experienced
from within. Morisot figures once more alongside her colleagues
Degas, Manet, Monet, Pissarro, Sisley, and Renoir in the history
of Impressionism, in museum collections and exhibitions, in
galleries and at auction. And now she also takes a central place
in the history of women artists, a history she could not foresee
because she was so much one of its pioneers.

Yet the example she set belongs as much to the everyday as to
history. Responsibility meant many things to Morisot. In her last
letter she dreamed of a museum devoted to Impressionism, and
she also remembered the needs of the two porters in her build-
ing. She was a woman who felt obligations and who fulfilled
them—to her own creative capacities, to her parents, to her
friends, to modernity, to art, to her sisters, her husband, her
child: to the gifts she had been born with and to the choices she
made. She lived the life of the mind and the life of the heart, with
ardor and with honor.

Notes

All unpublished citations of Morisot's letters or notebooks are taken from manuscripts in private collections. Published citations are from Denis Rouart's 1950 *Correspondance de Berthe Morisot* or from Philippe Huisman's 1962 *Morisot: Charmes.* Unless otherwise indicated, all translations are the author's. In all cases Morisot's writing remains under the copyright of Rouart Frères.

1. Family Background 1841–1857

1. The school founded by Napoleon I for daughters of officers decorated with the Legion of Honor. It was then thought to offer among the most rigorous and pedagogically advanced educations for women.
2. Archives Nationales: F1 bI 167/31.

2. First Lessons 1857–1867

1. Edmond Duranty, "L'Atelier," *Le Pays des Arts* (Paris: Charpentier, 1881).

3. Contacts 1859–1867

1. Marie Bashkirtseff, *Journal* (January 2, 1879), trans. Mathilde Blind (1891, reprint, London: Virago Press, 1985), p. 347.
2. Morisot's historians have all said she worked in Rosbras. She apparently stayed in Rosbras, where her mail was addressed, but her surviving paintings, studied in comparison with nineteenth-century photographs, are not of Rosbras but of Pont-Aven seen from just down the Pont-Aven River from its harbor.
3. Geneviève Viallefond, *Le peintre Léon Riesener, 1808–1878. Sa vie, son oeuvre, avec des extraits d'un manuscrit inédit de l'artiste* (Paris: Editions Albert Morancé, 1955), p. 29.
4. See Charles Baudelaire, "Hygiène," *Oeuvres complètes* (Paris: Gallimard, 1961), pp. 1265–70. Morisot's adaptation reads:

 The more one wants, the better one wants; morally and physically I have always had the sense of the abyss: the abyss of action, of dream, of memory, of desire, and . . . of the beautiful . . . I glimpsed my hysteria with sensual joy and terror. Now I always feel dizzy, and today, 23 February 1862, I experienced a singular warning: I felt the wing of madness pass over me. Oh! the number of presentiments and signs already sent by God! And It is high time to act, to look upon the present moment as the critical moment, and to make of my daily torment, work, my perpetual pleasure. To be cured of everything, of poverty, sickness and melancholy, all that is needed is the taste for work! To do one's duty every day, to trust in God for the morrow. The power of obsession, the power of hope. Any shrinking of the will is a bit of substance lost. How wasteful, then, is hesitation! And only consider how immense the final effort necessary to repair so many losses! The man who says his prayers in the evening is a captain who posts guards. He is able to sleep. Work is bound to breed good habits, sobriety and charity, consequently better health, wealth, an ongoing and progressive genius, and charity. I vow to myself from now on to adopt the following rules as eternal rules of my life. Every morning, to say my prayers to God, fund of all strength and justice, to my father, to Maria, to [?] as intercessors; asking them to communicate to me the necessary strength to fulfill all my duties, and to grant my mother a life long enough to enjoy my transformation; to work

all day, or at least for as long as my energies permit; to trust
in God, that is to say in justice, even for the success of my
projects; to say another prayer every evening asking God for
life and strength for my mother and myself; to divide all that I
earn into four parts: one for daily expenses, one for my
creditors, one for my friends, and one for my mother; to
observe the principles of the strictest sobriety, of which the
first is to do away with all stimulants, whatever they may
be. . . .

4. Encounters and Partings 1868–1869

1. Theodore Reff, "Copyists in the Louvre, 1840–1870," *Art Bulletin* 46
 (1964): 552–59.
2. "La Demoiselle," Agathe Rouart-Valéry (unpublished family mem-
 oir).
3. The essential article on Gustave and Eugène Manet, as well as on
 Édouard's political life, is Philip Nord's "Manet and Radical Politics,"
 Journal of Interdisciplinary History 19, no. 3 (Winter 1989): 447–80,
 which I was generously allowed to read in a longer version.
4. Eugène Manet, *Victimes!* (Clamecy: Imprimerie A. Staub, 1889).

5. Alternatives 1869–1871

1. 1868–69, *The Balcony;* 1869, *Berthe Morisot in Profile, Berthe Morisot
 with a Muff;* 1869–70, *Repose;* 1872, *Berthe Morisot with a Pink Shoe,
 Berthe Morisot with a Fan, Veiled Young Woman, Berthe Morisot with
 a Bouquet of Violets;* 1873, *Berthe Morisot Reclining;* 1874, *Berthe
 Morisot in a Mourning Hat, Berthe Morisot in Three-Quarters View.*
 In addition, Manet made two prints after *Berthe Morisot with a Bou-
 quet of Violets* and a watercolor after *Berthe Morisot in Three-Quar-
 ters View.* So a different kind of count might give eleven paintings but
 fourteen variations.
2. Manet sold *The Balcony* to Gustave Caillebotte, a fellow painter and
 future member of the Impressionist group; *Repose* to Paul Durand-
 Ruel, the first dealer to support Manet and the Impressionists; and
 Berthe Morisot with a Fan to Dr. de Bellio, one of the Impressionists'
 most loyal collectors as well as Manet's physician. To his friend the
 collector and art critic Théodore Duret he sold or possibly gave *Ber-
 the Morisot with a Bouquet of Violets,* and he sold him the watercolor
 version of *Berthe Morisot in Three-Quarters View* for six hundred
 francs in 1873.
3. Of the five actually in Manet's studio, four figured in his posthu-

mous sale. The last, *Berthe Morisot in a Mourning Hat,* was given to de Bellio in gratitude for his care of Manet during his last illness. From de Bellio the picture passed into Degas's collection. Manet's widow kept *Berthe Morisot with a Muff.* A cousin of Morisot's bought *Berthe Morisot in Profile,* a close friend *Berthe Morisot with a Pink Shoe.*

7. Personal Crisis 1870–1872

1. Baronne Staffe, *La Femme dans la Famille* (Paris, n.d.), p. 56.
2. Ernest Legouvé, *La Femme en France au XIXe Siècle* (Paris: Librairie de la Bibliothèque Démocratique, 1873), p. 25.
3. E. Boursin, *Le Livre des Femmes au Dix-neuvième Siècle,* 5th ed. (Paris: Rome, 1865), p. 62.
4. Marie Bashkirtseff, *Journal* (June 20, 1882), trans. Mathilde Blind (1891, reprint London: Virago Press, 1985), p. 536.
5. Alphonse Daudet, *Le Nabab* (Paris, 1881), p. 258.
6. Edmond Duranty, "L'Atelier," *Le Pays des Arts* (Paris: Charpentier, 1881), pp. 151–52.
7. Geneviève Bréton, *Journal 1867–1871* (Paris: Ramsay, 1985), p. 121.

8. Resolutions 1872–1874

1. Jacques-Émile Blanche, "Les Dames de la Grande-rue, Berthe Morisot," *Ecrits Nouveaux* (Paris: 1920), p. 21.
2. Ibid.
3. Monique Angoulvent, *Berthe Morisot* (Paris: Morancé, 1933), p. 39.

9. Joining the Impressionist Movement 1873–1874

1. *Gazette des Femmes,* July 10, 1883, p. 99.
2. Jean Alesson, ibid., December 10, 1879, p. 2.

10. The First Impressionist Exhibition 1874

1. Philip Nord, "Manet and Radical Politics," *Journal of Interdisciplinary History* 19, no. 3 (Winter 1989): 472.
2. Ibid., pp. 471–72.
3. Ibid., p. 472.
4. Léon de Lora, "Petites nouvelles artistiques: Exposition libre des peintres," *Le Gaulois VII,* no. 2013 (April 18, 1874), p. 3.
5. Jules-Antoine Castagnary, "Exposition du Boulevard des Capucines:

Les Impressionnistes," *Le Siècle,* April 29, 1874. In *The New Painting: Impressionism 1874–1886* (San Francisco, 1986), p. 110.

11. Eugène Manet

1. Henri de Régnier, "Faces et Profils: Berthe Morizot," *Nouvelles Littéraires,* July 13, 1935, p. 4.
2. Eugène Manet, *Victimes!,* p. 23.
3. Ibid.
4. Ibid., p. 26
5. Ibid., p. 149.

12. Artistic Events

1. Cited in Rouart, *Correspondance,* p. 84.
2. O. d'Alcantara, *Marcello: Adèle Affry Duchesse Castiglione-Colonna, 1836–1879* (Geneva, 1961), p. 167.

13. A New Bond

1. Théodore Duret, *Histoire des Peintres Impressionnistes* (Paris: Floury, 1906), p. 114.

14. Impressionism Comes of Age

1. Albert Wolff, "Le Calendrier Parisien," *Le Figaro,* April 3, 1876.
2. *The New Painting,* p. 149.
3. Ibid., p. 477.
4. Stéphane Mallarmé, "The Impressionists and Edouard Manet" (1876), ibid., p. 33.
5. Ibid., p. 33.
6. See Nord, "Manet and Radical Politics," p. 450.
7. Paul Mantz, "L'Exposition des Peintres Impressionistes," *Le Temps,* April 22, 1877.

15. Fulfillment 1878–1883

1. Cited in *The New Painting,* p. 244.
2. Ibid., p. 54.
3. Mary Cassatt, *Cassatt and Her Circle: Selected Letters,* ed. Nancy M. Mathews (New York: Abbeville Press, 1984), p. 149.
4. *The New Painting,* p. 295.

5. Lionello Venturi, *Les Archives de l'Impressionnisme: Lettres de Renoir, Monet, Pissarro, Sisley & Autres. Memoires de Paul Durand-Ruel. Documents* (Paris and New York: Durand-Ruel, 1939), p. 120.
6. Cited in *The New Painting*, p. 379.

16. Loss 1883–1886

1. Angoulvent, *Morisot*, p. 70.

17. La Grande Dame de la Peinture 1884–1891

1. Camille Pissarro, *Lettres à Son Fils Lucien*, ed. Lucien Pissarro and John Rewald (Paris: Albin Michel, 1950), p. 88.
2. Camille Pissarro, *Correspondance, Vol. 2, 1886–1890*, ed. Janine Bailly-Herzberg (Paris: Editions du Valhermeil, 1986), p. 25.
3. Pissarro, ibid., p. 45.
4. Jean Ajalbert, *La Revue Moderne*, June 20, 1886. In *The New Painting*, p. 451.
5. Stéphane Mallarmé, "Berthe Morisot," *Oeuvres* (Paris: Gallimard, 1961), p. 533.
6. Edgar Degas, *Lettres*, ed. Marcel Guérin (Paris: Grasset, 1945), p. 56.
7. Henri de Régnier, "Mallarmé et les Peintres," *L'Art Vivant* VI, no. 127 (April 1, 1930): 265–66.
8. Théodore Duret, *Histoire des Peintres Impressionistes* (Paris: Floury, 1906), p. 164.
9. Mallarmé, *Oeuvres*, p. 534.
10. "Vous me prêtates une ouïe / Fameuse et le temple; si du / Soir la pompe est évanouie / En voici l'humble résidu."
11. Régnier, "Mallarmé et les Peintres," p. 266.
12. Régnier, "Faces et Profils," p. 4.

18. Art Closer to Home and Farther Abroad 1885–1891

1. Camille Pissarro to Lucien Pissarro, May 15, 1887. *Correspondance de Camille Pissarro*, ed. Janine Bailly-Herzberg (Paris: Editions du Valhermeil, 1986), p. 167.
2. Ibid., p. 278.
3. Sans t'endormir dans l'herbe verte / Naïf distributeur, mets-y / Du tien: cours chez Mme Berthe / Manet, par Meulan, à Mézy.
4. Mrs. Augustus Craven, *Récit d'une Soeur: Souvenirs de Famille Recoueilles* (Paris: Clay, 1866).
5. Cassatt, *Letters*, p. 214.

19. Bereavement and Acclaim 1892–1894

1. G. Albert Aurier, "Deux Expositions: Berthe Morisot," *Mercure de France* II (July 1892): 260.
2. Georges Lecomte, *L'art Impressionniste d'après la Collection Durand-Ruel* (Paris: 1892).

20. Summation 1895

1. Mallarmé, *Oeuvres*, p. 536.
2. Henri Mondor, *Vie de Mallarmé* (Paris: Gallimard, 1941), p. 709.

Selected Bibliography

HERBERT, ROBERT L. *Impressionism: Art, Leisure, and Parisian Society.* New Haven: Yale University Press, 1988.

HUISMAN, PHILIPPE. *Morisot: Charmes.* Lausanne: International Art Books, 1962.

MANET, JULIE. *Journal (1893–1899).* Paris: Klincksieck, 1979.

NORD, PHILIP. "Manet and Radical Politics," *Journal of Interdisciplinary History* XIX, no. 3 (Winter 1989): 447–80.

REY, JEAN-DOMINIQUE. *Berthe Morisot.* Naefels: Bonfini Press, 1982; 2d ed. Paris: Flammarion, 1989.

ROUART, DENIS, ed. *Correspondance de Berthe Morisot.* Paris: Quatre Chemins-Editart, 1950.

STUCKEY, CHARLES, WILLIAM SCOTT, AND SUZANNE LINDSAY. *Berthe Morisot—Impressionist.* New York: Hudson Hills, 1987

The New Painting: Impressionism 1874–1886. Exhibition catalogue. San Francisco: The Fine Arts Museums of San Francisco, 1986.

Index

ABOUT THE AUTHOR

Anne Higonnet graduated from Harvard College and Yale University. She is Associate Professor in the art department of Wellesley College. Her book *Berthe Morisot's Images of Women* was published by Harvard University Press in 1992.